MEGAN VOLPERT

ILLUSTRATIONS BY ASHER HAIG

SIBLING RIVALRY PRESS
LITTLE ROCK, ARKANSAS
WWW.SIBLINGRIVALRYPRESS.COM

1976
Copyright © 2016 by Megan Volpert

Cover art by Asher Haig
Cover design by Seth Pennington

Illustrations by Asher Haig: January: *History*; February: *Perspective*;
March: *Sovereignty*; April: *Body Without Organs*; May: *Self-Identity*;
June: *Desire*; July: *Tragedy of the Commons*; August: *Encounter*;
September: *Revolution*; October: *Politics*; November: *Hybridity*;
December: *Jouissance*

Sibling Rivalry Press, LLC
PO Box 26147
Little Rock, AR 72221

info@siblingrivalrypress.com

www.siblingrivalrypress.com

ISBN: 978-1-943977-05-5

Library of Congress Control No: 2016931401

This title is housed permanently in the Rare Books and Special
Collections Vault of the Library of Congress.

First Sibling Rivalry Press Edition, April 2016

DECLARATIONS

PROLOGUE

McGovern is Dead ... The Vote for Most Grouchy ... Bird & Pie in The Villages ... Retrospeculative Gumbo ... A Soundtrack for Saved Lives ...

JANUARY

Employment Rates in Cambodia ... Bob Dylan's Morse Code ... Brothers and Brothers ... Year of the Fire Dragon ... The Price of the Republic ... Blowing Away the Thin White Duke & Miranda ... Amusements in Amityville ... Attempts on the Life of Gerald Ford ...

FEBRUARY

Flipping the Bird to Raymond Carver ... Maximal 1876 ... Mohawking It ... Race Riots in Pensacola ... Raking the Muck of Patriotism ... Assassinations Real & Imagined ... How Mormons Lose ... Leap Day Voodoo ...

MARCH

The Libertarian Party's Novelist Laureate ... Progressive Rush ... Temptation to Identify with the Antagonists ... Ladies' Night for Cults & Coups ... George Wallace Goes Down Again ... Led Zep Hugs It Out ...

APRIL

35 Hours With Dad ... Conquering a Motorcycle ... Two Waynes Dispense Their Wisdom ... The Ramones are Alright ... Hughes & Jobs in a Pissing Contest ... Two-Dollar Bill Mythology ... Transcendentalist Aerometry ... Forget about Z-14 ... The New Masculinity ...

MAY

Dazed & Confused About so Many Things ... The Holy Trinity of Ride Songs ... What's in a Nose-Touch ... All the Rage in Texas ... The Graduates are Missing ... A Moment for Old Bentsen's Anti-Climax ...

JUNE

Joan Jett Looking for Three Good Men ... Cherry Bombing with Horses or Monkeys that Talk ... Waking Up in Soweto ... Resolution 392 ... White House Boasts Terrific Pool ... A Winning Word ...

JULY

Real Estate Prices in Kettle Falls ... What Happens After the Library ... Ron Kovic Dances the Twist ... All the Fireworks on the 2nd ... How Best to End Troy Gregg ... A Choice of Concerts ...

DARK INTERLUDE

LATER IN JULY

America's Birthday & Ford's ... DNC at MSG ... One & a Half Keynotes ... Draft Dodgers, Astronauts, Veeps ... Situation-Specific Independence ... Uncle Sam's Son's Bulldog ... Guest's Best Guess ...

AUGUST

Melting Ferrari ... Duck, Duck, Incumbent ... The Time Capsule Gag ... RNC Coincides with International Disasters ... How to Steal from or Seduce a Ghost ... Casey Kasem Spins the Truth ...

SEPTEMBER

The Ballad of Tony & Paulie ... 50th Anniversary Schlep ... Thunder Road Realism ... U2 & Siouxsie Sioux, Mao & The NY Yankees ... A Tree Grows in East Islip ... Sally Knows A Guy ...

OCTOBER

Presidential Birthday Gifts ... Also-Ran: Sex Pistols & ABBA ... Reasons The Yankees Suck ... The Politics of Richard Avedon ... A Face For Everyone Who Touched Watergate ... Erasures Are Not Accidents ... Hoodie Crusader ...

NOVEMBER

Beatles Bomb With *All This & WW2* ... First Megamouth Shark Discovered ... Surrealist Painter Dead: Man Ray "Unconcerned,

But Not Indifferent" ... Armed, Drunk, Arrested: Jerry Lee Lewis at Graceland ... Howard "Mad As Hell" Beale Assassinated ...

DECEMBER

Arguing With My Father-in-Law ... Why Hate Blondie ... Standard American Samurai ... The Offices of Bergen, Curtain & Radner ... Diana Nyad Is A Lesbian Atheist ... The Bangs-Belushi Affect ...

EPITAPH

Plenty of Room at the Hotel California ... Four More Years ... Fear & Loathing Above All ...

PROLOGUE:
DECEMBER 31, 1975

*McGovern is Dead ... The Vote for Most Grouchy ... Bird & Pie
in The Villages ... Retrospeculative Gumbo ... A Soundtrack for
Saved Lives ...*

'm on the upper level of a double decker bus six hours outside of Gainesville and the Percocet is going to kick in shortly. McGovern recently died and my copy of *Fear and Loathing on the Campaign Trail in '72* is lodged carefully in the fishing net on the back of the seat in front of me. Also just the other day, I helped re-elect Obama and had strong feelings that doing so constituted some sort of vengeance against a past in which I did not have any opportunity to participate.

Let's get something out there right away: I was born in 1981. I am just now heading into my thirties, which is supposedly the time to get your ducks in a proper row. But I married early and got a steady 8 to 5 as an English teacher at a public high school in the suburbs, so all my eggs made it safely into the misshapen hand basket of the American Dream and now I'm beginning my thirties with really not much to do except get started on the main project of my forties, which I am told is to reflect on history and my role in it.

Because I was born in 1981, the last low pendulum swing of Gen X, I am too young to appreciate why so many people think Ronald Reagan was a great president and just old enough to feel begrudgingly toward the concept of having to owe anybody any kind of respect in the first place. I grew up on Kurt Cobain but eventually turned toward Pearl Jam. I graduated high school in 1999, the last class of whatever. My fellow seniors voted me most grouchy and most likely to be teaching at my own high school in ten years. I actively campaigned for most grouchy. The girl running that campaign thinks the person writing this book is a sell-out. I'm not sure if I owe that girl anything or if there is anything to which I am indeed selling out.

So I find myself giving a shit about 1976. My mom was

graduating high school and the whole country was trying to get behind the bicentennial. "The seventies obviously suck." This is a laugh line in Richard Linklater's *Dazed and Confused*, which is my favorite movie. I first saw it as a freshman in college, and have watched it with such regularity in the intervening years that I could perform a one girl reenactment of the entire thing spontaneously and with ease. The crucial missing piece of course would be that killer soundtrack.

I am listening to it as I write this. I should mention that the bus is taking me to the largest retirement community in Florida, where my wife and I will spend four days with her parents, getting our asses handed to us in a ridiculous yet grueling sport for old people called pickle ball. We will careen around corners in golf carts and try not to walk on anybody's finely manicured lawn. It's Thanksgiving, traditionally the fleeting American moment chosen both for deep introspection and for totally nihilistic overconsumption of bird and pie.

It is a season for taking naps, but like all good thirty-somethings, I am increasingly having a bit of trouble sleeping. Can't do it at the drop of a hat anymore, partly because whenever I close my eyes, all this shit about 1976 is swirling around my bowl. I was never going to be a history teacher. Facts don't last long intact with me. My bag is more about induction, analytics. You pour in the facts and the gumbo gets to simmering pretty quickly. So I'm not worried that these paragraphs will contain too many I-statements for a treatise on a time when I did not even exist. It can't be a retrospective. It's a retrospeculative.

1976 is surely responsible for the culture into which I was born. My roots are there somewhere and I'd like to investigate. OK, that's a lie. I'm going to interrogate, and it isn't so much a

matter of me liking to do it as it is just the way I operate. The buzz word for 1976 is pretty clear: independence. The only thing I have control over is where to find it, so I'm going mainly with politics and art, particularly rock and roll. Rock and roll saved my life and I owe it a debt of gratitude. I would like to discern what I owe specifically to 1976, and possibly what, if anything, 1976 still owes to me.

I know as much about the preceding era as anybody else my age. Kennedy, King and a bunch of Cambodians got their heads blown off. There was a lot of Never Forget and everybody began the long process of sobering up. Charles Manson ruined the Beatles for a little while and Nixon ruined the presidency as an office. There was a colossal feeling of desperation for the dust to settle, but then '76 rolls in and the thin veneer of national apathy is yanked up to reveal a crazed maniac with red, white and blue grease paint all over his face. Actually, the red is coming off the teeth. That's some fresh blood on there. Happy 4th of July. Happy 200 years of America. Woot!

Ted Nugent's "Stranglehold" just came on, which reminds me of a few last notes. This is Wooderson's theme song, the anthem for a Linklater character who has graduated but can't psychologically move on after high school. Looking at the girls walking into the Emporium, he remarks to Pink, the football player occupying the slot Wooderson himself once held, "I get older; they stay the same age." He views this as a positive. Teachers also face this. We are all on the Nietzsche trip, eternally returning to high school, this time as the authorities we once went to such great lengths to disrespect. I raise a fresh crop of 150 sixteen year olds every year.

Their taste in music changes from time to time, but basically, sixteen year old kids believe the same things about their

relationship to the world that I did when I was sixteen. They just want a dose of independence. When I was sixteen, my best friend bought me a copy of Nirvana's *In Utero* album for my birthday. My dad made me take it back to the store. He said he had heard that band was no good for kids, that it was for dope fiends and losers. He'd never actually listened to any of the songs. I eventually did as I was told and was utterly despondent about it. Moreover, I was embarrassed. I could only get store credit and after meandering the aisles for eight days, I landed upon the most revolutionary solution available and traded my precious Nirvana badge for a copy of The Sex Pistols' *Nevermind the Bollocks*.

My dad never even thought to ask about or examine the fresh hell raiser for which I traded the offending grunge album. His mistake, and I learned the wrong lesson. Meanwhile, my dad continued to enjoy the image of himself as paterfamilias, ensconced in the illusion of successfully censoring the young mind he was attempting to raise. Ted Nugent is a much more conservative asshole than my dad ever could be, but I bet Ted Nugent threw one hell of a party for the bicentennial.

So I am looking forward to seeing what changes and what remains the same. Dick Clark is dead now, but before that, he hardly aged at all. At midnight, they always drop the ball in New York and I don't doubt they always will. America loves a countdown. It's a nice tradition, and I don't mind rolling with a tradition as harmless as that. Here we are then, looking into the abyss of 1976 and preparing to get the stranglehold on whatever I find down there. 7, 6, 5, 4...

JANUARY

Employment Rates in Cambodia ... Bob Dylan's Morse Code ... Brothers and Brothers ... Year of the Fire Dragon ... The Price of the Republic ... Blowing Away the Thin White Duke & Miranda ... Amusements in Amityville ... Attempts on the Life of Gerald Ford ...

my mother turned eighteen years old on the same Monday Pol Pot presided over the ratification of Democratic Kampuchea's new Constitution. She was still one year short of the drinking age, with no other legal freedoms worth claiming except the delayed gratification of a right to vote against Ford that following winter. Cambodia's new regime had very little to say about the right to vote, except in Article Six, where the distribution of representation among members of the legislative body is outlined as one hundred and fifty for the peasants, fifty for other working people, and fifty for the revolutionary army. Those two hundred and fifty people get to elect the administration, as long as they elect Pol Pot.

This was Year Zero, where everybody not eligible to vote was eligible to assist the Khmer Rouge in this grand new vision of communism by marching off to dig themselves a slice of mass grave. This is because, as Article Twelve explains, there is absolutely no unemployment in Democratic Kampuchea. Either get busy living or get busy dying. A little song I can't get out of my head is the drumming that alerts me I'd surely be killed in any genocide ever. Forget about being a Jew or a queer. I'd have enough trouble in Kampuchea as a left-handed intellectual. In the preamble to their Constitution, the first adjective used to describe the new state is independent. The next three are unified, peaceful and neutral.

But in fairness to Pol Pot, The United States of 1976 couldn't really lay claim to those last three adjectives either. That's my segue into Bob Dylan. Bob Dylan: now there's a man with two cynical fingers on the mysterious pulse of a specifically American humanity. The same day mom is eating birthday cake and a

million Cambodian undesirables are starving to death, Dylan launches his new album, *Desire*. It was his seventeenth and did rise to the top the charts, but the story of its musical success is not as interesting as the story of its foray into matters of social justice. I'm talking primarily about Rubin Carter, who was found guilty of a triple homicide in New Jersey ten years before Dylan's song drew attention to the racist nature of the conviction. We were integrated but not unified.

"Hurricane" was the opening track on this album and the centerpiece of a fundraising campaign to free falsely-tried Carter. The song valorizes him as a boxing champ whose attitude outside the ring was entirely upstanding, which is not especially true. Carter never won the middleweight title he sought, and he was sent up to juvie for assault and robbery. He escaped into the Army, where after two years he was discharged as undesirable and then promptly returned to a life of felony, marching from Annandale to East Jersey State to Rahway to Trenton before his prison time was up. Whether as a prizefighter or as a criminal, the country's interest in Hurricane Carter was hardly grounded in any suspicion that here was guy with a peaceful nature. Nobody here is interested in peaceful.

As for American neutrality, I don't think the country ever has been or ever will be. Ours is a nation founded upon the stubborn flipping of the bird, the right of dissension, the pride of rebellious thinking. There's nothing neutral about it. The Prince of Cambodia said his country was neutral and Nixon secretly bombed the hell out of it. Excuse me, sir, we're just rooting out your communists. Too bad they're not as easy to spot as black people. Despite the wave of publicity from Dylan's number one single, Hurricane Carter's re-trial ended in a guilty verdict. A federal judge finally

let him go ten years later, and another ten years after that, Carter was briefly arrested for dealing drugs when he was mistaken for some other black guy.

Pol Pot took roughly the same amount of time to murder Cambodia as Hurricane took to get himself free. The Year Zero experiment had enough gas to keep trucking for quite a while, thanks to a big buy-in from China, who armed and trained the Khmer Rouge extensively. It had every reason to believe the neighboring dictatorship of Brother Number One would succeed. On Saturday the 31st, it was not the celebration of any ordinary Chinese New Year going on. It was the Year of the Dragon, and not just any dragon, but the Fire Dragon.

The last time China saw one of those was the year it briefly tried to reinstate the monarchy. That didn't go so well, but still, the allure of this particular zodiac mythology is not to be denied. The fire dragon does not engage in diplomacy. Tactless in its self-assurance, ruthless in the exertion of its influence, a nation that celebrates the fire dragon is a nation whose view to a valorous ascent hair-pins into a steep drop on the blind side. But the Great Leap Forward was happening nevertheless, with Chairman Mao's signal coming through to Pol Pot loud and clear.

Out of this mass grave, part famine and part execution, the newly transfigured nation would somehow arise. So, back to Bob Dylan. If you're beginning to suspect I might go through the album track by track, congratulations. If you're suddenly very worried that you don't really know anything about Dylan besides the one song I've already covered, go get a copy of the record and spin it a couple of times before you read the rest of this. Courage, man! Have you any idea how much space-time I have burned up in order to connect all these dots to Dylan? The continuum has

bent in this direction now. We must press on, by God. It is nothing short of our civic duty. Seriously, I'll dog-paddle around in some more background mythology until you come back with your head in the game.

Isis, Egyptian goddess of the throne, was married to her brother, a guy named Osiris, who eventually became king and judge of the underworld. Their other brother, Set, killed Osiris out of envy. Isis rescued all the dismembered parts of her husband's body and temporarily resurrected him. She had powerful magic at her disposal and spent it on making her beloved into a zombie for just long enough to bear him a son. The family carries on to do things that strongly parallel some of the most memorable plots of American daytime television soap operas.

The second track on *Desire* is "Isis," in which a fortune hunter marries Isis on the Day of the Dead, promptly ditching out on her to hit up the treasure of the pyramids on the strength of a sketchy stranger's proposition. Half way to the prize, the stranger mysteriously dies. Our boy opens the tomb, finds nothing, realizes he's been a bastard and goes crawling back to his powerful queen. Not clear whether our boy is Osiris. Not clear whether he just buried a part of himself and resurrected the rest.

Dylan doesn't like to make any lyrics go down easy. His story may be mythic, but the approach is pretty punk rock, which in this moment had not yet been actually discovered or officially invented. The story tells of a guy who would dig on the idea of fire dragons, who perhaps was one. Yeah, I just strung up Egyptian mythology, the Chinese New Year and Mao's influence on Pol Pot all to dry out on the same clothesline of a song by Bob Dylan. That kind of leap is probably going to keep happening, so look sharp or hit the medicine cabinet.

Maybe we take a small detour into the land of the cheeky: track three, "Mozambique." This song is so upbeat and romantic that the tourism board should consider getting a license to use it in the country's ads. In 1976, nobody was going to hang out in Mozambique—actually, the People's Republic of Mozambique. It gained independence from Portugal just six months before this song came out, and was in the midst of a terrifically bloody civil war on behalf of what else but communism. The nation was good friends with the People's Republic of Angola and also the Soviet Union, neither of which exist anymore.

The Beatles also did not exist anymore, but that didn't stop Bill Sargent from offering them thirty million dollars to get together one more time. That's the same day Jimmy Carter won the Iowa Democratic Caucus. That was on the same Monday Ted Nugent was celebrating Confederate Memorial Day somewhere in Texas. Within ten days, Morocco and Algeria will formally be at war with each other, the United States will be the lone veto to strike down a United Nations resolution supporting Palestinian statehood, and the IRA will bomb a dozen spots in London's West End. Everybody wants a republic. Nobody can afford one.

The Beatles are from the Sixties and the Sixties are not coming back. What's coming out of England at this point is David Bowie. Well, Bowie had been consiglieri to the Young Americans for a decade at that point—who or what I'm really talking about is The Thin White Duke. *Station to Station* is Bowie's tenth album and last great character. The TWD is all flawless on the outside and asshole on the inside. This numb little echo on the trials and tribulations of chronic cocaine overuse, this alien discourse on the merits of a strict red peppers and milk diet, this occultist hedgehog who fell to Earth delivered a series of near totally opaque lyrics

on top of an attitude and an orchestral reach so crystal clear that it can only be described as German.

Actually, some guy in *The Village Voice* compared it to Lou Reed. But Lou wasn't doing anything at this moment besides riding out the spectacular tanking of his double album comprised of nothing but electronic audio feedback loops. There's proto-punk rock and then there's this noise. Only Lester Bangs liked it, whereas everybody was captivated by The TWD. He was more polarizing than cilantro or Brussels sprouts. There was that whole photo-op thing where he appeared to be giving a Nazi salute and endless speculation about was he or wasn't he doing that. If he didn't mean it that way, fine. To me, the actually disturbing part is that he was giving off a vibe where a bunch of people could find such a fascist opinion credible on him in the first place.

Who cares if he really meant to do that move instead of a proper waving—the issue is that people's judgment of The Thin White Duke was that he plausibly could have been a Nazi. Bowie himself says that when he listens to *Station to Station*, it sounds like it was made by somebody else. Is the other guy a Nazi? It sucks that your Golden Years are sprung from the mind of a persona so far gone that it might as well not even be you at all. It speaks to a total lack of desire, to a pathetic dependence, that he looks back on it now and shakes it off with a head jiggle, an amusement to himself that he himself can barely access.

Meanwhile, in the parking spot adjacent to Naziism, these United States are vetoing a United Nations resolution calling for Palestinian statehood. A couple countries abstained, but we were the only ones who voted it down. Now that's independence. Everybody gets a vote, as long as you vote with us. If you don't vote with us, our vote means everything and all of yours mean

nothing. But on the upside, please do keep going about your international business because we're not interested in doing the mass grave thing right now, and that's what makes us a morally superior form of governance when measured against the rising star of Pol Pot.

But back to Dylan, who understands this kind of whitewashing. He uses the same methodology on "Joey," track number one on side two, as he does with "Hurricane." Yeah, I'm skipping the two duets with Emmylou Harris at the end of side one. You're welcome, but that's your last get out of jail free card. As I was saying, "Joey" is fully eleven minutes long, which is longer than Bowie's title track by almost a whole minute—and Bowie's was already dragging on for two or three gratuitous minutes. Dylan tells the story of a downtrodden young hoodlum named Joey who turns to the mafia for survival, depicting scenes of escalating confrontation with the law and his mob buddies that ultimately result in his melancholy, undeserved death. This version of Joey tried to keep the peace between prisoners. He didn't like to flash his gun around little kids and he just wanted to feed his family. This man understood the plight of blacks because he, too, was an outcast.

They shot him down in Umberto's Clam House—that much is indeed true. But Dylan left out a few things. Crazy Joe Gallo was a diagnosed schizophrenic and the son of a bootlegger. His two brothers were criminals and he joined up with them because he liked gangster movies. Joe was an extortionist and owner of sweat shops who went to jail for crimes he unsuccessfully attempted but genuinely desired to commit. His best friend in prison was a black man because that man was an organized drug trafficker. Dylan speaks true when he says Joe was reading up on existentialism, but

neglects to mention his favorite author was Machiavelli and that the Colombo family's beef with Joe was based on their reasonably evidenced understanding that he was trying to usurp them. So although Dylan's choral repetition of the rhetorical question is sweet, it does seem fairly clear to those who knew Joey what it was that made them want to come and blow him away.

Also blown away, on the eve of the Chinese New Year, was Ernesto Arturo Miranda. Yeah, that one. The Miranda of *Miranda v. Arizona*, the case in which our Supreme Court declared that criminal suspects must be informed of their rights before undergoing interrogation by the police. When this overturned Ernesto's original conviction, he was retried without his confession in evidence and was again found guilty of kidnapping and rape. After he was paroled, he made a living hawking autographed cards with the Miranda rights printed on them. He died in a skid-row bar fight at age thirty-four from a knife wound inflicted by a Mexican national who fled prosecution. Imagine the irony of catching the guy and reading him his Miranda rights. I wonder what the fight was about. I'm also concerned about this recurring motif of new trial and same verdict.

This month is seriously haunted. It is overgrown with petty criminalities, the shadows of felonious intention, and a truck bed full of mythos regarding the size of young men's testicles in times of yore. I don't know how much of it feels uniquely American, if that is important. If you want a truly American haunting experience, you're looking for 112 Ocean Avenue. My wife grew up on Long Island, and she said her parents never let her go to the amusement park because the route would take her past this address. I'm talking about the scary business of generating an allegedly true story and a successful franchise that is ten films

deep—The Amityville Horror.

It is Wednesday, two days after the death of Agatha Christie and two days before a full moon, and the Lutz family is getting the hell out of the house. Or, I guess if you believe in this kind of thing, they are leaving the hell inside the house and moving on to less gory real estate. They are fleeing an ocean-view village located within the town of Babylon—no kidding, for those of you who dig The Book of Revelations; it's not far from Fire Island. George and Kathy had lived there less than thirty days, but it seems the grisly ghosts of the massacred DeFeo family were determined not to leave.

Butch DeFeo shot his four siblings and two parents with a rifle. He ran to his local bar and tried to blame the mob. His confession popped up promptly the next day and an insanity plea didn't stick. Butch's current place of residence is Green Haven Correctional, where he is serving six concurrent sentences of twenty-five to life and the parole board always rejects him. Green Haven remains the home of many mafia guys, and was home to Crazy Joey long before Butch went on the rampage. Joey was murdered by then, but his Harlem drug lord buddy, Nicky Barnes, served alongside Butch until Nicky turned snitch and gave up everybody he knew so he could get out. Mr. Untouchable went into witness protection.

Who knows where he is now, which brings me back to Dylan and "Romance in Durango." A pair of lovers is attempting to flee a murder charge and the man sells his precious guitar for some ready cash. He gets shot and hands his gun over to Magdalena, all the while repeating in Spanish that she shouldn't cry because either God is watching them or God is watching over them. Translation depends on whether you're a glass half empty type of person. Either way, you ought to know that Durango is the

birthplace of Pancho Villa, a Mexican Revolutionary general who stuck his finger in the eye of Texas and lived to tell about it. After his eventual assassination, six different women claimed to be his widow. They called him The Cockroach.

La Cucaracha's exploits were legendary. He stole hundreds of thousands of acres of land from William Randolph Hearst, in part to fund some communist master plans. Thanks to Jay Anson's *The Amityville Horror*, Butch DeFeo's exploits would also become legendary, though his plan was neither masterly nor communist. He was likely just out to cover up an ordinary robbery charge, which was itself an effort to cover up a run-of-the-mill heroin addiction. Nobody likes to live in a house whose previous residents were all murdered, so the Lutzes got the place for cheap. They sold their story to Anson, who wrote a bestseller from it, but failed to write a solid screenplay. There are ten films based on the book anyway and twice as many lawsuits. Nobody believes in it and everybody still buys into it.

On a happier note, two tracks to the finish line! I can't understand why "Black Diamond Bay" wasn't the big single. This is my favorite song on the album. The tempo is just as strong as "Hurricane" and the arrangement is just as evocative as "Joey," but the story is better and more honest than either of those other two songs. For six and a half minutes, people are frantically and futilely running around on a tiny island in variously sinful and self-important last-ditch attempts at happiness while said island is quickly sinking thanks to a sudden volcanic eruption. It's like a Hieronymus Bosch tableau: the woman wearing a tie and Panama hat, the suicidal Greek mistaken for the Soviet ambassador, the randomly French desk clerk, the unspoken love between soldier and midget. The story keep marching, six verses deep and no

chorus in sight, until one last verse zooms out on the whole ugly thing.

It turns out, there's some asshole in Los Angeles watching the aftermath of Black Diamond Bay's destruction on the nightly news and he turns off this totally ridiculous yet clearly compelling real life story to go grab another beer. And that, folks, (jazz hands) is America! I wonder how he could do that message and then still tour under the droopy banners of Joey and Hurricane. Can't raise the one from the dead and can't re-try the other with any success. Dylan knows that, but I guess he wanted to push the big rock up the steep hill, cause that's America, too. Bob Dylan is totally independent.

If you don't understand the lyrics, too bad. If you don't like his politics, too bad. If you don't like this version of the events, too bad. He could give the finger to the man and the revolutionaries at the same time, like La Cucaracha. Too bad he never wrote a song romanticizing the DeFeo murders. Maybe Butch would be out on parole today, cause that's the power of Bob Dylan. If Dylan and The Thin White Duke were to engage in mortal combat, Dylan would kick The TWD's ass, and quickly.

Of course, before The Duke, there was Ziggy Stardust. In this incarnation of himself, David Bowie wrote "Song for Bob Dylan," wherein he declares his intention to take over rock and roll from Dylan, whom he accuses of failure to provide leadership to his legion of fans. Indeed, Bowie's army could probably defeat Dylan's with ease. Bowie's army might well be stocked with secret Nazis. By contrast, Dylan was never very good at commanding his crowds. He couldn't even swing many one on one relationships.

When he secretly married his first wife, it was under an old

oak tree about fifteen miles from Amityville. Her name was Sara and "Sara" is the closing track on *Desire*. So Dylan succumbed to actually writing a personal song in order to save his failing marriage, which is kind of interesting, but not as interesting as the other Sara. The day after the Lutzes moved out of Amityville, Sara Jane Moore, the second of Ford's would-be assassins, was sentenced to life in prison.

I would say excuse me while I digress, but really, thinking about Ford hits the bullseye more accurately than anything else in these pages so far. This is a sick position to be in, because on the one hand, you have this very moderate guy who's a football hero, and on the other hand, you have the fact that being a Republican in 1976 means you have certain definite things in common with assholes. Whatever part of me that's the part selling out, she sees occasional virtues in a president like Ford. Then the rest of me remembers this is the politico who pardoned Nixon. He paid the piper in one foul swoop. Jerry Ford: the luckiest loser in America.

Every time, he was in the wrong place at the right time. I mean the list is unbelievable. Let's begin with the fact that "Gerald Ford" isn't even the name he was given. His birth certificate originally had Leslie Lynch King, Jr., on it, but c'mon. Westerners won't vote for Leslie. Yankees won't vote for Lynch. Southerners are bound to be suspicious of a King, Jr. Fortunately, the King, Sr., was such an abusive son of a banker that he ran out on his wife just two weeks after little Leslie was born. When the kid was two, his mom remarried to a Ford, Sr., and that's how he came to be Gerald Rudolph Ford, Jr. That's all fine and dandy, except he wasn't ever officially adopted and didn't get the name changed on his birth certificate until he's in his twenties with a short view to his first toe-dipping into the world of politics.

All that stands between him and politics now is nine kinds of football. He played for the All-City in Grand Rapids, then turned the Wolverines into such killers that they took two national titles and retired his number. They played the Michigan fight song during his funeral procession. He turned down playing for the Packers and the Lions to go coach at Yale because he wanted to go to law school there. Yale said thanks for the trophies, but we're rejecting your application. So he coached there for four years and eventually they let him in. He graduated in either the top third or the top twenty-five percent of his class, depending on who you ask. Either way, decidedly mediocre.

So he was likely in for an unimpressive and uneventful law career, but then for some reason Pearl Harbor, and into the Navy he went. His boat saw plenty of action in the Central Pacific Theater, with Ford lending a hand as assistant navigator and athletic officer. The closest he came to combat himself was a battle with a typhoon that nearly put him overboard. Back on land with his ship decommissioned by storm, Ford concentrated once more on the sports action and waited to be released from active duty. Then with two bronze stars on his chest and a wedding ring on his finger, he was elected in his first campaign for office. Oh yeah, he also took a moment to join the Freemasons—that type of thing speaks for itself.

Imagine trying to marry an ex-dancer and department store model who had been divorced for less than a year in the middle of your first effort at running for office. Betty Ford must've been some firecracker. They trounced the incumbent isolationist and began a twelve-game winning streak in Michigan's fifth district that kept Ford in the House of Representatives for twenty-five years. He won with more than sixty percent of the vote every

single time. During this two and a half decade-long tenure, he did not author even one single piece of major legislation. This glowing record of inaction makes plain that his ambition was to be Speaker of the House.

But you have to get picked for that gig and his colleagues weren't up for it. Ironically, the Speaker is second in the line of presidential succession, just after the Vice President. There was also talk that Nixon would pick him for a running mate, but that didn't pan out either. He ended up having to give the convention nomination speech for Henry Cabot Lodge, Jr., who did an excellent job of helping Nixon lose to JFK by the slightest general election point spread in more than half a century. So Jerry would need to get his foot in the door of the Oval Office some other way, meanwhile settling for House Majority Leader.

That's a position where your party elects you by secret ballot, not unlike the Freemasons. His party elected him—this eight-term Rep who had proposed no big pieces legislation and who had coasted his entire life on compulsive instincts for being a joiner—to this prestigious post just three months after the release of the Warren Commission report. I don't mean to be alarmist, but there's a bell ringing somewhere and here's what it sounds like to me: Kennedy ekes one out over Nixon, Kennedy gets shot, Johnson takes his job, Johnson appoints Ford to the Warren Commission, Ford argues staunchly that Oswald acted alone, the Commission reports Kennedy wasn't killed by his own government, Jerry gets a big promotion in said government by secret ballot. And if you're into weird voodoo numerology shit, the report is eight hundred and eighty-eight pages long.

Smells like pigskin and they're passing the ball, slick with the sweet nectar of collusion, to Jerry Ford. The young Turks are in

revolt! They meet with Ford to prep him to take over Majority Leadership, and I don't even want to tell you who was in on this meeting. It's too obvious to be a joke. It's young Donald Rumsfeld, who was at that time serving as chief hell-hound to Tricky Dick. Ford also took over as Chairman of the Convention that handed its nomination to Nixon, twice. Nixon picked Agnew for a running mate and Agnew picked tax evasion as his embarrassment of choice. Then there's Jerry Ford, a surprisingly familiar and palatable member of his species, steadfastly swimming laps beside them and waiting for one of them to drown. Sneaky Spiro beat Tricky Dick in their little race to the bottom, but not by much. What Nixon lacked in speed of bad judgments, he made up for in strength of same.

The Twenty-Fifth Amendment of the United States Constitution has only been invoked twice in the entire history of our nation. Both times, it was on behalf of Gerald Ford. Nixon appointed Ford to the Vice Presidency after Agnew resigned and pled no contest on his felony. The great state of Michigan had been electing Jerry by a wide margin time and again for years. OK, I get that, but Michigan is not the only state that gets to weigh in on a vice presidency. Still, the circumstances do dictate that something must be done and Ford is a decent mid-season draft pick, I'll admit it. The news didn't cover it very deeply one way or the other, cause at this point Watergate is starting to break.

Betty and Jerry haven't even moved into the vice presidential residence, and we're pulling the trigger on the Twenty-Fifth Amendment once again. Bye bye Tricky Dick, hello football hero. Ford could've picked Reagan as his wing-man, but he didn't. Reagan had just decided not to attempt re-election for Governor of California and was plainly planning to leapfrog over Ford in

'76. He picked fellow moderate Nelson Rockefeller, looking to build a team that would help him win by popular vote what he'd previously only won by dumb luck. It looked like he stood a pretty good chance of success. He could go neck and neck with Jimmy Carter.

But then Ford pardoned Nixon by Presidential Proclamation 4311. Maybe he did it because Nixon secretly offered him a deal, the resignation for the pardon. Maybe he did it to spare the American people a lengthy impeachment circus. Maybe both, but in any case, Ford suffers from the same image problem as The Thin White Duke. Maybe he conspired and maybe he didn't, but if you think Ford is even capable of conspiring, then Ford probably doesn't get your vote. It's the Schrodinger's Cat of electoral politics.

The hippies were in revolt! A moderate Republican candidate is no good if he can't attract any hippies. So, bait the hook with Presidential Proclamation 4313: welcome home, Vietnam draft dodgers and military deserters! And don't forget to vote for the one that brung you. This is a mere two weeks after the Nixon pardon. Just for laughs, I looked up Proclamation 4312. I wanted to see what sort of thumb-twiddling was going on between these two huge deals, and you really can't make up stuff as good as this reality. It was a statement to announce "Citizenship Day and Constitution Week." Yes, there certainly is a lot of Constitution action happening. Know your Twenty-Fifth Amendment, people.

It's at this point that I would like to mention that during Gerald Ford's short time in the Oval Office, he was often accompanied by a dog named Liberty. No, literally, a golden retriever, not a metaphor. Ford's dog's name was Liberty. The name of his first would-be assassin was Squeaky. Lynette "Squeaky" Fromme and

Sara Jane Moore both attempt to shoot Ford in California, the home state of his primary challenger, and these attempts were less than three weeks apart from one another. In the entire history of the office of the presidency, only two women have been arrested, charged and imprisoned for pointing a gun at the leader of the free world. Both times, it was on behalf of Gerald Ford.

The first time was at the State Capitol. Squeaky, who already had her fifteen minutes as one of Charlie Manson's groupies, drew a Colt .45 on Ford. There were four in the magazine but none in the chamber, and she didn't pull the trigger. The Secret Service got to her quickly and the court handed down her life sentence quite slowly, because Squeaky refused to cooperate with her own defense. She was paroled after Ford eventually died, serving more than thirty years with the exception of two days. For those two days, she successfully escaped a federal prison camp in West Virginia and was on her way to see Manson for Christmas. She made it half way across the country before they captured her in Fort Worth.

During the second incident, seventeen days later in San Francisco, the Secret Service completely dropped the ball. Employed as a bookkeeper in the humanitarian aid group founded by Daddy Hearst to keep Patty's weirdo cult at bay, Sara Jane Moore was also a narc on these activities for the FBI. She was vetted by the Secret Service and she passed. The day before she pointed a gun at Ford, she was held on an illegal firearm charge for a .44 revolver and one hundred and thirteen rounds of ammo. Police kept the gun, but the show must go on! So she bought a .38 the next morning, waited around in the crowd until Ford was less than fifteen yards away, and fired.

She barely missed him and went to fire again, at which point a

nearby Vietnam vet tackled her. The second bullet wounded some cab driver, but the driver lived to tell about it. What Harvey Milk told about it was the fact that the hero ex-Marine was also gay. The hero's mother disowned him and he got a brief note of thanks from Ford, while the media circus raged outside this poor guy's door. The VA Hospital turned him away and he died of pneumonia complications at the ripe old age of forty-seven. Thanks for your service, buddy.

In the dead center of January 1976, Sara Jane Moore is sentenced to life in prison. Like Squeaky, she served more than thirty years and was let out only after Ford eventually died. She did this time in the same facility as Squeaky, and like Squeaky, she scaled the twelve-foot chain link fence to escape. Sara Jane only lasted four hours outside the wall before they captured her. She regretted not stopping for a burger and a drink. Sara Jane was sentenced on January 15th because this particular date was still fully a decade away from being observed as Martin Luther King, Jr., Day.

Ford put in a call to Coretta Scott King at eleven in the morning and she didn't answer until he called again six hours later. The call lasted thirteen minutes. Afterward, Ford went swimming for a half hour, ate dinner and returned to the Oval to work on the most recent State of the Union draft. He gave the speech five days later, on the same day that Jimmy Carter won the Iowa Caucus. Technically, Carter lost to Uncommitted in a ten-point spread, but he did beat out all the other actual candidates on the ballot. Fifteen minutes before he went to bed that night, Ford took a phone call from the Republican Governor of the state of Iowa that lasted for one minute.

By contrast, the State of the Union Address he'd just finished

33

giving lasted forty-six minutes. Ford does not at any point use "independent" as an adjective to describe our country. He says, "we are at peace," but not that we are peaceful. He does not use any of the adjectives that are used to describe Democratic Kampuchea in its new constitution. Ford only once refers to "the day of our independence two hundred years ago." He does not mention the ugly new face of Cambodia's fledging freedom or the fact that Nixon is off the hook, but does mention Thomas Paine and "the stirring deeds of 1776."

Ford closes the speech with a quotation he erroneously, whether by accident or with intention, attributes to Eisenhower: "America is not good because it is great. America is great because it is good." This is neither Alexis de Tocqueville nor rocket science, but the simple rhetorical device of chiasmus. It's a form of inverted parallelism. First, you put the horse before the cart and give everybody a minute to acknowledge the sense in it. Then, you put the cart before the horse and everybody marvels at the depth of your intellect, though the resultant argument cannot withstand even the most basic scrutiny. The horse should be pulling the cart, not pushing it. So much for the prospect of New Realism.

But to my thinking, this device is deeply appropriate to the characterization of independence in January of 1976. Chiasmus comes from the Greek, to shape like the letter X. Neither the cart nor the horse can do much work alone. All potential, no kinetics until you hitch one to the other. Independence is a very dialectical prospect, man! It operates station to station. It operates on desire, for the romance of the mafioso and the prizefighter and the old-fashioned show-down. It operates on revolutions, against capitalism and poltergeists and faux fascist rockstars. It operates by trial and hopes for no obvious errors or escapes. It takes epic

risks without genuinely hoping, the bold folly of the fire dragon that scorches everything in its path. Whatever survives the fire, that's what's independent. But does the dragon survive its own blaze?

FEBRUARY

Flipping the Bird to Raymond Carver ... Maximal 1876 ...
Mohawking It ... Race Riots in Pensacola ... Raking the Muck of
Patriotism ... Assassinations Real & Imagined ... How Mormons
Lose ... Leap Day Voodoo ...

don't really know anything about Raymond Carver, but I have three associations with his name and each of those cosmic vibrations makes me feel stupid. I'm not referring to the kind of stupid that denotes unintelligent thinking, but the other kind, where your entire humanity as an individually jealous, shortsighted, petty representative of your species is splayed across the conference table for your academic peers to drool over indirectly and simultaneously attempt to avoid acknowledging directly.

The first incident occurred during my freshman year of college. I mistakenly enrolled in an aggressively expensive Lutheran liberal arts place with a lot of trees and keggers. Yes, I made it all the way to age seventeen without ever having heard of Raymond Carver. Then I'm sitting in this class full of juniors because I am an overachiever and we are reading "Cathedral" aloud together. At first, it is definitely in the realm of possibility that I was falling asleep. Eventually, I entered the freaky liminal zone in which all such incredible stories are read. I remember telling myself not to forget this. Now all I recall is that the story is about a blind guy, but the plot is not really what is at issue.

I tore it down in class. I was proving myself to nineteen year olds, which naturally seemed more important at the time than the respectful awe I felt for Carver in that moment. This type of genuinely emotive connection to a text is rare, and I put it in the crosshairs. Pulling the trigger on that was also an amazing feeling. I'm a junky for that now, and end up taking the critical fix over the actually enjoying the story fix pretty much every time. It is a defining feature of my adult life, perhaps of any adult life. I

gave the finger to Raymond Carver and that was my best gesture of respect.

The second time was my first year of graduate school. I mistook Carver for Cheever. You can see how that might happen: the consonances, the alcoholism—theirs and mine. It was at some very schmoozy thing full of room temperature cheap reds and whites, and the conversation went on for an additional six or seven minutes before somebody pointed out that I had no idea what I was talking about and there was nowhere to run for cover.

The third time was in my last year of graduate school. By then, I had wrestled enough bigger kids to accrue heavyweight titles like "promising." There was a first year kid in my workshop and I just hated him. His work was that good. I could never think of anything mean to say about it. It was fully formed. Then one day, somebody said, "his writing reminds me so much of Raymond Carver." It is definitely in the realm of possibility that I threw up in my mouth a little bit. But like Carver, this kid wore the drink as a rope around his neck, so for a long time he didn't really amount to anything. We're best buddies these days and I stopped resenting his superiority to me long ago. I even helped him get his first book published when it seemed like he couldn't help himself to do it. Someday he'll win the prize I never could.

So there's all of that. In 1976, Raymond Carver was still proving himself and simultaneously killing himself quickly with liquor. His debut collection of short stories, *Will You Please Be Quiet, Please?*, was a finalist for the National Book Award. Probably he spent that night as a loser the same way he would have spent it as a winner, meaning he doesn't remember jack about it. He lost to

Wallace Stegner, whose work I have never laid eyes upon. If you smoked a cigarette every time somebody in one of Carver's short stories smokes a cigarette—excuse me, "cigaret," minus that last T and E and I have no idea how those two letters were either lost or found—you'd be at least two cartons deep by the last page.

My first cigarette was a Marlboro Red given to me by an older and tougher girl who played drums in the marching band. She didn't ask if it was my first one and I certainly didn't volunteer it. We had just eaten fast food across the street from school, before some night event we both had to attend. She gave it to me already lit as we crossed the four-lane, and I swear I waited to be turned into a pillar of salt or some such nonsense the minute my sneakers hit school property. Neither divine intervention nor mortal authoritarian infliction of punishment occurred, so that was the moment I was born again as a hell raiser.

Nobody in Carver's book raises any kind of hell except the kind that engulfs their own ordinary living. Every story in *Will You Please Be Quiet, Please?* bristles with quiet desperation. You can feel it right there in that double please. It doesn't want to explode. It just wants to settle into the couch and smoke another cigarette. Personally, as a newly smoking teenager, I could always be counted upon for acts of loud desperation, as opposed to the quiet kind. Seems like that type of quietude is only available to adults and I'm not anxious to grow up to that high water mark.

Carver's book came out on a Sunday, the same day Florence Ballard of The Supremes died from cardiac arrest. She was thirty-two years old. That's a loud bit of desperation there. I can't spend much more time thinking about Carver. We had a good moment

when I was a kid, but basically, I need something more sprawling. Minimalism can only take you so far—that's why it's minimalism. You want several notches louder, you go to two weeks before *Will You Please Be Quiet, Please?,* to Gore Vidal's release of *1876.* This is the same Thursday that Sal Mineo died. Two days before Valentine's Day, one of the only openly queer actors in West Hollywood, the son of coffin-makers, age thirty-seven, is stabbed once and to death by the pizza delivery guy. That's also pretty loud.

Compared to Carver, Gore Vidal is ancient at this moment, some thirty books and three decades deep. *1876* is the third in a series of historical novels, but what the hell. You have to have real cojones to title your book with just the year, to harpoon your personal human flag into the still-moving beast of time and claim your interpretation of that freeze-frame as the ultimate word on the subject.

Where Carver is minimal, Vidal is maximal, detailed to the point of ornate and extreme. You can dive right into this one because the narrator is going at full volume about his fully politicized life, keenly aware of how to manipulate the judgments of others, yet utterly willing to criticize himself with the entire weight of his self-knowledge. Nobody in Carver's fiction has high standards like this. Nobody in Carver's fiction even reads the paper in the morning and everybody has names like Dick and Jane.

Vidal launches this epic book on the Centennial just in time for the Bicentennial. He is taking stock of where we were as a nation with the first hundred years under our belt. Actually, he

says this was the low point in American history, so I checked into it. The narrator supports Tilden for President, the Democratic candidate. Turns out, the election of 1876 was highly contested. Tilden had a crystal clear majority in the popular vote, but then there was some shady business in Florida and a couple of other Southern states, and a special commission ended up giving the victory to Hayes, the Republican. All of that kind of rings a bell. In fact, at the moment people have begun reading *1876*, young Al Gore, possible distant relation of Gore Vidal, is announcing his first bid for House Rep in Tennessee.

The icky thing is that Democrats in the South were totally willing to let Tilden go gently into political obscurity. They agreed to accept Hayes if he would withdraw all the remaining federal troops from their states, putting an official end to Reconstruction. Tilden died a bachelor ten years later and his tombstone reads, "I Still Trust in The People." That's a lot sick and a little silly. Brings to mind one of the only two mental pictures I possess from Martin Scorsese's *Taxi Driver:* a freshly mohawked DeNiro standing around in his army jacket with the campaign button on his chest that says, "We *Are* The People," and he's waiting to shoot a senator.

The film doesn't actually discuss the political affiliation of Senator Palantine, who is running against a guy named Goodwin in the presidential primary. So this is some sort of allegorical set-up where DeNiro's Travis Bickle sees that politicians and prostitutes offer New York City the same style of corruption. He's going to free up the city, especially Cybill Shepherd, whose Betsy is wearing white in every single scene, or white with red stripes.

Bickle is going to clean up the city with a rain of blood. Palantine survives when Bickle has to flee the park, but various pimps and mafia guys get shot shortly thereafter. Bickle can't have a grown woman like Betsy, so he settles for saving a child prostitute played by Jodie Foster. He ships her off with enough dough to return to her family in Pittsburgh. Thusly, psycho Travis is transformed into hero Travis and the film cuts off before he can revert to his more natural state of lunacy.

The mohawk just happens. We don't see him cutting it and nobody in the crowd looks twice at it. There are just a couple of scenes in the film where he's getting his war on, and then the full head of hair is back. The mohawk as a contemporary cultural symbol is, first and foremost, a homing beacon for people who like loud music to find each other. To put such an intimidating display atop one's head is surely an act of rebellion. For Travis Bickle, as for so many other vets, it means he is getting into the action. It also leans heavy on the paranoia. The hairstyle is centuries old, but is named for a defensive move practiced by many nations of the Iroquois confederacy.

You can't scalp a guy with no hair on his head. They didn't shave it off—they pulled it out in tiny little clumps until all that was left was a square bit on the back of their heads. If some asshole wanted that scalp for war or money, he couldn't get but one little shred of it. What a way to give somebody the finger. If you're sporting that haircut, you're a tough soldier. Travis Bickle maybe died with that haircut on. That's the other image burned into my memory: Travis sitting on the couch, spattered with bad guy blood, pulling his imaginary finger trigger against the side of

his own head. Whether the cops shot him there and the rest of the film is death knell fantasy or he lived to drive his four-wheeled coffin through metropolitan hell once more, Travis has nice, quiet Raymond Carver hair when the credits roll.

It looks like Palantine is going to get the job. Good thing he wasn't offed by some paranoid loser in a mohawk. The white guy in the navy suit is off the hook because most of the freaky suspicion in the film is pointed squarely elsewhere. Travis shoots one black guy for trying to rob a corner store. He points his gun at a wholesome-looking couple of black people dancing on *American Bandstand* before he kicks over the television. He walks or drives by several dozen black people who are mostly minding their own business, Travis always squinting to the alluringly ominous chimes of minority conspiracy clanging around in his own head. Nobody calls him a racist. He's just saving a twelve-year old hooker named Iris, just trying to give her enough expansiveness to let some of that bright white light shine.

Sure, he's just lonely. He's just frustrated, a loner, an outsider. But there is the loud desperation of a guy in a mohawk who stands out by choice, and then there's the quiet desperation of a forgotten vet driving a taxi and slipping through the city's cracks without much say in the matter. He was losing control of his city and it was not the idyllic place he remembered before going off to war. *Taxi Driver* came out on the weekend following the Escambia High School race riots, and I bet those kids down in Pensacola thought Travis had the right idea. More than one thousand students were involved in the violence on Thursday the fifth, to the point where they cancelled classes on Friday. A bunch of them sat through

this movie, and two weeks later, there are flaming crosses on the lawns of school board members and a Klu Klux Klan rally in the works.

The school had been forcibly desegregated by court order, but judges don't really get to go in for the whole kit and caboodle. So the Escambia High School mascot was still the Rebels, their song was still "Dixie," and the Confederate flag still waved at football games. Their admin did the democratic thing and had a student election to decide whether they ought to be the Raiders instead. The Rebels didn't get a supermajority, so they crabbed about the fairness of the election and attempted to hoist the rebel flag in protest of the results. That's when everybody started breaking windows. More than two dozen kids were injured and four were shot, including the school's quarterback. While they waited for the court to catch up on the details, Escambia finished out this year with the most hilarious possible temporary choice of mascot: the Patriot.

At the end credits of *Taxi Driver* copies distributed for television, there is a weird little note from the filmmakers: "In the aftermath of violence, the distinction between hero and villain is sometimes a matter of interpretation or misinterpretation of facts. *Taxi Driver* suggests that tragic errors can be made." I don't really know what the hell kind of pointy fence that's sitting on, and increasingly, I am losing sight of any reasonable or commonplace interpretation of patriotism. I'm pretty sure Travis Bickle thought of himself as a patriot, as some independent type of guy who just loved these United States so much he got murderous about it. Also in the foggy but apparently forgiving territory of alleged

45

anti-heroism, Gore Vidal himself ran for office twice. The first time was for House Rep in 1960 in New York's 29th. It was a notoriously Republican stronghold and he managed to whittle it to a fourteen-point spread, which was a better finish than any other Democrat there since the turn of the century. They must've thought he was a patriot.

The second time, he primaried Jerry Brown in California for a Senate seat. Brown beat him to the nomination but lost the election, and was widely considered to be out of the game for good until this moment in 1976, when he is just three weeks away from announcing his challenge to Carter. Carter is Gore Vidal's fifth cousin. Vidal had deep roots in the Democratic Party. His grandfather was elected Senator for the newly-made state of Oklahoma, serving sixteen years, taking a decade off, then serving another six. After his mother divorced his father, she remarried Hugh Auchincloss, Jr., so Vidal shared a step-father—although no genetic material—with Jackie O. Sometimes I get mad about the fact that all roads lead to a Kennedy.

This propels me toward atheism, an idea to which Vidal was as expressly devoted as he was to the Democratic Party. Eventually, the American Humanist Association awarded him an honorary presidency. In this position, he was succeeding none other than Kurt Vonnegut. The day after *1876* was released was a Friday the thirteenth. It was not any ordinary unlucky day, but a day of cosmic importance to those that loved Vonnegut: the day of the fictional death of *Slaughterhouse Five*'s Billy Pilgrim. Vonnegut, Vidal and of course Billy are all Army vets of the same war. Vonnegut saw the fire-bombing of Dresden, Vidal saw a bunch

of tiny islands between Alaska and Russia, and Billy saw four-dimensional time-traveling aliens that looked like toilet plungers.

Billy Pilgrim, born on the Fourth of July, age fifty-three, successfully predicts his own death by assassination. Actually assassinated in real life that same day is Murtala Mohammed, national hero of Nigeria. On this unlucky Friday, the day before Valentine's Day, Ford was in Florida just down the road from Escambia all day long. He was there to announce Orlando as the location for the next RNC and to shake hands with a bunch of people working on his primary campaign. He made no remarks whatsoever concerning the race riots that had happened just nine days prior, and he also gave no public statements about the murder of Mohammed, which happened that very day. Three days later, on President's Day, he even avoided mention of the riots during remarks to the National Association of Secondary School Principals. This was headline stuff, as was the shooting of Mohammed.

Murtala Mohammed was a key player in the long string of coups and counter-coups that basically characterized the fragmented governance of Nigeria after it won independence from Britain in the Sixties. The most famous of these efforts to split up Nigeria were the Republic of Biafra, which lasted for several years, and the Republic of Benin, which lasted for twenty-four hours. Mohammed was like a Nigerian Ulysses S. Grant, who was President during the contested election of 1876. He fought strategically, he unified his country, and he was made head of state for his trouble. Of course, Mohammed then chose to align his nation with the Soviet movement to liberate Angola from

Portugal, which included the use of Cuban troops and therefore in the eyes of the Ford Administration constituted a clear example of flipping the bird. He said that Africa had come of age. So, on the day before Valentine's Day, Mohammed was ambushed in his Mercedes-Benz. The coup was aborted a couple of hours later, its leader was shot by firing squad, and there's an airport named after Mohammed in Lagos, which is the biggest city in Nigeria but not its capital.

The capital of Cuba is Havana, which is a big thing just now. Two days after Mohammed bites the bullet, the fourth and current Constitution of Cuba is adopted by national referendum. The first one swapped out Spanish colonialism for American imperialism. The second one lasted about four minutes. The third one must've been pretty progressive, because Fidel Castro promised to reinstate it after the revolution but he never did. After sixteen years of not keeping his word, Castro went whole-hog on institutionalizing socialism, and ninety-seven and seven-tenths percent of the public voted for it. No word on how long it took the remaining two percent to disappear. Ford did not make any public remarks about this on the day of the vote, or the day the Constitution was implemented, or the next day as he welcomed delegates to the Annual Mexico-U.S. Interparliamentary Conference.

This glorious commitment to free healthcare and education via a centralized grip on the market entered into effect on the day of the New Hampshire primary. Ford beat Reagan by less than a point—well within the margin of error and good cause for flop sweat since he couldn't move the needle past a measly two-point spread in Iowa the month before. Carter fared better, giving Mo

Udall the shake by five points and change. He took Birch Bayh by more than a dirty dozen, so the jig was up for the esteemed Senator from Indiana at this point. Incidentally, Bayh was also an Army vet and served pretty near to Vonnegut. Udall would continue to be a threat through the spring, but America has never elected a presidential candidate from Arizona and certainly not a glass-eyed member of the Mormon Church.

Udall wouldn't fade until after a total failure to secure black votes in Michigan, which should've been an easy thing to do for a guy running to the left of Carter. The Mormons decided to allow black members two years later, as soon as they realized it cost their guy his momentum at the very minute he was poised to overtake the frontrunner. The best part is that Udall had been vocal about disapproving those racist policies for quite a while. Ford spent that afternoon doing a photo op with the Boy Scouts of America. The Scouts still had segregated troops as recently as two years prior.

There are no black people in Carver's *Will You Please Be Quiet, Please?* and there are no non-threatening black people in Scorsese's *Taxi Driver*. There are riots in Florida and a Constitution for Cuba. In Vidal's *1876*, there are so many black people in our nation's capital that the narrator privately refers to it as Africa. Meanwhile, actually in Africa, the westside is going to pieces. Nigeria is without a leader and while Ford is out getting a haircut, the Polisario Front declares independence for Sahrawi Arab Democratic Republic. It is not particularly Arab or Democratic, nor is it a republic or especially independent. One part Spain and one part France, fought over by Mauritania to

the south and Morocco to the north, recognized by other equally fraught African nations and never by the United Nations, this little plot of socialist sandscape remains the undisputed Palestine of the Sahara.

Sandwiching all this gorgeous race turmoil in the unseasonably warm month of February are two holidays that serve up more than their fair share of irony. On the first day of the month, we have National Freedom Day. That Sunday, Americans are supposed to be reflecting on our country's commitment to freedom and harmony, for the first of February marks the day that Abe Lincoln signed a joint resolution that eventually became our Thirteenth Amendment. That's the one abolishing slavery. Too bad at this moment we are still only giving three-fifths of a hoot about international relations with Africa. And actually, you can still go to the bank on National Freedom Day because it's not even a federal holiday.

The last day of the month is a Leap Day. This is not a federal holiday, but rather a quietly slipped in concession to the inviolable laws of nature. As it turns out, if you want to impose any kind of organized calendar on the rotation of the sun, you're going to run into a head-scratcher once every four years. Ford is using the extra day to gear up for the Florida primary. Celebrating teenage birthdays on this particular Leap Day are noted American serial killers Richard Ramirez and Aileen Wuornos. Born today was Jeffrey Atkins, better known as Ja Rule, master of the style of hip-hop feuding that is perhaps the closest Americans will ever get to caring about tribal warfare. Meanwhile, back at the mansion, old Hefner is polishing his NAACP Image Award, bestowed upon

those citizens willing to make money off of all races equally.

Also celebrating an anniversary was Hattie McDaniel, better known as Mammy from *Gone with the Wind,* the first African American to win an Academy Award. Viva la Reconstruction? Viva la mohawk? Here's the hat trick: On Tuesday the tenth of February, President Ford formally announced that we would henceforth be observing Black History Month. Then he spent the afternoon reviewing television ads with his election committee and the evening at a performance of *Bubbling Brown Sugar,* a Broadway musical about the Harlem Renaissance. It opened for public preview two days before Motown lost Florence Ballard. I'm sure she was a patriot.

MARCH

The Libertarian Party's Novelist Laureate ... Progressive Rush ... Temptation to Identify with the Antagonists ... Ladies' Night for Cults & Coups ... George Wallace Goes Down Again ... Led Zep Hugs It Out ...

'm on an airplane headed to Chicago, a place that is quite nice to visit as long as your entire family does not live there. My visits are therefore seldom. The special occasion that provokes this return to my roots is the birth of a nephew, a real coup considering the sperm donor is the youngest of my three siblings, none of the rest of us have kids, and he is as yet unmarried though recently possessed of the temerity to hand over a diamond to the knocked up girlfriend in question. So they are saving up for the banquet hall, the brownstone and the college fund. Meanwhile, I have been saving up my thoughts on Canadian progressive rock music, a source of torment for my hip hop loving little brother that I do fully intend to cultivate in my new nephew once he is of proper age to appreciate it.

But before we can begin to discourse on the odd miracle that is Rush, it is necessary to make a longish detour into the Libertarian Party's novelist laureate. Yes, we needs must click our heels three times and broach the amusing matter of Ayn Rand. When I was sixteen years old, I took it upon myself to read the entire philosophy shelf of my high school's library. Please realize that this was partly out of an inability to socialize at lunch and partly due to a hunger for higher concepts than those available in the neighboring classrooms. Rand's novels were not filed under philosophy, of course, but under fiction. I don't recall what book I was reaching for when that copy of *The Fountainhead* right next to it fell down and hit me on the head. Newton's proverbial acorn, certainly, but I promise you, no origin myth. That eight-hundred page harbinger of doom did indeed literally fall off the shelf and down onto my head. I'm indebted to the librarian who chose to order the paperback instead of the hardbound.

Teenagers love omens like that, so I read the book—

voraciously, as kids in search of the big solution tend to do. In the hands of an unreliable anti-hero who is already simultaneously downtrodden and sort of elitist, I'd lay good money that *The Fountainhead* seals the deal every time. It gave me permission to be an asshole by laying out a world where the assholes were clearly winning. The morons may be in charge, Rand said, but the assholes are morally in the right. Make no mistake about my definition of asshole: only later did I discover she meant more "on the Right" than "in the right," but we've got more story to go before those money-colored glasses come off. I moved on to *Atlas Shrugged*, the alleged masterwork, then tunneled my way back, plugging up the gaps with the earlier, slimmer volumes and eventually gathering enough momentum to pony up gung-ho for miscellaneous memberships and newsletters. My parents were just glad I'd found a scholarly hobby, never mind that the Kool-aid was spiked.

So I sit down next to my dad one morning before school and tell him the big news, which is that I have realized through the mystic powers of fiction that I'm a real live Libertarian. He scoffs into his coffee, possibly because the only Libertarian he knows is Ralph Nader. But hey, at least I'm not some pinko liberal, which was the assumption he had been working under up until that point. I should also mention this hearty chuckle of disdain was one of the nicest things my dad had said to me in a couple of years—most of the time we argued at a decibel level so fierce that only the family dog could adjudicate those debates. It's at this point I should make you aware of the general fact that my father will mourn for the rest of his life that he was too young to have voted for Nixon. So, if his eldest was waving the Libertarian flag, he wasn't managing parenthood too poorly. A couple of ugly

lessons in pragmatism and surely I'd end up as the good little straight-ticket Republican for which he and his five brothers had each always hoped.

I was off to a good start, too—choosing an astronomically expensive private college in the middle of nowhere where I could accumulate enough courses relevant to my aspiring future job title of Ayn Rand's intellectual heir. As it turns out, however, Rand's novels are filed under fiction for a reason and she is far from the only author having to admit to this type of failure. Militant adherence to any philosophy whatsoever is a lot of work that does not grow easy over time or with patience. I would be willing to characterize ninety-seven and seven-tenths percent of my effort to be a perfect Ayn Rand devotee as defense. There was very little room for offense, for the type of evangelical atheism that would help these big ideas catch on with my peers. It was so much work setting myself up to get attacked that I got bored, but there was really nothing to do about it since my fellow students had already correctly identified and isolated me as an asshole.

Eventually, I had to give it up to get out of quarantine. Looking back on the two or three years when I tried my best to live a selfish life that would fit in with this reactionary utopian free market fantasy, I do still fondly recall Rand's message about strength of character—but only in direct proportion to the shame I feel over the fascist political views I espoused with all the fervor of the blind college freshman that I in fact was. My only consolation is that a lot of people love those books in exactly the same way at exactly the same age that I did, so if I was an idiot, I was not a bigger idiot than anyone else jumping off that bridge—and the view was beautiful before we all went down. Interestingly, Rand's ideas about capitalism did not really achieve maximum practical

application until the end of the Cold War and the rise of Ronnie Reagan, for whom my father did indeed have the opportunity to vote. I was born into that peculiar land of the free and I knew in my heart I was brave.

While Ayn Rand was working on *The Fountainhead*, she occasionally needed a bit of a break. So that's where the novella *Anthem* is born. In the midst of this richly characterized epic work of fiction, Rand took a breather with an overly vague and deeply obvious minimalist one hundred pages about a dystopian world where some nice young man rediscovers electricity and the guardians of the realm don't allow it to catch on despite its obvious benefits. He runs away with his lady friend and they live happily ever after, dreaming of raising an army to defeat their former captors. Rand had good reason to run away from the Soviet Union and you can easily see how her teenage mind was frozen in the moment of her defiance. That's why kids fall so hard for her fiction. No matter which book you read, the ending is basically some version of run away and plot your revenge.

It's at this point I should let you know that *Anthem* is on the tenth grade reading list. I introduce it to more than a hundred kids every spring and this is one of my favorite personal challenges: to do it justice as a piece of philosophical fiction without allowing it to convert into gasoline thrown on the sparky teenage feelings hovering in the air, lest I inadvertently buttress the future of The Republican Party. You know who shares this delicate balancing act with me? Rush. So now let's talk about those Canadian pillars of progressive rock music and the ideological suppositions that catapulted them into mainstream notoriety via the album *2112*, which was released on the first day of March, 1976. It begins with a twenty-minute suite, "2112," written by drummer Neil Peart

and dedicated to "the genius of Ayn Rand." Then there are five other songs about smoking pot and watching television to which nobody paid any attention, likely because they were themselves fairly busy smoking pot and watching television.

Rush had tried unsuccessfully to break into American rock radio and had been informed by Mercury Records that if the rabbit wouldn't come out of the hat, they were going to void its contract while it was still stuck in there. The band had released far too many concept tracks and nothing approaching commercial blockbuster viability, but they convinced the record company to give them one last chance. Rather than deliver the mainstream album they had promised, Rush decided to double down on the things they loved and somehow it all gelled together perfectly in the nick of time. Thusly, *2112* was born through a basic unwillingness to follow the instructions of corporate overlords. It is the same feeling that threads throughout Ayn Rand's work and in particular adheres closely to the plot of *Anthem*.

"2112" has seven parts and *Anthem* has twelve, because apparently Rand can't keep from bloating up even a short novella. But back to this most excellent song. "Overture" sets an ambient zone of future anonymity, a greyscape of stomped out rebels with a dose of foreshadowy uplift in the middle that turns on the dime of an apocalyptic explosion and Matthew 5:5—"And the meek shall inherit the earth." Let me pause for a minute to state an all too obvious fact, which is that nobody really believes this. The soft and gentle are powerless. Humility is not an American value. It is not even a Canadian value and is in fact the opposite of an Ayn Rand value. *Anthem* ends by literally spelling it out: e-g-o. Rush likewise highlighted this by adopting the cover art from the *2112* album as their subsequent logo. Their Starman is the solitary

individual who pushes back against the evil red pentagram of collectivism with both hands.

This incarnadine star is the emblem of the Solar Federation, a series of small planets unified under the thumb of the priests of the Temples of Syrinx. Things you might like to know about the etymology of the word syrinx: a virgin nymph who was turned into a hollow river reed to escape rape by the wild god Pan, a woodwind instrument featured in the science fiction of Samuel R. Delany, a vocal organ in birds located at the base of the avian trachea, a pseudocyst formed by blockage of the cerebrospinal fluid within the spinal cord or brain stem. So the priests are the censors of culture and everybody worships at their temple. The result of this worship is that everyone is equally a sheep, allegedly contented and indebted.

The second part of "2112" is "The Temples of Syrinx," where we first hear the collective voice of the priests around the five-minute mark. Ladies and gentlemen of the jury, I give you: the signature sound of Geddy Lee. The priests should be scary. They should have a voice that conveys their capacity to oppress. But the lead singer, keyboardist and bassist of Rush is not scary. His voice is not the thundering boom of giants who enslave. Geddy Lee is the Jewish Robert Plant—more funny than sexy, more neurotic than bluesy, more clammy than sweaty. Geddy is the heavy metal son of two concentration camp survivors and he probably does not enjoy being constantly compared to Robert Plant.

Nobody ever requests more of part three, "Discovery," on the set-list at Rush shows. It is the awkwardly acoustic, slowly gathering steam of Starman's effort to learn to play guitar. Alex Lifeson does a remarkable job of transitioning smoothly in and out of this radically different section, as well as conveying the

feeling of the heart leaping up within it. But at concerts, people go nuts for "The Temples of Syrinx." This is because Geddy Lee makes those priests pretty fucking cool-sounding. You know those guys are evil and full of shit, but there you are at the top of your throat—lungs are not required for harmonizing with Geddy—singing the words that put you in their malevolent shoes. They are just villains and not very likeable. Nevertheless, they have the best lines and the most badass instrumentals. At least Rand did readers the courtesy of making her council of douchebaggery sound like the bureaucratic morons they were, so there was no temptation to identify with anyone other than her protagonist. But it's hard to get on board for soothing waterfall noises and Lifeson's tender meanderings once you've heard how the priests can wail.

During "The Presentation," you hear both the voice of Starman and the priests. Starman is stuck with the folky gentility employed by the verses in "Discovery," and then every other stanza, that screeching harpy noise snatches all the glory. The priests are not stupid, they're dismissive. Electric beats acoustic and at the eleven-minute mark in the twenty-minute suite, they shut Starman down. Likewise for the hero of *Anthem*, praise and progress were not forthcoming. The interesting reversal is that in *Anthem* the leaders are stuck in a hopelessly medieval position of denouncing electricity, whereas in "2112," it is precisely this electricity Rush bestows upon the priests that facilitates their ability to put the smack down on Starman.

Then there's "Oracle: The Dream" and "Soliloquy" to reinstate the vision of a world more free and more full of guitars than the world Starman knows. Increasingly, Geddy is singing Starman's parts with the strength and strain of the voice he gave to the priests. Perhaps there is a better world yet to be, but the vengeful

fantasies of *Anthem* fade quickly away in this darker tale as our hero lapses into despair and eventually kills himself. No room for a triumphant sequel, but both stories do leave an open ending. For *Anthem*, the good guy and his lady are home-schooling themselves in their conveniently furnished cabin of exile, dreaming of the day when they aggregate enough stragglers to mount an armed resistance against the relatively weak red-tape fanatics currently in power. They name themselves Prometheus and Gaia, fire and earth. The last two minutes of "The Grand Finale" however, come blazing in with a classic American cowboy taking care of business riff. It turns out that Starman, our fire in the sky, is not needed for the revolution. The ending arrives happily without him as an unnamed cavalry announces, "Attention all planets of the Solar Federation. We have assumed control."

This is the big question for all rebels that succeed in some type of liberating movement: will we be greeted as assholes? It is simplistic, even idealistic, to interpret the ending of Rush's epic in a positive light. We have no reason to believe that the defeat of the Temples of Syrinx means a more permissive let alone supportive attitude toward guitar heroes. It's Robert Frost's essential gag: the shallow interpretation is to believe that the road less traveled is the better road, whereas the smarties who look at that poem see clearly that any road makes all the difference and there is no such thing as an unconditionally best road. History will reveal the value of our decisions, so I'd like to switch gears now and discuss some historical things about which fans of Rush, whose demographic base is ninety-seven and seven-tenths percent composed of white males, are fairly unlikely to care. This month of March is particularly well-seasoned by an assortment of coups whose effects were largely negative. A good liberator is hard to

find.

On Thursday the fourth, United Kingdom politics goes up in flames as the Northern Ireland Constitutional Convention is formally dissolved. Westminster resumes direct rule and the Provisional Irish Republican Army launches into The Long War of attrition with some of the cleverest and most devastating bombings pretty much since the invention of bombs. Simultaneously, IRA prisoners are no longer granted Special Category Status and are asked to wave bye bye to their Geneva rights, which they did by organizing a series of prolifically publicized hunger strikes. Everyone everywhere was rioting or striking and such was the violent daily life of citizens in the four historic counties that they simply refer to this entire swath of the fabric of their history as the Troubles.

Had the unionists and nationalists bickered somewhat less amongst themselves long enough for the NICC to get a proper footing in governance, thousands of lives could have been spared. Less than two weeks later, U.K. Prime Minister Harold Wilson resigned. It was sudden and it was the day after the Ides of March—not only a day late but also a dollar short, the smoky villain of Alzheimer's already ding-dong ditching at his door. His Resignation Honours included one guy later imprisoned for fraud and another who committed suicide before investigation into his corruption was complete. Wilson's replacement served a few quick years and then first female juggernaut Margaret Thatcher, England's own Ronnie Reagan, came to stomp him out.

Reagan himself is a party to the first of two back-to-back coups late in the month, breaking Ford's string of a half dozen Republican primary victories with his North Carolina upset in a relatively comfortable six-point spread. It's awhile yet before the

neck-and-neck stretch of the race gets going and still longer before the convention head-to-head, but Ronnie is at least beginning to show Jerry that maybe acting would've been a more productive pastime than football. The next day, Isabel Perón is deposed in Argentina. Only one non-royal female head of state in the Western Hemisphere at a time, please, and Thatcher is on her way now. Curiously like Ford's wife, Perón's first gig was as a dancer. Though Betty ended up abusing alcohol while Isabel ended up abusing the massive armed forces of Argentina, so it's not hard to lay odds on which husband more often had his hands full.

In March of 1976, spring had sprung for cults and coups of all kinds. Capturing both these phenomena in a way most symbolic of that panicky polarity infecting our national pop cultural consciousness of this time is the verdict of Saturday the twentieth, whereby Patty Hearst was found guilty of armed robbery. Having been raised within the extremely privileged bubble of publishing magnate Granddaddy Hearst, the Berkeley sophomore was either a rebel in search of a cause or a candidate ripe for a brainwashing, depending on who you ask. You can't ask the few other members of The Symbionese Liberation Army, because they died in a shootout before Patty went to trial. I'd also like it noted for the record that "Symbionese" is not even a real word, let alone a country or a proper ideology.

But here again we have the communist root, and Patty changed her name to Tania because that was Che's girlfriend's name. Score another one for Argentinian revolutionaries. Score another one also for Patty's lawyer, F. Lee Bailey, next to his other tremendous media circus wins for Sam Sheppard, the Boston Strangler, and an Army captain off the hook for the My Lai Massacre. Before his subsequent disbarment, he would go on

to defend O.J. Simpson. No matter the reasons why Tania did it, Patty certainly did rob that Hibernia Bank at gunpoint. It was a rifle, to be precise. The president who would soon commute her sentence is at this moment just an ordinary Georgia Governor en route to North Carolina to trounce once and for all the three-time big-time loser in the presidential primary race, George Wallace. North Carolina was his best volley on this fourth go around and Carter still took him by almost twenty points.

Wallace had been running for president for twelve years at that point, which is surely the definition of insanity. He was meanwhile elected Governor four times in between those four swipes at the elusive presidential brass ring. Here's a guy who literally took a bullet for America. Or if you want to get really literal, he took five bullets, which is one for every failed presidential bid and one to pour salt on the wounds. These bullets have a fine legacy all their own: from Arthur Bremer's gun, to the premier of *Taxi Driver* last month, to John Hinckley, Jr. And there's old George, with the television showing his wheelchair plain as day so the voting public understands that metaphorically he hasn't got a leg to stand on in this race. Say what you will about Patty Hearst, but for my money, it's George Wallace who got stuck with the Stockholm syndrome.

Capture-bonding seems like a total representation of American, not to say democratic, political philosophy. This corrupt machine, steadily gathering steam via the eternal swindle and beat-down that is governance through bureaucracy, comes tapping tapping tapping at Wallace's cranium until he swears he's called to do it. So they beat the drum and he beats his head against the brick wall of primary fail after primary fail, lovingly counting all the votes he did not get. I say lovingly because no other adverb adequately

conveys the eager tenderness with which the candidates must turn themselves over to the sadistic machinations of vote-getting. I think it's freaky that he kept trying. Personally, I could lose a presidential primary once, maybe twice, and then I'd throw in the towel. But Wallace kept coming back. He loved it though it paralyzed him from the waist down for the final quarter-century of his life.

So, back to Rush. And back to Geddy Lee, the monstrous siren that draws us into glorifying "The Temples of Syrinx" instead of Alex Lifeson's fragile acoustic "Discovery." Rush fandom suffers from Stockholm syndrome. Everyone knows Neil Peart is kind of a self-righteous jackass, and yet, dudes like him and George Wallace are princes among losers. Their influence is everywhere quietly manifest in the social fabric of the ties that bind us together at the concert and in the voting booth. We love traps, coups and cults. But there is a far greater power that compels us toward one tall shadow cast from this calendar's furthest corner. And nobody puts Jimmy Page in a corner.

As a perfect bookend for a month that begins with Rush's greatest work, we have the release of Led Zeppelin's *Presence* on Wednesday the thirty-first. It was the slowest-selling album they ever made and the shortest amount of recording time they ever spent. During those eighteen days, Robert Plant was largely confined to a wheelchair due to injuries sustained in a car accident and Jimmy Page stepped up. No keyboards whatsoever and mostly no acoustic guitar. The boys were burning up inside and they lovingly forged that electric current into seven tracks of howling desperation. First, the amusing irony of "Achilles Last Stand," as Plant was nursing a broken ankle. A couple of fancy Greek mythology references in there, especially Atlas, previously also

snapped up for similarly epic ballads by Ayn Rand. Then there are the tremolo dive bombs of disapproval for the collective Los Angeles coke problem, as opposed to Rush's journeyman quest for Thai-stick in "A Passage to Bangkok."

Plant and Page actually have no objection to marijuana, as they explain in "Royal Orleans." The Royal Orleans is a great hotel on the corner of Saint Louis and Chartres where bass guitarist John Paul Jones fell asleep with a joint going and set the place ablaze. There was also some mention of unmasking transvestites, whereby this song begins to parallel Rush's "The Twilight Zone." There are three or four more songs at the end of each album, but neither set is worth much discussion. Rush devolves into a frantic striving to prove their diversity of sound, while Led Zeppelin slow-boils toward a rageful blues, both bands lamenting the unattainability of perfection that once seemed within their grasp. These two albums from Canada and England go all-in on what is ultimately among the finest American conceits: that we can hug it out with those demons under whose thumb we are stuck.

Our demons are not so bad! In fact, we will join the ranks of these demons without completely becoming them! You can jam to the big baddies of *2112*. You can sell your soul and lose your legs to the Democratic Party for four consecutive presidential primary runs. You can give up daddy's money and change your name to Tania. You can read thousands of pages of Ayn Rand. You can ditch out on peace agreements. You can harness that *Presence* fear and anger with a fine leather saddle of the blues. Whatever it takes to make it is whatever it takes to make it, right? But the main thing I have to report to my nephew is that it would be excellent if in future when presented the predictable string of these types of human opportunities, he could refrain from turning

into an asshole, because to find yourself in the unenviable yet inevitable position of loving an asshole does not mean that you must yourself become one. Of course, none of this means that the meek shall inherit the earth. Not unless the cult of the meek stages a coup.

APRIL

35 Hours With Dad ... Conquering a Motorcycle ... Two Waynes Dispense Their Wisdom ... The Ramones are Alright ... Hughes & Jobs in a Pissing Contest ... Two-Dollar Bill Mythology ... Transcendentalist Aerometry ... Forget about Z-14 ... The New Masculinity ...

rivers' Ed was mandatory at my high school in Illinois. You could pay for private or enroll in the class for which your parents' taxes already paid. I had it right before lunch and the instructor, who was also a gym teacher, was a crabby asshole named Rotollo, or Rizzoli or something. The only time he took us out on the highway, I flung my quarters too high and had to get out of the car at the tollbooth to pick them up. There were dozens of unclaimed quarters down there and no way to know which ones were mine.

Never got my driver's license. I passed the class with a B minus and can recall in vivid detail one time I was making a left and was a few inches away from t-boning a mom and her two kids in car seats in a lavender minivan. Rotollo slammed on the passenger side break and reached across me to turn the wheel sharp right. He may have cursed at me under his breath. I hope he did. In addition to passing this class, kids in Chicago also had to spend so many hours in the car practicing at home and parents had to sign off on these hours when the kid went to the DMV to take the driving test.

Imagine my father's sadistic delight when he discovered he held the power to deny me this rite of passage. I had no job and couldn't afford a car, nor could he afford to buy me one, so really the license was a moot point. But he declared that not only would I do all the hours with him instead of my mom, who indeed was a terrible driver, but I would additionally learn to do things like change my own flat tire before he would sign off on my hours at the DMV. Well, I never spent one single hour behind the wheel with my father next to me.

He poked me about it every weekend without fail for that entire

school year, until I finally just announced that I had no intention of getting a license because I had no intention of suffering him for 35 hours plus all the side torture of jacks and spare tires and anti-freeze and snow shovels or whatever he could conjure up. He said if I wanted to cut off my nose to spite my face, that was fine with him. It was fine by me, too, as long as the nose was in my own pocket rather than his.

So I still don't have a driver's license, for a car anyway. About a decade ago, I decided to try a motorcycle. This involved calling my mother to inform her that I was breaking a promise I made to her when I was still in high school. Uncle Jimmy got in a pretty bad bike crash and mom made us all promise we would never get on a motorcycle. Truth be told, I'd already broken this promise, riding bitch on back of a tricked out scooter with a zebra fur seat once when I was in grad school. I never told her about that, but it was a fun little ride—enough of a taste to keep it on my mind for a couple of years.

In the state of Georgia, you can take a three day course using a loaner bike for a few hundred bucks, then go to the DMV and take a ten minute signs test, and walk out with a bike license. So that's what I did. I went to this course and it was two grizzly old dudes in aviators making fun of us until we learned how to relax and pay attention. This course changed my life for ten years, during which time I absolutely lived by the credo that was breezily bestowed upon me by these two gnarly goats teaching two-wheeled living to a bunch of suburban cubicle workers in crisis. There was a tall, handsome one who drove a fully loaded yellow BMW, a rich man's bike decked out with a rogue's accessories. The short one's name was Karl. He saw the look of virgin panic in my eye

as I literally embraced this huge machine with my body for the first time, and Karl leaned over and stage whispered through my helmet, "You know, girl, the machine can only do what you tell it to do."

Presto, I was hooked. It was a beast and I was its boss. I was commander of my soul and captain of my bike. Invictus! Bought one and grew into it. The day my first bike got stolen, I thought I'd lost a toe or something. It hurt that bad, with ghost pains and everything. As you might guess, the second bike was bigger. I still ride it every day. I'm one of those crazy rain or shine, summer or winter motherfuckers. The bike is my companion animal, some metallic little seedling of my being, not to get too transcendental about it. Last year when I was in the hospital for a month, my bike also got sick. It missed me, and although I did not tell it to miss me I was more than pleased that it did so.

This brings me to my second giant bit of biker wisdom, and the principle under which I am currently operating. I was having some problems with the starter a few weeks ago and rolled the bike in to see my mechanic, who is a delightfully mumbly man-child named Wayne. We were going through the electrical piece by piece and the seat was off, leaving a huge gaping hole in the middle of my precious, half her guts open to the wandering eyes of strangers. Wayne is full of odd bits of geekery that almost nobody takes time to listen to because he can get overly technical, but I always try to keep alert and boy was I glad I did that day. He's bent over with his head fully inside the lion's mouth, if you will, and Wayne says to me, "you have to give the machine what it wants."

My head exploded at that point, because let's be real: the catchy

one-liner delivered me by Karl is only useful to a person who has no knowledge of bikes whatsoever. Only a shit-eating baby-face suburbanite would take to heart the untruth that a motorcycle is a machine over which you are fully in control. Even on its face, the idea makes no sense. You turn the key, the machine does seven things, making that series of beautiful purrs to evidence the fact that clearly it is thinking without you. The only nugget Karl got right on the money about was the prospect that my body could have a relationship with the body of the bike.

I was not lord over it. Only a kid believes that kind of freedom is free. An adult, and a real biker, understands the price of freedom to ride. Wayne explained to me that a bike requires a relationship. It's not my gimp, not slave to the selfish and irrational cartoon fantasy I have of the open road. Just as my body grows old and crabby, so too does the body of my bike. I have to learn its preferences and be accommodating. Likewise, my bike will have to accept the fact that we leave the house at 6am to go to work, no matter how wet or cold it is. We are sharing a body, making decisions together. If the bike does not always do what I tell it to do, it's because I have failed first to respond to its needs in some way. A bike must be kept happy or it cannot keep its driver happy. At our best, we are sharing one cyborgian consciousness and cruising together in one body—corporeal, incorporated.

That's my current best guess at a theory of machines, which is central to the corporate machinations of April 1976. This month marks a new era in corporate living, of making a functioning body out of a brilliant idea. For alongside the death of wackadoo gazillionaire inventor Howard Hughes, April gives birth to the twin terrors upon which the new American corporate culture is

founded. I am speaking, of course, of Steve Jobs and the Ramones.

My high school debate coach was an intellectual property lawyer by day. At the end of the year, the team always went over to his condo in Wrigleyville for a barbecue on his rooftop deck. I'm telling you this because it is the story of how I discovered the Ramones. This is just a few years after the invention of the compact disc and awhile still before they became ubiquitous. My coach, whose name was not incidentally also Wayne, had a huge CD library and I spent an hour browsing through it. It was full of bands I'd never heard, though the main thing was that I grew up poor but loving rock music, and I'd never seen a collection this size in my wildest dreams.

So Wayne was picking through the shelves with me a little bit and I asked who his favorite band was. We crouched down to the lowest shelf and he unhesitatingly went for a case with a black and white photo on the front. You know what I'm talking about. It's the debut album with those motherfuckers in their well-worn leather and worn-through denim lined up all cool against the bricks. They don't care if you're gawking at them or giving them the stink eye. In fact go on and do it, because they draw power off the vibe of middle class suburban judgment like it's a goddamn electrical socket.

I'd never heard of them. That night, we didn't even listen to them. But I loved them already. I knew from jump that the Ramones were my people. It was of secondary concern that I take a moment to hear the album; the point is that I was instantly far less lonely. That photo said everything I needed to hear. I had those ratty jeans and I wanted that badass jacket. These were guys you could shoot the shit with over a couple extra-large orders of

fries. You didn't even need booze to have a good time in their brownstone jungle, but these guys probably knew where to get some if you wanted it. I made a mental note that the Ramones were my friends, and that's it. I don't think Wayne and I ever talked about them again.

No recollection of when I finally got around to the music, and even when I did, it didn't turn up heavy in the rotation. But in April of 1976, I have no doubt that the noise was inescapable. They were pioneers, and I don't think there is any point in differentiating between the members to the extent of laying credit for their collective genius at the feet of any singular individual in the band. I don't have any dog in the fight over Johnny or Joey. The force of the Ramones was never in the unique personalities of each performer, but in their collective commitment to maintaining a unified front in the face of overwhelming social...what? I am lacking a noun that can adequately convey the slight but deeply pressurized boredom that accompanies the expectancies of life in duplexes and culs de sac outside the metropolis.

The Ramones were not bad kids. They were like me: fed up with the parental, squirrely for anything resembling adventure, willing to enjoy ostracism, safe in the knowledge that their fate was to be rocketed beyond the sad futures that pass for success in their peer group. If you liked the Ramones in 1976, at first, you stood alone with the other loners. Then eventually, everybody got on board for what the band had to offer, and the good news was that if you loved them early, you could still love them long despite their explosion of popularity. For, ladies and gentlemen of the jury, I set before you this proposal for posterity's understanding of early punk rock: the Ramones were not sell-outs.

The Ramones became a corporate juggernaut precisely because they never deviated from the band's original mission. They seamlessly shuffled new members in and out. They toured psychotically extensively for over twenty years. They released very many albums that all sound roughly the same. Just draw a straight line from "Judy Is a Punk" to "Suzy Is a Headbanger" to "Sheena Is a Punk Rocker," or a little later for a more narrative arch, from "I Wanna Be Sedated" to "I'm Affected" to "This Business Is Killing Me." The Ramones did not evolve, ever. They personally grew old and gray and sick and cantankerous, but did not condone or experiment with adulthood in the image they presented to their rabid public. The Ramones never broke their collective character, and therefore, they do not meet any reasonable definition of selling out. This continuous performance of the Ramones as a coadunation of grizzled teenage soul is so unimpeachable, so thoroughly curated, so perfectly glossy, that I even feel a little bad discussing it in the past tense.

The Ramones have great mileage. They built their machine and they maintained it vigilantly for longer than any other band attempting to set foot and defend ground in the ballpark of what became punk rock. Hey ho, let's go! And everybody formed a straight line behind them, the kids proceeding to lose their minds at a tempo as fast as the speediest pop songs anyone had ever heard, at least since Buddy Holly. The Ramones were greatly invested in nostalgic comparisons to Fifties rebels, even as they were propelling turnover on a new teenage consciousness so quick that it verged on violence, unleashed on the alien land of the grownups like so many hilarious monsters endorsed by the band's affinity for B movies.

We could talk about the album, how it was composed or recorded, what the songs mean. But that is still all beside the point. The lyrics and the noise are but two components of the band's brand. As far as my personal pantheon of music heroes, sprung as it was from the outer reaches of the seventh circle of suburbia, those words and instruments are smallish compared to the deafening volume with which the image on the cover of their debut album spoke to me. The point is that the totality of this enterprise that is the Ramones embodies an approach to the very concept of youth in a manner that remains undeniably effective, frozen as it is in the homogeneous amber of that iconic debut photograph: a portrait of American life that makes their idea ageless and therefore invincible.

The apex of excellent design of any thing is reached only through the Herculean intellectual accomplishment of marrying timeless concepts to contemporary spaces, attaching amaranthine machines to our fragile flesh. A guitar and a Ramone. An airplane or a video camera and Howard Hughes, Jr. A computer and Steve Jobs. On April Fools' Day, Apple Incorporated officially became a thing. It was a Thursday, and as soon as Howard Hughes, Jr., got wind of this one small step for Jobs and one giant leap for corporate America, he resolved to die immediately on the first available business day, Monday the fifth. So there's Stevie futzing around with putting the ducks in a row in Cupertino, and then there's this barely identifiable corpse of the great aviator, flying back to Houston. It rained in Houston every day that month. Texas was crying for Hughes, but the insane cross-platform phenom of the 20th century had just given way to the insane cross-platform phenom of the 21st century a couple decades ahead of schedule.

By the Bicentennial, Jobs and Wozniak would be hawking the Apple I personal computer kit. The retail price was $666.66. No kidding.

In the "also ran" slot for the first of April: Consolidated Rail Corporation, the government bailout of bankrupted Northeastern trains known as Conrail. When a company becomes a wild success, there are only two things it can do. It can either steamroll every last competitor through to an unbreakable marketshare and its attendant brand legacy, or it can cash out on hulking pieces of its infrastructure and fade away into profitable obscurity. Conrail broke up and disappeared. Howard Hughes's father died suddenly when he was still a teenager, and Howie had to choose between selling off the drill bit company that revolutionized the oil industry, or trying to manage it intact. He kept it as a monument to his father.

Howie and Stevie both had fathers who taught them to tinker. They both played around with radios they'd built themselves. They both sucked at school and dropped out of college. They both had no clue about women. They both parlayed fiercely stubborn personalities into mammoth risky business plans. They were both demanding assholes on the job. They were both interested in the movie business. They both died young. Let's not belabor the finer points. In 1976, Jobs was just a couple years younger than the Ramones, and Hughes was fifty years older than Jobs. Neither of them were listening to the Ramones. Jobs has Dylan's *Desire* album going on a loop, as did Jimmy Carter. The day after Howie died, Jimmy was running for his life in Wisconsin with Mo Udall nipping at his heels. Jerry had meanwhile whupped Ronnie by a full eleven points up there and was getting ready for the kill in

78

Pennsylvania.

One week later, the U.S. Treasury reinstated the two-dollar bill. It had been out of print for a decade and the Fed was hoping to see singles fall out a bit with fresh Jeffersons in circulation. During his time as a third president of these United States, Thomas Jefferson negotiated the Louisiana Purchase. The largest land grab on the continent at that point, it enabled the Lewis and Clark Expedition without which neither Hughes nor Jobs would have the space to make their fortunes. And of course, he also wrote up a little thing called the Declaration of Independence. The two hundredth anniversary is beginning to loom large now, just a couple months away with an army of Rotarians planning patriotic spectacles from Cupertino to Queens. The back side of the 1976 printing of the two-dollar bill includes a depiction of the drafting of the Declaration of Independence. It was replacing a depiction of Monticello, Jefferson's Virginia plantation built on five thousand acres of slave-labored tobacco. This is not so much progress as the elimination of redundancy, since the plantation still sits on the backside of the Jefferson nickel, which has been in circulation since 1938. It costs more than eleven cents to mint this nickel. That's just bad business.

The two-dollar bill would've been great business if anybody had picked it up and run with it. Nobody did. There are so few circulating around town now that most people mistakenly believe we're not printing fresh ones. People are hoarding them, thinking they're either bad luck or good luck. Or queer, like "queer as a two-dollar bill," though two-dollar bills are in fact lying around everywhere. Steve Wozniak fabricates them at home and claims the Secret Service has approved them twice as government spec.

Apple Incorporated also made money out of thin air, convincing ordinary citizens that they needed the power of computation at home.

Hughes made money in thin air, not out of it, flying with as much bad luck as if he were spending two-dollar bills. He killed three pilots and a mechanic in order to make *Hell's Angels* with as much aerial realism as possible, and for this trouble the movie netted zero awards while allegedly grossing double the production value. In 1936, he drove drunkenly into a pedestrian and killed him. In 1946, he crashed a plane so badly that the regimen of painkillers would follow him for the rest of his life. In 1956, he dropped out of the airline business and the movie business despite owning far more than half of both, and loaned a couple hundred thousand dollars to Tricky Dick's brother in a move that later definitely either did or did not prompt a break-in at the Watergate Hotel. In 1966, he began his oddball tenure in the neon shelter of Vegas, hemorrhaging money on two hundred gallons of banana nut ice cream and other publicity nightmares like the takedown of the sign at the Silver Slipper. In 1976, he gave up the ghost. Suffice it to say that when laying odds on the many comebacks of his own genius across a network of differing industries, Howie did not do well on the sixes.

As the world's most evident spokesperson for obsessive-compulsive disorder, Hughes himself would have appreciated this superstitious fact. In the "also ran" slot for celebrity OCD: Joey Ramone. But I digress, for we are talking about motorcycles, and the third bit of wisdom on that score is this: if you successfully meld your mind with that of the machine, that new animal is up against the wind. Bob Seger released the *'Live' Bullet* album in

April of 1976, but "Against the Wind" doesn't come out until four years later. The aerometry, the experience of air pressure when riding a motorcycle is the thing about the experience that makes it unlike any other thing you can do. We forget that we live constantly submerged in atoms, because most of those particles are invisible. When I'm driving a bike, those tiny pieces gather themselves into a wall, and I can tell the difference between forty and eighty by the amount of force that ghost substance applies to my breastplate.

This ain't no easy zephyr blowing in from off the coast, nor ain't it a hurricane or a roller coaster. And most of all, asshole, it bears no resemblance whatsoever to driving with the top down. If you don't wrap your arms and legs around the engine of a speeding motorcycle, you will never have any idea what it feels like to do so. I'm doing my best here, but Jesus, some shit is just too actual to render using words. Right about the same time as "Against the Wind," Billy Joel did "You May Be Right." This motherfucker even rode his motorcycle in the rain. We have that in common.

The first time I did it, I was sore for three days. In the minute, I was a king. This heavy, sudden Southern downpour was peppering me from sideways like it was full of clear paint-gun pellets, and I was skidding across the slick blacktop with my jeans so soaked the water was running right off my calves down into my boots. It was getting to me, but I would not be stopped. This bike and I were beating the weather together, cutting through the remarkable thickness of space-time like the flesh and steel android creature we had in fact become. It's not only that the person melts into the bike, but the bike must also inject itself into the person.

You begin to understand the hiddenness of atmosphere. That

81

weight begins to lay on your chest like a pet, curling up around your neck and shoulders and shifting around with you when you change gears. You grow used to it there, comfortable with the physics of it, and that's when I began to make headspace for noticing the smell of things. There's the rain, of course. But you can also tell which house is doing laundry, which house is baking cookies. You can tell whether that irregular lump up ahead a quarter mile is a possum or a dog, just by the smell of it. You can pick out the pine trees, night-blooming jasmine, corn fields, pig farms, fresh cement. The layers of it peel down endlessly, getting up into your nostrils and flickering out into the next scene. Motorcycling gifted me an increasingly discerning nose.

Enter: Halston. No, seriously, hang in here with me. Halston is best known as the fashion designer who made Jackie-O's pink pillbox hat and then parlayed that hat into no better cause than the resurgence of suede, but this month finds our man intensely concerned with the properties of air. He is at that moment working on elegant new uniforms for all the personnel at Braniff International Airlines, but more importantly, he is launching a fragrance. And then it turned out to be two fragrances. He had these two guys fiddling around to find it, and when they delivered their best prospects, they just referred to them by their lab codes. Halston thought they sounded like race car models so he kept the original names, and undecided as to which of the top two was a better choice, he flung them both into the marketplace and waited to see what would stick.

I wasn't alive for the heyday, remember, so the first time I saw something with Halston's name on it, it was a bottle of *Z-14*. Well, I saw the box. There was no tester and I wasn't so desperate

for a whiff that I would bust open a box. But there was something in the font on that box that drew me, and I filed *Z-14* away for later. For years now, for as long as I have been living my grown-up scent-wearing professional life, I have still been passing by that box. To this day, I've never smelled it, though safe money does lay odds that I have picked it up anonymously on strangers at least once or twice. Never liked it so much that I asked for the name and had the mystery of Halston revealed to me. *Z-14* is also the name of a recent incarnation of the Kawasaki Ninja.

Instead, I ended up with its alleged lesser cousin: *1-12*. I-12 is also the name of a highway I traveled frequently when I was living in Baton Rouge. You could get a drive-through margarita. Those were the days. Anyway, you never see *1-12* in department stores because the market shook it out for being too subtle next to *Z-14*. The underdog always intrigues me. I found a huge bottle of it for a little over ten bucks online, then forgot about it until it arrived in my mailbox. The packaging is identical to *Z-14*. So is the bottle, this bile-colored glass discus with a lop-sided top and a donut hole pressed two-thirds of the way through the center. It's not fun to look at, but Elsa Peretti designed it to be appreciated by the hand, not the eye. Despite its cancerous alien appearance, the bottle feels intuitive when you pick it up, organically molded to the shape of your hand. Once you're holding the thing, you immediately realize the depression in the center is angled just so, perfectly aligning the formerly awkward spray angle so it flirts with your pointer finger, just waiting for you to strike.

I could smell it as soon as I took off the cap, some waft of an ancient era of perfumery that had an entirely different idea about how a fragrance should be properly mixed and what a body

should smell like. I sprayed it into the air first, and immediately blacked out—except everything behind my eyelids was not a sea of black, but of green. Eureka, synesthesia! My initial collapse into vanquishment gave way to an equally panicky feeling of inescapability as my airspace mutated into some kind of invisible jungle. Determined to press on with an experiment that was quickly turning against me, I opened my eyes and detonated the *1-12* six inches from my right wrist. I tamped down whatever second volley the cologne was about to deliver by mashing my left wrist against my right, my left hand still wielding the bottle whose extremely comfortable ergonomics had lulled me into forgetting it was there.

Then the scent was on me, aggressively creeping up my arm all bergamot and basil, plus something going by the name of galbanum. This is a beastie in the bottle of its same color, some kind of resin produced by a hollow-stalked plant that grows like a weed in the mountains outside of Tehran. It popped up occasionally as the bitter pill in several big colognes since the previous World War, but it is truly a dinosaur, around so long that its incense even rates a shout-out in the Book of Exodus. The old guys in houses of god from Cairo to Jerusalem said this bitterness was symbolic of sinners who went deliberately unrepentant. It comes from the same family as anise, fennel and hemlock. Serious stuff.

Not to sound snobby, but it's got one hell of a dry down. I was at the mercy of a pine forest, or lost in a peppery field of carnations with a half-empty bottle of gin in my hand like a drunken Dorothy in a different Oz. It was an earthquake in my nose. I tried to remain calm and wait patiently for a base note, but that too snuck up on me like some cheeky old gypsy man blinking

into existence on the periphery of my sight line. There was no way to find a footing on so much moss, the pine scent giving way to some deeper spice of balsam or cedar. If you're an idiot who's a little bit dead in the nose, it's so clean you could mistake it for talcum powder. Underneath it all, there is a serpentine sweetness of some kind, like a moldy vanilla, perhaps a hit of tonka bean. Tonka is a seed from a tree that grows primarily in South America. Its use in food preparation has been banned by the Food and Drug Administration because of its anticoagulant properties, but you can still commonly find it laced into most cigarettes and many voodoo rituals.

It grew on me. It lingered all afternoon, sweated out a long night and woke up with me in the morning. Took it on the bike and afterward, I smelled more like the road than I ever had before, and it was good. *1-12* has foreign menace and patchouli-free mysticism. For all this thinly-veiled yet easy-to-miss complexity, the total experience leaves you with just that one note, just that ancient green thing. It pokes you in the eye and you like it. It is not unlike the Ramones.

The day before their debut album launched, Barbara Walters became the first female nightly news anchor. It was a Thursday, so it seems ABC didn't want too many people watching, just in case she blew it. Her co-anchor, the ironically named Harry Reasoner, was pissed. He bailed on his contract as soon as he could, then had to come crawling back to promote his new book five years later, as she condescended to interview him on *20/20*. Walters was instantly more famous than Reasoner would ever be, landing a prized gig moderating the third and final Ford-Carter debate just before Halloween. Sixty-two million people saw that. Around the

time of the Reasoner's interview, Walters caught serious flack for asking Katherine Hepburn, who said she might like to be a tree, exactly what kind of tree she would be. An oak, Hepburn said. That is not an answer plucked from thin air.

A book that everybody is talking about at the moment is *The Forty-Nine Percent Majority: The Male Sex Role*, a study in manliness collected by two professors that divides the major social roles of average dudes into four categories, one of which is the sturdy oak. So Hepburn is actually tapping into the fact that she's as tough and confident as any of the boys. Walters was probably more appreciative of the male role behind door number two at that point: be the big wheel, succeed in competitions for status. The other two roles are no sissy stuff and give 'em hell.

Most people forget that The Rolling Stones released an album, *Black and Blue,* the same day as the Ramones' did. It was Ronnie Wood's first record replacing Mick Taylor, and it charted with ease while the new rock and roll was really happening over in Forest Hills. Everything is in New York, actually. Barbara Walters is making her own news as a pioneer on the small screen the same night that Amos Poe and Ivan Kral's *The Blank Generation* comes to the big screen. It was just under an hour of black and white home movies, if you could apply such a label to random bits of footage from the punk music club scene strung together in such a way that the audio barely tracks to the video. From even this erratic morsel of historical documentation, the future is clear. Patti Smith could absolutely stomp Mick Jagger. I'm sorry, but that's just how I feel.

The sights, sounds and scents of a new masculinity are loitering everywhere, pouncing as needed! It is a time of crisis

in the establishment. As a last desperate gasp, Lorne Michaels offers the Beatles three grand to reunite on *Saturday Night Live*. A week after the premier of *The Blank Generation*, a young prince Springsteen hops the big green gates in order to seek a certain wisdom wafting through the haunt of the last great king of the old rock and roll, and is escorted out of Graceland by the cops. Elvis was over in Lake Tahoe, hand over fist making serious green, and dead a little over a year later. Johnny Ramone was a huge Elvis fan. But then Johnny Ramone also voted for Nixon, and I don't know how the fuck to begin to talk about that.

Dazed & Confused About so Many Things ... The Holy Trinity of Ride Songs ... What's in a Nose-Touch ... All the Rage in Texas ... The Graduates are Missing ... A Moment for Old Bentsen's Anti-Climax ...

y first year of college sucked. The reasons it sucked are manifold, but in the dead of my own emotional winter, I did manage to live happily in one home: Richard Linklater's *Dazed and Confused*. A girl down the hall from me had a VHS copy and I had never seen it, and she also knew how to get beer. We drank cans of Bud Light by the case together, gently lifting the lids on pizza boxes to determine which one recently arrived and which one was last night's. Every idea was stagnant, the incessant ticking away of life as we remained purposefully cynical, unfazed by any revelation that approached us. I was seventeen, watching the last day at Lee High like it was my own, until it might as well have been.

Friday the 28th of May, 1976, is the last day of school in the fictional parallel universe outside Austin where Richard Linklater comes of age. Yes, a minute-by-minute ode to *Dazed and Confused* is absolutely warranted—so necessary as to seem unavoidable, inevitable. Hit the ibogaine and join me.

:13... The trumpets sound and the sun comes up over the backside of our planet. Universal! Indeed.

:42... Aerosmith! We are not even finished with the title slugs, just the logos over which attention skips. There's no movie yet, but there is rock and roll. "Sweet Emotion" is thirteen months old by this moment. The boys from Boston just launched *Rocks* twenty-five days ago.

1:11... Here comes that tangerine dream, "The Judge," making a left through the parking lot. The first character in the film is a car, not a person. In a field of vintage red, white and blue, it turns the volume up to eleven. There's a tan arm resting casually out

the window of that muscular GTO, and I don't care who you are, you want whatever is on the other end of that arm for a boyfriend.

1:25... Nope, we have not seen any faces yet. This film is about something in the air, the sound of things at the time, not about any looks on any faces. All of these actors are nobody at the time. Linklater discovered Matthew McConaughey sitting around at the hotel bar, for crying out loud.

1:30... "Home of the Fighting Rebels." How many Robert E. Lee High Schools are there in Texas? Let's set the over-under at 90, in honor of the number of seconds that have elapsed so far.

2:55... Randall "Pink" Floyd is The Everyman. His first word in the film is, "oh." He acts surprised without being alarmed, kisses his girl, is noncommittal, flies by the seat of his bootcut jeans.

3:45... The foreground is a conversation about party logistics. The backdrop is a giant mural of blue soldiers sticking a flag into Uncle Sam's mountain of blue shoulder, with cutouts for the drinking fountains. Slater's t-shirt has nothing but a marijuana leaf on the front of it. When I was their age, and fuck me for beginning a sentence with those words, I would have been sent right to the front office for wearing that. I had this baseball t-shirt with the Schlitz logo on it, and if I ever wore that to school, Jesus, I was dead meat.

4:04... A close-up on Uncle Sam reveals that somebody has drawn in a blunt and a major case of red-eye.

4:12... Mike and Tony are greeted as Woodward and Bernstein. *All the President's Men* has been in theaters for a little over a month now. Their *Final Days* book came out the same day as *Rocks*. Mike laughs, possibly with sarcasm, when Pickford calls him this. What part of the legacy of these two journalists is the

cause of this identification? Or are these names just floating around in the air of the times?

4:17... Pickford is out of earshot and Mike calls after him, "I guess that makes you Deep Throat." It's a political scandal cum dick joke. That particular porno has been around since these boys were in seventh grade. It is likely dearer to their hearts than Nixon.

4:41... Cynthia proposes poker as usual. Mike ups the ante to the summer's first party. Tony doesn't appreciate the higher stakes. I guess that makes him the Woodward? He caves to Mike's desire to carpe a diem, then proceeds to lower his voice and confess to a weirdo Abe Lincoln fantasy. He's got forefathers on the brain.

6:06... Here comes the dreaded pledge to stay drug and alcohol free for the summer. Pink folds the paper many more times than necessary to fit it into his pocket. He is squeezing the sentiment of it, not viewing it like the other football players, who are happy to jump another bullshit obligatory hoop.

6:55... A remarkable amount of work is actually taking place here on the last day of school. There's a kid learning how to build a bong. Another kid is going room to room planning the party. A third is carving out the paddle with which he will beat up on freshmen. These are some big deliverables. The only guy asleep at the wheel of summer destiny is the teacher, literally asleep at his desk in front of the room. No guardians at the gate!

7:37... Mike tells Pink that his honor pledge is neo-McCarthyism. Cynthia asks if he's going to have to pee in a cup. They lament the suppression of their age group. Tony is hung up on the word neo-McCarthyism and Mike gives him a verbal pat on the head.

8:17... The ladies in the bathroom contemplate the male viewpoint, the fantasy of being stranded on *Gilligan's Island* with

both Ginger and Mary Ann. The show had been in syndication for almost ten years at that point and the girls know the truth of the matter, that a man never really need choose between the movie star and the girl next door. They could both be found in every episode. On the other hand, the ladies had the Professor and that's it. Nobody ever fell in love with the Captain.

9:01... Pink gives Jodi his word that they will take it easy on her little brother, Mitch, when the paddling gets going. This is clearly a lie. Pink has no trouble making false promises to one of his lady friends, but won't sign the paper to placate his coaches.

9:13... Shotgun! Crucial competition, since the vehicle in question is a Chevy C10 pickup. Is there anything more intimate than riding in a car with your friends? No, no there is not.

10:30... They park the truck in a spot that is for busses only. They use the CB radio to make really a pretty egalitarian bargain with the rising freshmen; just line up and get your one lick, rather than live in fear all summer. Except for Mitch Kramer, who is obviously screwed. The rising seniors exert their power and render their judgments. They will do unto these others what has been done to them, for that is the price of freedom.

11:55... Pink is not just a player; he's the quarterback.

12:18... The head coach informs Pink that he needs an attitude adjustment, that he needs to get his priorities straight, that the other crowd he runs with is no good. Did no one ever fall in love with the Coach?

12:53... Pink has a good arm on him, which he uses to chuck the pledge paper across the lawn after the coaches have left.

13:10... Ben Affleck with an afro! He of the famous FAH-Q paddle, he of the ultimate fifth-year senior douchebaggery and of the pricey but well-earned comeuppances, squeals into the parking

lot in a powder blue Plymouth Duster and gives us somebody to root against. The coaches are an obvious but ultimately an insufficient choice.

13:43... Don sees a random kid in the empty hallway and fake-out punches him. The kid runs off shaken as Pink continues his diatribe against the stupidity of the summer pledge.

13:53... Pink proposes that he and Don could get laid just as often if they quit football and started a band. What an equally great but totally different movie that would be. Or it might be exactly the same movie, because as I said, this is not really about what they are doing as much as their feelings about the doing.

15:15... Mitch's teacher compares the boys' upcoming ass-whooping to his time in Vietnam, dashing their hopes of saving themselves by leaving early. The teacher is black and has no sympathy, and we have no reason to believe those two tidbits form a causal chain of any kind. After all, there is one other black guy in the movie, and he is rather nice. This is Texas.

15:22... Milla Jovovich is a lefty! I always notice that in movies. She's doodling pot leaves across the U.S. Constitution as her teacher concludes the last moment of school by saying, "You know, the '68 Democratic Convention was probably the most bitchin' time I ever had in my life." The bell rings and she reminds them that as they celebrate the Bicentennial this summer, they shouldn't forget it's about "the fact that a bunch of slave-owning, aristocratic white males didn't wanna pay their taxes." This is the Republic of Texas!

15:41... Alice Cooper declares that school's out for summer and a celebratory montage ensues. Relatively nerdy, benign-looking high school kids with paddles chase down only slightly more nerdy, helpless-looking eighth graders.

17:40... Parker Posey! Kneel before the sound of every ultra-hot cheerleader queen you have ever met, whose first words are, "Wake up, bitch!" She is shoving pacifiers into the mouths of prospective freshmen babes. She has a voice like an ice pick.

18:30... Car chase! Everything crucially important in the life of a high school student happens in a car. Swerving, crossroads, rocking out, escape.

19:40... Mommy + shotgun = Ben Affleck is foiled for the first of many times.

21:00... Parker Posey's despotic reign over the tender future of the cheerleading squad continues, Woodward and Bernstein salivating and spectating with haughty but half-assed criticism from the sidelines. Then they break out the ketchup bottles to the tune of War's "Why Can't We Be Friends?" NASA and the Soviets beamed this song back and forth to each other during their first ever joint space flight the previous year.

23:26... Sabrina is forced to propose to Tony during cheerleader hazing. Neither of them speak the language of the cooler kids required for this exchange. The world is embarrassing. Everyone here is acting. It's high school.

24:18... "What're you looking at? Wipe that face off your head, bitch." The miracle of Parker Posey, unembarrassed and possibly not acting.

24:45... In the background, the drive-in marquee announces Hitchcock's last movie, *Family Plot*. It's a black comedy where two sets of shysters are looking for the same guy. The amateurs beat the pros in the end.

25:00... The token black football player returns Pink's discarded honor pledge. The guys ask him to sign it for them and for their team, not for the coaches. Pink is crabby about it and

they all look for a change of subject.

25:48... Prospective cheerleaders are screaming in a truck bed as they drive through the carwash. Seems inhumane and not at all sexy. The boys get paddled and the girls get this. Girls are more imaginative than boys.

26:28... Sabrina asks Jodi what the girls do for fun. She says they just hang out and drive around. Sabrina scores the invite.

27:00... Egg chair, with matching ottoman! Damn, I've always wanted one of those things. In the background is that trippy guitar solo from Ted Nugent's "Stranglehold," just before he starts spouting off all kinds of voodoo nonsense about immortality. Then they scramble for the air freshener with daddy knocking on the door. Forget living forever; daddy's about to kill their party.

29:05... Pickford makes a point of looking at the keg delivery guy and saying his name, Ben, which is also the name of one of the football players. Why does he say his name? Is it because he's an affable, personable guy, or is it because he's going to call up the beer people and get this guy fired? Pickford is wearing a completely unbuttoned Hawaiian shirt and a gold cross on a long length of chain. Is the beer guy going to read the shirt or the necklace as more important? He apologizes, but is it targeted for the benefit of the father or the son?

29:25… Cue the get this party started somewhere other than Pickford's house montage, featuring Edgar Winter Group's "Free Ride." Yeah, rides are the main ingredient. Many of the cars have more screen time than the supporting members of this ensemble cast. Now we meet everybody's vehicles, the moving fields of play for the evening.

32:18... On the actual ball field, Mitch nobly agrees to sacrifice himself for his friends, exiting on the opposite end of the field to

attract all the waiting paddles. He plays baseball for the Braves. The paddlers all play football. Mitch is pitcher to Pink's QB. He exits through a fence with a giant Happy Birthday America sign on it. Temporary vengeance for Ben Affleck.

36:26... Mitch's nose is running audibly from the beatdown, and here we have the first of many nose-touches for Wiley Wiggins (as well as nose-touches two through four). But he scores the invite. He's in Pink's car, the one year old black Chevy El Camino.

38:46... The opening cowbell of War's "Low Rider" announces that we have shifted gears toward The Emporium. Lowriding is a lifestyle more than a tricked out car though, as the majority of vehicles featured here are high-riding trucks. All the cars are tuned to this same station, so all the kids are grooving to this track despite their differing evening dramas beginning to unfold.

40:52... Mike's misanthropic crisis leads him to confess that he no longer wants to go to law school. He wants to dance! Adam Goldberg's mark of distinction as an actor is that one absolutely cannot tell whether he is being sarcastic or sincere. And one further cannot tell whether this heavily ambivalent tone of voice is generated deliberately or by accident.

40:01... The first sweet sound of Matthew McConaughey being himself, bolstered by the black beauty of a 1970 Chevy Chevelle SS 454 that he affectionately refers to with irony as "Melba Toast."

42:01... Enter David Wooderson, once upon a time the town football hero and now merely local legendary king of The Emporium, to the tune of Bob Dylan's "Hurricane." He is flanked by a slim posse of Pink and Mitch, the next two generations anointed by Lee High as the ultimate cool kids.

43:11... Wiley Wiggins nose-touch #5.

43:43... No KISS songs yet, but the statues are unveiled. Their subplot explanation is cut from the theatrical release of the movie, but Melissa and Michelle have stolen these statues from the bank and painted the Demon and Starchild's faces on them. The girls are hooligans. Technically, in fact, they are bank robbers. The boys just stand back and admire.

44:16... WWNT #6.

45:18... A little cross-car conversation at 35mph. The girls are noncommittal.

45:45... Slater laments that all the girls at their school are prudes.

46:55... The two scrawny musketeers go in search of their chubby third member, who is about to get to second base with some blonde braces in a darkened corner of their last junior high dance. He is crabby, but obliges his pals and unceremoniously ditches her without even saying goodbye.

47:31... The slim pals console the fat pal by informing him that freshman girls all put out. The fat pal is rightfully skeptical.

48:12... All three of them hear the car pulling quietly up behind them. They scatter two to one, leaving their fat pal to the beatdown that belongs to all three of them as the other two watch from a darkened corner of safety nearby.

49:10... The trunk of the car is filled with beer and ice! I never did that. Bathtub a couple of times, but never the trunk of a car.

50:19... A look under Wooderson's hood. The critic is the driver of a 1974 Pontiac Trans Am SD-455 that he has unironically named "White Lightning." The driver is named Clint Bruno, played by the actor Nicky Katt, and I can't for the life of me figure out why they didn't just let him use his own name, seeing as how

it's far cooler than the name they wrote for him.

51:13... This is the dead center of the movie. There is no climax. The ladies are bored and trying to determine the best course of next action. Wooderson counsels them to have patience.

51:23... WWNT #7

51:26... WWNT #8

51:54... WWNT #9, at which point it becomes impossible to listen to any of the dialogue between Mitch and Sabrina taking place in this scene and Head East pleads, "Save my life; I'm going down for the last time."

51:57... WWNT #10

51:59... WWNT #11

52:01... WWNT #12

52:05... WWNT #13, and then, blessedly, the camera begins to look elsewhere.

52:50... One of the scrawny pals tosses an empty high in the air over his shoulder. The fat pal curses him as they wait for the bottle to break on the street, then they run. Why do they wait until the bottle smashes? Are they uncertain of gravity? This is Texas. This is high school.

53:18... Wooderson and Don share their disgusting special handshake. This lighting angle also makes clear they share a haircut. Don is likely headed for a similarly washed-up future, though he does not seem to mind.

54:00... "That's what I love about these high school girls, man. I get older; they stay the same age." Everyone is smiling genuinely. Holden Caulfield is calling and he wants his shtick back.

54:15... Don calls shotgun. Slater relinquishes the front seat to nowhere with great ceremony.

54:54... Another car sequence, featuring ZZ Top looking for some tush. It's hard to think of those grizzled Texans as young men, but the band is only six years old at this moment, and all its members are barely in their mid-twenties.

55:23... Don leans out the window and grabs a trash can.

55:33... Don tosses this trash can into the next mailbox, uprooting it. Everyone cheers.

55:59... Pink does the same thing. His mailbox has an American flag on it. Everyone cheers.

56:30... Mitch throws a bowling ball into the rear windshield of a parked car. He was likely aiming for a mailbox like the big boys, but suddenly Mitch finds himself accidentally becoming cool. This hardly compares to the two ladies who intentionally stole a giant statue right out in front of a bank, but Mitch has a star on the rise while the imaginative artistry of the older girls has already been forgotten.

57:30... On the side of the gas station, there's a sign pricing cigarettes at sixty cents. I've been quit for over a decade, but I miss it every day. And Christ, if cigarettes were still sixty cents a pack, I think I'd miss them twice as hard. Blessed be inflation.

58:00... The car with the busted windshield screeches up, and in comes the gun at their window. The gun informs them that busting mailboxes is a felony offense and that the pigs are on their way. Pickford steps on the gas and three shots are fired. Remarkably, Wiley Wiggins does not choose this moment to touch his nose.

59:00... Tony sighs that there is nothing going on. Cynthia asks which one of them posited that Jerry Ford's football concussions were responsible for tanking the economy, and Tony asks if either of them knew that Ford served on the Warren Commission. Mike

summarizes his response to both inquiries by suggesting the importance of alcohol.

59:40... The token black football player gives Mitch cash for buying him a six pack. Life is full of anxiety-inducing socialization tests like these.

1:00:30... Cynthia attempts to deliver one overarching theme of the film, which is the importance of enjoying life in the present moment, as opposed to serving some unknown future laid out for you by the authorities.

1:01:00... Mitch relies on parroting Wooderson's talk of future job and community college plans in order to unconvincingly portray adulthood to the delightfully negligent old codger of a clerk who has just sold a bottle to a smoking pregnant lady. Sixer accomplished, Mitch plots to get even with Ben Affleck.

1:02:00... On the heels of a free ride and a low ride, we now complete this holy trinity of automotive glory with Foghat's "Slow Ride." Mitch makes his entrance at The Emporium with the sixer. The ladies are impressed. The boys let him keep the change.

1:03:00... Ben Affleck is being a douche at the billiard table. Mitch sets the subplot in motion.

1:03:49... WWNT #14

1:04:06... Ben Affleck makes squealing pig noises.

1:05:06... Ben Affleck gets a bucket of white paint dumped on his head as Black Oak Arkansas sings, "I've walked through the halls of karma; I shook hands with both the Devil and God."

1:07:15... Cynthia does not need a ride from Wooderson. She is clearly driving her own car. Woodward and Bernstein are grossed out. Cynthia is combing the giant pile of red frizz on her head and smiling.

1:08:15... KISS statue perched precariously in the back of the truck, it is now time to head to the moon tower to rock and roll all night. Cue the keggy, bongy, outdoor partying montage.

1:10:20... Nicky Katt pushes Mike, calling him Isaac Newton. Pink intervenes against the now shirtless Nicky Katt, rather embarrassingly saving Mike's ass as Nicky Katt continues to talk shit.

1:11:11... People are climbing the moon tower. There was never anything good like that to monkey around on when I was that age.

1:12:10... Mike posits that he just needs to get in one good punch then wait for the fight to get broken up. He believes that his loss of the previous scuffle will be a defining moment of his pathetic life, and simultaneously believes that nobody ever remembers who actually won any fight.

1:12:30... At the top of the moon tower, Pink judges that the town is dead. Slater posits instead that there are tons of people fucking out there. Transcendentalism overtakes ennui.

1:13:33... Mike declares that he is "being stalked by a Nazi."

1:14:04... Don clears room at the keg tap by loudly finger-pointing at the imaginary arrival of nonexistent cops.

1:14:44... WWNT #15

1:15:30... Heart to heart intervention over Pink's reluctance to sign the summer pledge. State championship hanging in the balance and so forth. Pink just wants to play on his own terms. Pink's own terms seem to screw over the team.

1:16:20... The Runaways! This is an anachronism, as the album technically doesn't drop until four days later than the day on which this movie is set, though the single might have been playing on the radio. Parker Posey shoves Joey Lauren Adams on

the ground after they have both independently fallen down drunk. They laugh together, menacingly. Upright drunken teenagers nearby steer clear.

1:17:07... Again, from the beginning, Ted Nugent's "Stranglehold."

1:17:35... Cynthia delivers another big idea. "It's like the every other decade theory, you know? The fifties were boring. The sixties rocked. The seventies, oh my god, they obviously suck. Maybe the eighties will be radical."

1:17:54... Mike is drinking a beer.

1:18:11... Pink kisses Jodi, who is not his girlfriend.

1:18:55... Slater discourses on the fact that the founding of our nation went so smoothly because Martha Washington was a hip lady who packed a bowl for George every night.

1:20:16... WWNT #16

1:20:33... WWNT #17

1:20:54... WWNT #18

1:21:25... Parker Posey demands homage from Sabrina. Tony objects loudly. Every time Parker Posey counts another number down from five, she chews her gum once in the same rhythm as she is dropping her fingers onto the zero of Sabrina's fate. Sabrina objects silently. Poor Parker Posey. The next year of Sabrina's life will be made a living hell, if only Parker Posey can remember to make it so that next morning.

1:22:22...Nicky Katt's back is turned and Mike pours a beer on his head. He turns around and Mike cold cocks him in the face. Nicky Katt goes down for a second, but then he bounces up and wails on Mike. There are upwards of a dozen audible punches to his stomach and his face. The crowd is so stunned that Mike started it, it's taking a while for anyone to decide to intervene.

Pink and Wooderson both get ahold of Nicky Katt.

1:23:23... Cue the sad balladry of Lynyrd Skynyrd and the hissing keg tap to indicate that the party is over.

1:24:21... Jodi complains about the unfairness of Mitch being out and about after curfew. The tradition of paddling is too harsh for her taste, but the tradition of curfew is not harsh enough.

1:25:17... Wooderson promises Cynthia front row seats to see Aerosmith in three weeks.

1:25:30... Pink says goodnight to Mike and Tony's crew, jokingly calling Mike "Ali." During the course of this movie, Mike has been likened to the journalist who brought down a president, the scientist who defined gravity, and the world's most famous boxer. And Mike just wants to start a fist fight and become a dancer.

1:27:47... The empty football stadium, shortly before dawn. Pink sits on the fifty yard line. It's nearly time to make life choices. This is high school. Parodying his coaches, he declares, "only the strong survive!"

1:29:40... Wooderson has found the drug-free pledge paper in Pink's glove box next to the rolling papers. Pink says he likely will sign it; he just doesn't want to have given in to it immediately. It appears as if an opportunistic sense of pragmatism overwhelms his natural inclination toward oppositional defiance. Blessed be selling out.

1:30:18... Wooderson delivers his life philosophy, noting that it doesn't get better as you get older. As far as the volume of commands from authority figures, it gets worse. "You just gotta keep livin', man. L-I-V-I-N."

1:30:55... Don is not quite headed for the same fate as Wooderson. "All I'm saying is that I wanna look back and say

that I did it the best I could while I was stuck in this place." The camera is doing a three-sixty around Pink during Don's whole monologue.

1:31:31... It really is the cops this time. They are Wooderson's peers.

1:32:49... WWNT #19 and suddenly it's daylight.

1:33:33... Pink tells off his football coach and refuses to sign the drug-free pledge, declaring Aerosmith tickets the top priority of the summer. We fight to live another day! Attaboy.

1:34:42... Pink declares shotgun. Slater never gets shotgun.

1:36:17... Mitch passes out with "Slow Ride" coming through the headphones. Pink and Wooderson high five as the Chevelle heads along down the open highway.

You know what isn't the top priority of the summer? These kids are not going to go see David Bowie starring in *The Man Who Fell to Earth*. His first compilation album had come out the week before as part of the hype campaign for the film, though the film actually contained no musical contributions from Bowie, right on the heels of the new material that landed a mere five months ago. But the teenage rage of Texas will brook no cold alien invasion. They are a hot-blooded bunch whose top priority of the summer is Aerosmith tickets.

Fictional world domination by the cocaine-dusted shell of the Thin White Duke is not on the menu. Nor is non-fictional world domination in the form of the presidential primaries on their radar, which only had ears for the lovely screech of working class rock and roll. Because where are the graduating seniors in this movie? Where are the eighteen year olds exercising that beautiful rite of American passage known as participation in democracy? Whether

to vote and for whom to vote are not given their due attention in this otherwise fantastic flick. Maybe the kids don't care. The Texas presidential primary contest was held on a Saturday, the 1st of May, so mighty good chance of high turn-out plus everybody in a good mood for pay day.

But Texas has a view of leadership potential that is about as useful as an asshole stitched onto an elbow. Nobody looks at the results coming out of Dallas or Austin and does a victory dance. The heat shimmers along all that desert sand and up out of the mirage comes some very weird, very offbeat political opinion. Primary day in Texas in 1976 is what you might call a ditch digger's paradise. None of these horses can ride! It's the third Southern state to ante up, after Florida and North Carolina in March.

In fairness, North Carolina also got it wrong, but at least Jerry could say that Ronnie only beat him there by a seven-point spread. Single digits plus a generous sense of the margin of error are always a hard spin for the victor, but Ronnie ran himself ragged into the South and came out cleanly on top in next round by fully doubling down on Ford's 33% for a seriously whoop-ass 66% of the vote. He would go on for an additional three in a row over the next two weeks, but there ain't too many delegates between Georgia, Indiana and Nebraska, and Indiana was the same type of squeaker as North Carolina.

Then there's the matter of Lloyd Bentsen. Old Lloyd was a bomber pilot who had a hand in wiping out half of Germany's fuel supply during the war, before he was twice shot down and settled into the boards of every oil company back in Houston. The Bush regime stalled out at first, thanks to Bentsen crushing the elder Bush's hope for a Senate seat in 1970. Just four years

later, a full two years before the election, the freshman senator announced his candidacy for 1976. He raised a truckload of cash and never hit a high point. He garnered less than 1% of the vote in North Carolina, dragging himself to the finish line back home in Texas, where he could hopefully secure enough of a second place victory as a native son to warrant consideration as a veep option for Jimmy Carter. He managed 22 to Carter's 48, but George Wallace rolled up right behind at 18. He therefore didn't get a shot at the Vice Presidency until 1988, and vengeance was Bush's, both in Texas and at large.

Texas is an unusual place, always thinking for itself, for better and for worse. The May 1976 issue of *Texas Monthly* ranked all twenty-two congressional reps and Barbara Jordan came in fourth.

JUNE

Joan Jett Looking for Three Good Men ... Cherry Bombing with Horses or Monkeys that Talk ... Waking Up in Soweto ... Resolution 392 ... White House Boasts Terrific Pool ... A Winning Word ...

The first time I saw a Joan Jett show, I was old enough to appreciate it. Everybody there had on nothing but black, denim and leather. I was in my mid-twenties, there with my mom and my wife. Should have been just my wife, but my mom announced she was dropping in, and I sure as hell wasn't going to abandon my chance to finally stand around sweating and breathing in the same airspace as Joan Jett, so we just bought an extra ticket and hoped my mom wouldn't embarrass us.

When I was a little younger, it was easy to feel embarrassed at concerts. Everybody is sizing each other up. There are silent contests for biggest fan, most obvious train wreck, richest bitch, most feminist boyfriend, whatever else. And the ladies spend a lot of time looking you full on in the face, a style of eye contact so aggressive that it verges on asking aloud whether or not you're a queer. Everybody wants to show you their badges and everybody has a lot of fucking badges. You suddenly feel as though the world is teeming with life and you have been the only one hiding under a rock for too long.

Joanie had just come out of the closet herself, in the best possible way, through details that had been leaked about the sudden constant presence of alien sex machine Carmen Electra on the tour. The irony of a most excellent cherry bomb. So on this particular leg, the lesbians were all actually smiling while eyeballing each other, because hey, Joanie was one of us officially now and this was a thing worth celebrating. And she still looked terrific. I mean, she could shred and her abs were tight and her voice was unchanged. She was a vessel carrying around the sound of health, not to mention the picture.

Two songs in, just two songs, she lifted her arms. By the

time these arms reached shoulder height, the whole audience from front row to nosebleed was clapping appropriately to the snare and further instruction was totally unnecessary. Those claps lasted the whole fucking song, never fading or even lagging a little lazily behind the beat. I've never seen crowd control like that, everybody eyes wide open and Joanie pushing fifty at the time. For the next two hours, we obeyed. We were glad to do it. It was that simple.

She led the Blackhearts as they played some of the hits from the Runaways. This is a band she rustled up by putting an ad in *L.A. Weekly* calling for three good men. There was no reason to look for women. At this point, I want to pause to suggest that you close your eyes and mentally make a list of female rock guitarists. They don't even have to be particularly good ones. Just name some names that aren't too pop or too country, and then cross off that already short list any woman that isn't reasonably current, that hasn't made an album or toured in the past five years. This is still a serious uphill battle, being a woman and also being a heavy-hitting rock star, and then marshaling enough acknowledgement from grizzled old dudes to attain anything in the career department resembling longevity. Nearly thirty years later, *Rolling Stone* listed Joanie as number 87 in its list of the top hundred guitarists of all time. The only other woman on there is Joni Mitchell, who side-stepped her for slot number 72.

And Joan Jett was just a kid. She was a fucking cherry bomb of kid. Hello, daddy! Tons of girls, perhaps all girls, feel these feels. We run around in the dark, human and wild, the same as boys. In 1976, her own manager though of her as a novelty act. He could find any number of other hot little freaks to replace her if she got too out of hand. I guess not though. Joan Jett has the

gifted shit-kicker instincts of a carny. She toughed out those early gigs, hundreds of gross and grabby dive bar bookies, chauvinistic spin jockeys, and so on. The other girls all bailed or fizzled or just plain disappeared, but Joanie growled on through to the other side.

This is an apple pie type of summer, with everybody focused on the independence for which our nation had been founded and fought. Look what good girls we raise here! These are girls who love the Bee Gees and Paul Simon and maybe a little Carole King, girls who have a bright future made of marriage and maybe a little college. Look, even the Ramones had only begun to trickle out of New York a mere sixty days ago. The Sex Pistols has not yet jumped the pond. And here's one formidable Joanie equipped to royally damage every single last neighborhood Chachi. No happy days here. Joanie doesn't love Chachi back. Either she can't or she won't, but we're still on the hook. It's emotionally exhausting, nap-provoking.

Vulgarity at its best, it seems to me, is always a matter of appropriation. This precision mode of obscenity is the most ancient form of protest. To be a girl on the boys' stage, to be playing their instruments and making their noises, and to do it with the same technical proficiency and charisma with which they do it, is vulgar. Obscene, meaning against the scene. It is not speaking a new language as much as it is putting the old language on a new tongue. You open your eyes to the possibility of creating a spectacle with only whatever props are at hand. You just take the keys to the car out of daddy's hands, and then you drive his car right through his fucking garage door. Imagine an all-male Runaways cover band. Or imagine the Runaways never existed and a band of boys sung all their songs instead. No way. There's

no point. No boy band is going to succeed at selling "Cherry Bomb."

Asking a girl to play guitar is a lot like asking a horse to talk. It wakes you up. *Mister Ed* was fucking surprising television, too! Uptight people thought that show was a total abomination, but they still looked at it twice. Maybe *Planet of the Apes* is a better metaphor, because the horse that could talk was still confined to his stable, whereas the girl who could play guitar was free, independent. Something can only be vulgar if it is also at least somewhat mesmerizing, and inside that feeling of enthrallment is a quick little drop-off into a pit of willing subjection. The damn dirty apes are running the show. Joan Jett is a king.

My mom loved the concert. She spent forty bucks on a t-shirt and she wore it until it wore out. My wife and I went to one other Joan Jett show, just a couple years later. My niece was graduating from elementary school, and so we took a twelve year old girl to see Joan Jett. It was a humid outdoor show and we sat on pinchy metal bleachers. It was hotter than hell and then it rained. I mean, torrential Southern style. Tons of people bailed. Our niece wanted to ditch out and I could see the weakness of auntie acquiescence welling up in my wife's eyes. I told them both to go to hell, that we would tough it out. We were soaking wet and the show was excellent to the end.

My niece is going off to college next year and I wonder if she is old enough yet to appreciate that totally American night we had. She wants to get into film. Her heroes are John Waters and David Lynch. I told her I don't care much for *Twin Peaks* and she told me to go to hell. She is going to turn out great. Right now she is vulgar, but some day she will be a king. She's on the verge of a major protest, a big wake-up call, but she doesn't quite speak the

language.

This was also the thing in South Africa. No, really, follow me. It is Wednesday, the 16th of June, and the kids are getting ready for school as the sun comes up over Soweto. They are walking to a place from whence thousands of them are already preparing to walk away. They will get up out of their little desks, these teenagers trying to keep calm though the rage has been building steadily inside them for so long, and rally all their friends to leave school with them, walking toward Orlando Stadium. The police block the main road, so they take another. At the end of this road, German Shepherds with froth dripping off their incisors and a volley of gunshots.

Somewhere around fifteen thousand high school kids, with no prompting from the Ramones or Joan Jett or the Sex Pistols, up and organized themselves into a protest against the adoption of the language of their oppressors in their schools. They held up signs saying that the students would be pleased to learn Afrikaans if the Prime Minister will first learn Zulu. If you ask me, that's fair as hell. They threw rocks and they set things, the dogs, on fire. Then one of the cops fired off a shot and 176 people were killed. Many more students made it to the hospitals. The hospital administrators were informed by the police that doctors were expected to hand over the names of anyone with a bullet wound that day. None of the doctors complied, instead listing all the bullet holes as abscesses. Word choice saves lives. The law looks over those charts and sees nothing.

I'll never understand where the Netherlands acquired a reputation for neutrality. You'd have to really be asleep at the wheel to drift into that version of history. This is a country that spent nearly four hundred years pillaging most every coastal metropolis

in Asia plus the east side of South America, and pissing on Cape Town between rounds. So this trouble of what language the teenagers growing up under apartheid would speak is not simple trouble. It's the whole megillah. Three days later, on a Saturday, the United Nations Security Council adopted Resolution 392 in specific support of the students. Chief organizer Stephen Biko is as punk as any punk ever was, and upon lighting the match in Soweto, countless young black South Africans put their feet up next to the blaze, content to let the country burn rather than put a Dutch tongue in their collective mouth.

So the question is whether driving daddy's car is really the best way to smash his garage door. It's uncertain whether Joan Jett will ever be truly embraced as a guitar god. It's uncertain whether adopting Afrikaans would have led South Africa toward a more bloodless end to apartheid. This is about the essential purpose of communication. In every alien encounter movie ever, the first order of business is to convey that you come in peace. But that's never really the truth. The truth is that we strive to be vigilant in those moments, on the lookout for anything obscene. You come in civility masquerading as peace until such time as it becomes clear you are not dooming yourself to submission in a hostile take-over, and then you have faked peace until you made it. On the other hand, if the alien is determined to indeed possess evil intentions toward your well-being, you have faked peace until such time as you're able to effectively make war that preserves your independence. Cherry bombs away!

A dog may not actually be sleeping when you decide to let it lie. The U.N. resolution was adopted by consensus, but there is no record of the vote count and thusly no official American position on the issue. Ford was busy with the situation in Lebanon. On the

same day as the riots in Soweto, newly minted U.S. Ambassador Francis E. Meloy, Jr., was on his way to formally present his credentials to Beirut. He never made it. Lebanon was at the beginnings of having a bit of a civil war issue, and when Meloy crossed the Green Line going west from Christian turf into the Muslim sector, he was abducted and shot by members of the second-largest flank of the Palestine Liberation Organization. It was a major bummer, except that it was perhaps the last time Syria and Israel agreed upon anything.

Ford called Kissinger at 9:30 that morning, and Henry kept him waiting for a half hour before speaking to him for four minutes. They met with the veep and the CIA for an hour at lunch. By 4pm, he released a three minute statement concerning the assassination. He said nothing about Soweto. Immediately afterward, he spent twenty minutes talking to nine hundred high school kids on a Government in Action Youth Tour. These were rural kids from eight countries and twenty-three different states, just wanting to see what the White House was up to while getting a pat on the back for being agriculturally inclined. Ford spent the evening with Prime Minister Trudeau, who presented him with Canada's big Bicentennial gift, a bilingual photographic essay collection about life on the border between the two countries. Eyes and ears, people! Then step lively. Ford spent eleven minutes in the pool before bedtime, because no matter the international scene, there's evidently always time for a quick dip.

The next morning, he passed an Executive Order directing the flags at all U.S. embassies to be flown at half-mast. He also met with some elementary school kids for five minutes so they could present him with a birthday card for the nation, and then twenty-five minutes with some high school students who were there for

116

the 8th Annual Teen Age Republican Leadership Conference. The number of students attending was ball-parked at 174, two less than the number of students killed the day before in Soweto. No worries, fifteen minutes in the pool before dinner. On Saturday, Resolution 392 is passed while Ford is at the ambassador's funeral. He spoke for five minutes, and later he spent seventeen minutes in the pool. During most of this week, Ford is also taking between one and seven minutes to go to his doctor's office, at both the beginning and the end of his day. Blink and you'll miss it.

During the week in between the advent of Joan Jett and the dissolution of Soweto, a boy from Syracuse, New York, won the 49th Annual Scripps Spelling Bee. His final word was narcolepsy.

JULY

Real Estate Prices in Kettle Falls ... What Happens After the Library ... Ron Kovic Dances the Twist ... All the Fireworks on the 2nd ... How Best to End Troy Gregg ... A Choice of Concerts ...

n hour northwest of Spokane there is one square mile of town that was settled in July of 1811. At its northern end there is a big white sign with ten cartoon white people on it that reads: Kettle Falls, 1550 friendly people. Hanging off of that sign is a smaller gray sign with red lettering: and one grouch. The entire police force is a chief, two patrolmen by the name of Dollar and Coon, and a secretary named Missy. Their office is closed on weekends. The falls are rapid, frothy and white, with a drop of more than fifty feet down to the quartzite kettles in some places. Crazy salmon on a mission to reproduce used to swim up it from the Columbia River, only to be speared or basket-trapped by local tribes. The average annual catch was estimated at six hundred thousand fish. The Hudson Bay Company fur traders lived peacefully here for about fifty years, until some rich men from New York got a hard-on about the potentially infinite hydropower located so close to such potentially bottomless gold mines. They argued about it a long while and then built the Grand Coulee Dam. It was engineered by John Savage, who also built the Hoover Dam. Its reservoir is named for Roosevelt, since he approved the plans. It was part of the New Deal. About three thousand people had to relocate before construction could be completed in July of 1942, plus this dam blocked the salmon migration and flooded much of the tribes' ancestral lands.

Lake Roosevelt covers one hundred and twenty-five square miles, with the original settlement of Kettle Falls buried about thirty feet beneath it and the falls themselves roughly ninety feet beneath it. Just before their land and its fish were flooded to make the lake, the Colville tribes gathered there to mourn in a Ceremony of Tears. The dam project was run by a branch of the

Department of the Interior, the Bureau of Reclamation. Also a part of the Interior, the Bureau of Indian Affairs attempted to diffuse the growing hostility over fishing rights by legally terminating the Colville Reservation in July of 1961. Each tribal member was to be paid sixty thousand dollars to give up any claims. This attack was thwarted in large part by the activism of Bernie Whitebear.

Thirty years later, Whitebear lived to see the government agree to a lump settlement of fifty-three million dollars, plus fifteen million annually. Meanwhile, at the other end of Stevens County, the Spokane tribe is still waiting on their own slice of that same pie. Stevens County encompasses twenty-five hundred square miles of land. The Colville Reservation sits on more than two thousand square miles and contains about seventy-five hundred people, which is about half of the members of their Confederated Tribes and four or five times the population of Kettle Falls. Every summer night since 1989, there is a laser light show projected onto the wall of the dam that glosses the history of these people who live just about eight miles away from the dam. The show is over a half hour long and is one of the largest light shows in the country. Of course, they also have fireworks on the 4th of July.

There are eight libraries in Stevens County. The Kettle Falls Library is on Meyers Street, so named because when Kettle Falls was relocated to build the dam, they annexed sixty feet of land that happened to already belong to Meyers Falls. None of the county's eight libraries is in possession of a copy of Ron Kovic's *Born on the Fourth of July*. There was one copy at the Kettle Falls branch, a beautiful trade paperback first edition from July of 1976. I bought it on Amazon for a penny plus $3.99 shipping. It still has a Dewey on the spine: 959.704 KOV. Inside the front and back flaps there is the library address stamp, with a big black

WITHDRAWN stamp on top of it. Also inside the back flap is the checkout card pocket.

There are eleven due dates on the pocket, with the first five written in blue or black ink with a meticulously clear feminine hand: 2/21/90 Schroder, 3/26/90 Garrett, 5-12/90 Pratt, 4-15-91 LeHeer, 4-27-92 Watkins. Luke and Val Schroder are the independent owner and operator of North Lake RV Park and Campground, formerly North Lake Roosevelt Resort. They have four cabins and the fancy one is fifty bucks a night. Jesse Garrett ran unopposed for the #3 slot on the Kettle Falls City Council. City Hall is a half block from the library. Florence Pratt still lives just four blocks from the library. Mike Pratt owns a liquor store about a third of a mile further away. Jay Pratt, age thirty-four, was killed in a head-on crash when he was going northbound on 395 and crossed the centerline at 5 o'clock on a Thursday morning.

Then the black stamps: SEP 10 1993, NOV 02 1994, NOV 28 1994 (I think that was one guy who was a slow reader, or a kid working on a big end of semester project), JAN 03 1996, JAN 28 1996 (another two-timer), MAR 22 2004. In March 2004, the town grouch was Don Worley, former principal of Kettle Falls Elementary School and partner at Downriver Orchard, purveyor of organic apples. The town of Kettle Falls holds a fundraiser every year and whoever collects the most quarters, by hook or by crook, is declared the grouch at their annual summer Town & County Days festival. Worley passed the torch to Lisa Brozik, a graduate of Colville High School's class of 1984 and owner of Little Gallea restaurant, which is about a third of a mile from Mike Pratt's liquor store. The Chamber of Commerce doesn't say anything about where all those quarters go.

That's everything I know about Kettle Falls, except a bunch

of shit about Fort Colville, which I am leaving out because its lessons are redundant with *Born on the Fourth of July*. So, here we are with the big kahuna, peace preacher Ron Kovic. His book has sold over a million copies and the gist of it is that American involvement in Vietnam had no purpose. Kovic is a poetic individual, inspired to join the Marines because of Kennedy's ask not what your country can do for you bit and because of a few too many John Wayne movies, particularly *Sands of Iwo Jima*. If you'll recall, they snipe off John Wayne just as his squad is raising the victory flag.

Kovic served two tours of duty. The timeline of the story isn't linear, but at some point, he got jumpy during an ambush and friendly fired on a nameless man who is repeatedly referred to only as the corporal from Georgia. Shot him through the neck. That's the big confessional reveal toward the end and the Major he reports it to takes great care to disbelieve him. Kovic gets a promotion from this man, takes a stab at leadership of a scouting party. Three months later, the first shot blew off the back of his right heel and the second shot collapsed his lung on the way through his spinal cord. The first man who tried to pull him back to evacuate was killed and the man who succeeded in saving Kovic's life was killed that same afternoon. Kovic is paralyzed from the chest down and gets around in a wheelchair.

The book opens on the scene of his injury, moves to the pretty literal shit storm of awful conditions in the VA hospitals, then reverts to nostalgic childhood memories. He played stickball in the street with the neighbor kids and all that, wanted to play for the Yankees someday. At the end of the book he harkens back to those times again, the simpler life where he was innocent and his sister taught him to do the twist. I lingered on that bit for a long

time after I first read it.

My earliest memory of having a good time with my folks was when I was maybe four or five years old and I was jumping on the couch. My mom and dad were dancing on the dingy beige carpet of their first little apartment together and they were still in love. I got up on the couch to get closer to eye level with them. There was that first tentative bounce that they didn't seem to mind, and suddenly I was jumping up and down on that couch like a madman and mom and dad were totally fine with it. They were even glad to see it. This was because they were teaching me to do the twist.

I don't remember how we got started on it, but my mom was aghast to find out that I did not know who the Beatles were. I was like two feet tall and I thought she was talking about bugs. This was what passed for a parenting emergency, so she called my dad into the living room and they dug around in the record collection until they came up with *Please Please Me*. My mom put on "Twist and Shout." My first taste of the Beatles therefore involved an Isley Brothers cover with lead vocals by John Lennon. We could spend a long time speculating on how this forever altered my life's trajectory, but suffice it to say, the most immediate lesson of that day was that rock and roll music is most excellent because it makes jumping on the couch permissible.

It is said that Lennon recorded this song perfectly on the first take. He was sick as a dog with a bad cold and they had just fifteen minutes left before they had to leave the studio. Kovic sat in his little beach shack in Santa Monica, feverishly writing the book cover to cover in one month, three weeks and two days. It has a lot of jarring shifts between first and third person narration. He was already popping up regularly as a speaker at all kinds of rallies and protests, so he knew going in that most

of this manuscript would be delivered over and over again into an endless and interchangeable string of microphones. The really hard parts are all "he" and "him." Though Kovic is telling his own story, he is also just sort of covering it, reporting it often quite vaguely like it belongs to somebody else in part because he aspired to figure himself as a symbolic vessel for what was lived through by everybody who served in Vietnam.

Despite this service and the unconscionable amount of physical and emotional sacrifices it demanded, America suffered a humiliating and decisive total loss to the Viet Cong, and the two halves of Vietnam were unified into the Socialist Republic of Vietnam on Friday, July 2, 1976. Throughout the chapter on basic training in *Born on the Fourth of July*, the staff sergeant responsible for drilling these young men repeatedly screams in their faces that the marines do not ever lose. Historically now, this is not at all the case, but I bet drill sergeants today are still saying it because such is the deliberate blindness of American hubris. And over a million South Vietnamese were marched off to reeducation camps because such is the deliberate blindness of Communist hubris.

Also on this day, in a set of five decisions that are collectively referred to as the *July 2 Cases* or sometimes referred to by the lead case, *Gregg v. Georgia*, the Supreme Court ruled that the death penalty does not constitute cruel and unusual punishment. Wonder what they think about the conditions in VA hospitals. Troy Leon Gregg, a white male twenty years of age at the time his crime was committed, murdered and then robbed two men who had picked him up hitching. This was during the legal precedent of the *Furman* case, wherein two Justices said the death penalty was unconstitutional and three Justices said the death penalty's

sentencing procedures were capricious and discriminatory, ending in a 5-4 decision to ban the murder of murderers like Gregg. But the Peach State, Governor Jimmy Carter at the helm, had passed a fresh set of state legislation inventing the consequence of life without parole. Given a choice between electrocuting Troy Leon Gregg or locking him up forever, a jury of his peers chose electrocution.

Seven Supreme Court Justices found this to be a constitutionally fair and adequate means of redefining Georgia's sentencing procedures, and the death penalty was made fashionable once again in 1976. Four years later at the end of another July, Gregg and two additional inmates would make history as the first successful death row breakout in the state of Georgia. They disguised themselves as guards, then fled to Charlotte where they knew of a biker gang with a safe house. Two of the prisoners were caught two days later, but not Troy Leon Gregg. He was beaten to death in a bar fight on the same night he was to be executed by the state and the cops had to pull his body out of a nearby lake. The man responsible was charged with second-degree murder, meaning that he would not face the death penalty.

Brennan and Marshall dissented. Over thirty years later, Stevens would tell the press he regretted his decision in this case and that he saw his previous opinion as foolishly grounded in a respect for past precedent in the court's traditions. He hadn't been thinking independently. He quite publicly but utterly unofficially changed his mind. But even so, three votes does not a majority make. This decision and its attendant undercurrent of approbation for Jimmy Carter's job well done as Georgia's Governor is coming down just a couple of days before Jimmy Carter becomes the Democratic presidential nominee.

The Dems were having a field day on the 2nd of July, as they were also popping corks for the twelfth anniversary of the passage of the Civil Rights Act of 1964. Televisions nationally were swept over by the rebroadcasting of Johnson's historic signing, reminding everyone that they could still ride the wave of Kennedy's vision, that the Democrats know where the hell it's at. It may have been the longest debate in Senate history but there was an echo of bipartisanship there, too, a couple of old elephants remembering what it was like to have cooperated, speculating on whether a moderate Southern like Carter could passably swing their axe.

As the *Gregg* decision dropped, Ford was getting a cool two-hundred thousand bucks to build a health sports center for handi-capable Minnesotans. It was built in Minnesota because the money was a Bicentennial gift from Norway. He went on television for a half hour that night just in time for the big 9 p.m. news cycle, doing a ceremony to open a Bicentennial exhibit at the National Archives. All the press photos from the event show that he hung out with Chief Justice Berger, who had written a few special concurrences but no majority opinions on any of the *July 2 Cases* that so clearly, even if unintentionally, favored Carter's groundbreaking legislative maneuver to look tough on crime.

July 2nd is the exact midpoint on a calendar year, day number 183 of 365, except in the case of 1976 because of Leap Day. It was actually on the 2nd of July in 1776 that the Continental Congress voted to add the resolution to sever ties with Britain, though it was two additional days until the Declaration of Independence in total was itself adopted. On the 2nd in 1777, Vermont became the first territory to abolish slavery. 1877, the birth of Nobel Prize winner Herman Hesse and 1961, the death of Nobel Prize winner

Ernest Hemingway. 1977, the death of Vladimir Nabokov. The last time anyone heard from Amelia Earhart was on the 2nd in 1937. In 1962, the 2nd was the opening of the first Wal-Mart ever, in Arkansas. 1908, the birth of the first African American Supreme Court Justice, Thurgood Marshall, one of two dissenting voices on the *Gregg* decision that was rendered on his 68th birthday. A birthday shared by Imelda Marcos and Medgar Evers, Lyndon Johnson's daughter and the Canseco brothers. Flag Day in Curacao and Police Day in Azerbaijan. And then there's all that important shit about communism and capital punishment and civil rights that we have already discussed.

We're in the eye of the hurricane now! Oh, so easy is it to reach down into the maw of history and pull up a number, to wrench out of the thundering storm a series of clown-colored flags tied end to end in an endless stream of historical significance. The montage sequence is fucking zooming by and we are all still waiting to spot the lynchpin. There isn't or I can't. Shut it down, boys! Fade to black so we can cue up the Bicentennial concert series complete with firework finale. Show us your pyrotechnics! Bring on Elton John, straddling his black piano just outside of Boston in a red-white-and-blue-striped shorts ensemble at Schaefer Stadium in front of 60,000 people with world tennis superstar Billie Jean King on back-up vocals for "Philadelphia Freedom," both of them technically still in the closet.

Meanwhile, at Rockford Speedway outside of Chicago, another option is Mahogany Rush, Foghat, Rick Derringer and Ted Nugent. Nugent was full of right-wing political sentiment, playing "Stormtroopin'" to explicitly reflect on the fact that America had been around for two-hundred years and urge his fans to a healthy exercise of their Second Amendment rights through

a metaphor linking modern American governance to the gigantic, bumbling imperial army from *Star Wars*. The stormtroopers are notoriously poor marksmen, leaving the implication that Nugent's own militia skills are presumptively superior. My mom wouldn't have been into that, though she lived close enough to go to the show. She would have much preferred to be outside of Tampa, with Loggins & Messina, Fleetwood Mac and The Eagles on their *Hotel California* tour, listening with fervent late-teenage devotion to Don Henley whining about pop stardom and lamenting the darkening pull of its attendant excesses even as the band acquiesced to absolutely everything it was offered by the City of Angels.

I would have been outside of Memphis, watching The Outlaws, Blue Oyster Cult and Lynyrd Skynyrd opening for ZZ Top. This is a lot of overlap with the sounds of the bands in Chicago that night, with two important distinctions that would have been key factors in my Bicentennial concert-going decision-making process. On the matter of form, the style of the Memphis contingent packed more songs into sets of the same size. The style that could perform "Freebird" for fourteen minutes without breaking a sweat ultimately shook down to a preference for tight little three minute numbers. These bands could string out the blues and improvise without any problem, but to do so every time was simply lazy. You couldn't repeat those trips, couldn't replicate the damn legacy notes that were frozen on the album. Ted Nugent had simply been there in the moment. It was all just jam and retreat! He couldn't rock it hard enough to stay tight. He is the type of guy who uses his guitar as a filibuster, always forcing the fire marshal to shut him down at the end of the night, though on paper he's technically only five songs deep into the setlist.

On the matter of content, Nugent took himself too seriously. He was a young man from the Midwest who wished upon a star every night to let himself have been a natural born Texan. He had a fierce attachment to this cowboy persona, despite having admitted to a prominent marijuana magazine that he hit the meth and shit his pants in order to avoid being drafted to Vietnam both times he was called up for duty. Yessir, that Nugent is one tough bastard. Meanwhile, actually raised in Texas and therefore showcasing the much more humorous lyrical sensibility of true longhorns, we have ZZ Top, just looking for some tush on the 4th of July. They were not handsome men, so they grew beards down to their belly buttons and made the best of it. They became sharp dressed men. Nugent went on to write a few short books about the virtues of bowhunting and ZZ Top was inducted into the Rock Hall of Fame by Keith Richards.

DARK INTERLUDE

've been to two ZZ Top shows. The first time it was really to see Aerosmith. It was the top priority of my summer, man. I bought tickets for my wife and I, but as the date of the show approached, it became more clear that she just wasn't that into it. It was on a week night at a bit of a shabby outdoor venue, rain was a real strong possibility, and even though she dug all the ZZ Top videos at the peak of MTV during the 80's and appreciated the fashion choices consistently made by Aerosmith, she bowed out toward the last minute in favor of beauty sleep. Can't argue with any of that, so I went on the hunt for a friend who might like to use her extra ticket and was surprised at how much trouble I had finding somebody to take this glorious freebie off my hands.

The thing about a concert is that the audience may have more than just one interest in common, and so a certain band will draw a certain crowd with some measure of predictability. Fans of ZZ Top are also seriously into wheels and the tailgating at these shows is a real feast for the eyes. Every local chop shop worth a damn is repping in the parking lot at the ZZ Top concert. And these fans are catholic in their willingness to consider any type of vehicular artwork as well as other enthusiasts of said creative enterprise. A black t-shirt is a black t-shirt no matter what kind of queer is wearing it. As we walked the mile and a half from our car to the stage, the loungers blasting *Tres Hombres* in the parking lot would smile and lift their cans of beer at us, strangely welcoming. This communal vibe lasted through the band's opening set and everybody's best expectations for the egalitarian nature of a hard rock and roll show were basically met. Felt good to be there.

The second time I saw ZZ Top it was just for them. They were opening for Kid Rock, who also hails from Detroit like Ted Nugent and is in fact very great pals with Ted Nugent. The fans of

Kid Rock take their rock and roll Jesus seriously and would most likely have preferred to see the Bicentennial concert in Chicago. These people will accidentally tip one of their two fists of beer on your shoes as they pontificate into your face while you wait in line behind them for the bathroom. They want to initiate you into their fandom. They are devotional animals! So I am listening to this woman for probably ten minutes as we slowly wend our way up the line of about a hundred ladies with full bladders. She is telling me about the Kid Rock cruise she went on and how I should meet up with her posse there next year.

I can feel my eyes beginning to glaze over, and in a last desperate attempt to wrench my freedom from her boozy jaws of Republican diplomacy, I tell her that I just came for ZZ Top and will likely leave after her savior's opening number. The blood rushed back into my veins and blasphemer that I was, I cut in front of the last dozen people standing between me and my pot to piss in. I cut the line because as my tormentor and I rounded the second bend in this great cavernous restroom, I noticed that there was a handicapped stall right at the head of the line that was vacant. Blessed be Title II of the Americans with Disabilities Act, which was modeled on the Civil Rights Act of 1964 and made law on the 26th of July when I was nine years old. This particular handicapped stall was vacant because there was no door on it. Some drunk bitch a mile of pissers ago must've tossed herself against it on the way to blacking out, and it splintered right off the hinges. None of these alleged badasses were using the stall with no door on it, despite the fact that the entire front of the line could plainly see it had a perfectly working toilet and a full roll of toilet paper besides.

So I jumped the line and watched as they instinctively

averted their eyes for my privacy, recognition of the profound difference between punk rock and Kid Rock dawning slowly in their collective consciousness as a woman with huge tits tucked neatly into a sparkling black ZZ Top tank top who'd been ten or twelve paces behind me lifted her eyes to meet mine and started actually clapping for me. It was a literal pissing contest and still, none of the ladies who'd given my win a standing ovation went into the open stall after me. It gave me the blues. I got a sore neck and calves muppeting around while ZZ Top was playing, then left about ten minutes into the headliner because I had already gleaned everything I needed to know about that scene and no amount of bitching frontman antics, pyrotechnics or strippers that might have been forthcoming was going to cheer me up about it.

Whatever his personal political convictions, Billy Gibbons sticks to the script at a ZZ Top show. It's just cars and pussy, maybe a little ode to the many virtues of cold beer. If it's any more serious than that, then shut the hell up. I went to fucking graduate school, you know, so I do comprehend completely how the personal is necessarily also the political, but I just do not believe that rock and roll must be personal. Sometimes the tighter you rock, the emptier you get, and with a full head like mine, sometimes that's a blessing.

LATER IN JULY

America's Birthday & Ford's ... DNC at MSG ... One & a Half Keynotes ... Draft Dodgers, Astronauts, Veeps ... Situation-Specific Independence ... Uncle Sam's Son's Bulldog ... Guest's Best Guess ...

n 1976, the hardest working man in show business on the 4th of July was Gerald Ford. He was at St. John's Episcopal by sunrise, no doubt thanking his lucky stars for the opportunity to administer the two hundredth anniversary of the founding of our nation just in time to completely steer the publicity in service to his first proper presidential campaign. I mean, really stop and focus on this for a second: the Bicentennial was presided over by a president that the American people did not elect. He spoke to a crowd in Philly at 9, another at 9:40, another at 11, to fourteen-hundred people at lunch, and in New York at 2. The press corps caught everything: every ship he sailed, every helicopter circle he made around Liberty Island, the silver bowl he accepted and the bell he rang, the guest books he signed, the very many dignitaries he met, the hundreds and hundreds of hands he shook. Before he watched the fireworks, Ford placed a call to Bill Dooley, an eighty-one year old veteran of the First World War who was convalescing in the Volunteers of America Hospital in Torrence, California. This call lasted two minutes and was televised. Ford thanked Dooley for his service in making America the greatest country in the world, reviewed how far we have come, and concluded by saying that there is one thing that hasn't changed: "We are still a people in love with freedom, and after 200 years, that love is undiminished."

This is such a careful wording. It isn't our freedom that is undiminished, but our love of the very idea of freedom that still remains. The deliverables are a little beside the point. Dooley's hospital was just down the beach from Ron Kovic's house, but Kovic was on his way to New York, to Madison Square Garden for the 38th Democratic National Convention. On Wednesday the 14th, Ford celebrated his 63rd birthday, which makes him a cancer if you're into that zodiac shit. On the following day, Carter

accepts the nomination. Happy birthday, you cancer, you! I know what you're thinking. The DNC! Now we're in the dirty! But it ain't so. There's no horse race and nobody much to grease. Carter has it locked up by the time they call for Ohio and the first ballot carries the day no problem. Talking about Carter's nomination is like talking about the Titanic. You know damn well what happens to the fucking ship, so the point is in dog-paddling around in the melee, looking for a less historical, more human angle.

The DNC is four days long. Every day, there are thousands of people on the shady side of MSG, raising their flags and banners and homemade signs of protest pertaining to whatever personal stake they have in the dog and pony show going on inside where the cameras are. Abortion, gay rights, whatever else the media won't cover. It begins on Monday the 12th with the convention manager, the vice chairs of committees, the mayor and the governor. Then they talk about money and watch a half-hour film, and then it's time for the keynotes, which are the real fireworks. Or, they're supposed to be.

First up to bat, John Glenn. This man is a Korean War fighter pilot, the first American to orbit the earth, distinguished Senator from the Buckeye State and current party of interest to the Vice Presidential ticket slot. It's 10:30 p.m. and he tanks it. He talks for fifteen minutes and the inattention of the enormous crowd grows more and more brutal until it's clear to Carter's people that three nights from now, American hero John Glenn will not be taking the stage as Jimmy's wing man. Either they kind of knew he was going to suck, or they wanted to double their audience appeal, because it was only the third time in the history of the convention that they actually invited two keynotes.

At 11:15 p.m., freshman House Rep from Texas District 18, Barbara Jordan walked on stage to a thunderous standing ovation

lasting so long that her introducer jokingly told the reenergized crowd they were not behaving like ladies and gentlemen. She wore low-key gold earrings with no dangle, her usual thick glasses, and a knock-out turquoise dress that popped right out of the television against the brown plywood of the platform and the plain blue background behind her. An old-school rhetorician and champion college debater, she clocked in at thirty-five minutes to Glenn's already forgotten fifteen, and delivered an oratory so unique and decisive that not only is it commonly considered one of the greatest American speeches ever made, but Jordan actually received one delegate's vote for the Vice Presidency in honor of her tremendous speech craft.

Her first remark is that it is unusual for "a Barbara Jordan" to be giving the keynote. Jordan was a black woman. She was also a secret lesbian who had recently been secretly diagnosed with multiple sclerosis. Grown tired of feeling so many facets of herself left out when keynotes get revving on all the "we the people" stuff, her address is filled to the brim with I-statements. Barbara Jordan speaks for herself! She goes on to identify the traditional strategy of a DNC convention speech: praise Democratic legislation, attack Republican candidates, recite the litany of contemporary American ills and promise vague solutions. Casting classical methodology aside, she defines the primary belief of the Democratic Party as "equality for all and privileges for none." Then, in marked contrast to Ford's simplistic Bicentennial portrayal of the nation as lovers of the idea of freedom, Barbara Jordan says that the bedrock of our governance is "a positive vision of the future founded on the belief that the gap between the promise and reality of America can one day be finally closed."

To those with a stake in the claim on a more egalitarian measure of freedom, the deliverables still matter. Jordan does something

so brash as to be judged unthinkable by all other politicians before or since and that is to admit that the Democratic Party has made mistakes, temporary mistakes of the heart that were made in haste to accomplish too much too quickly, mistakes that will be undone by the individual common sense that compels us toward a national community. She has this to say about Ford's American idea: "Though it is shared by all of us, [it] is realized in each one of us." She finishes with Jefferson on the restoration of social harmony and Lincoln on the undemocratic nature of masters and slaves.

Usually if an American politician or activist gives a super excellent speech, that speech comes to be called by the name of its most common theme. But Barbara Jordan is loaded down with ideas. There is no lynchpin, no refrain or culminating moment. Her speech has no title whatsoever. Everyone just refers to it as Barbara Jordan's 1976 DNC keynote. She owned it. And we do need to specify that it was 1976, because Barbara Jordan holds the distinction of being the only person ever in the history of the Democratic National Convention to deliver a keynote twice. The second time was in 1992, for Clinton, where she one again spoke smooth as hell right on the rails, this time from her wheelchair.

On Tuesday, it's meetings all day long. This and that from the rules committee and then at 8 that night, McGovern and Humphrey each say a little something. On Wednesday night at 9, they nominate Carter and do the roll call. Ford and the First Lady had just finished his birthday dinner. A few pieces on the floor are a little sloppy coordination-wise, but nobody is there to hustle. They're just glossing everything with party unity until the verdict is in and it looks indeed like it's supposed to: Carter breaking away at a clean seventy-five, with Udall and Brown each sitting at ten percent and Wallace trickling in at just under two.

They announced at 11:30, while the presidential birthday boy is soundly asleep.

When he woke up, he spent two minutes on the phone with Carter to congratulate him. That was sweet, but also a kind of wish projection because Ford's job was still somewhat up for grabs to Ronnie Reagan. On Thursday evening, there was much ballyhoo and sentiment amongst a small group of people who had no power but still wanted to make their point. The entire crowd momentarily shushed as it noticed that his attendants were having a hell of a time getting Ron Kovic to the platform, which was thirty feet above the convention floor with no ramp. Kovic then delivered his famous poem about being a firecracker exploding in the grave, told the story of his misguided quest for military manhood, and proceeded to nominate Fritz Efaw for Vice President of the United States. Efaw was a draft dodger of whom almost nobody had heard. To avoid going to Vietnam, he went to London and did not come back. The FBI was waiting to send him to trial in Oklahoma, but Efaw struck a deal with the Assistant AG to spend a few days with his family first. His family was conveniently located at the site of the DNC.

His symbolic selection was meant to convey the importance of universal and unconditional amnesty for those who resisted the war and declared their independence from the military draft. Efaw got up on stage to give Kovic a hug, then respectfully decline his emotional nomination. He scored twelve votes anyway. Two weeks later in *United States v. Fritz W. Efaw*, Judge Fred Daugherty ruled contrary to the express wishes of the feds and ordered a $5,000 bond. Unable to pay, Efaw was escorted out in handcuffs to spend a day and a half in jail until his many new allies could raise the funds. Judge Daugherty was a retired Army major general who served in World War II and again in Korea, two

140

stars, third rank from the top. He was appointed by JFK. Publicity ran high and the case was eventually dismissed.

The convention closed with Mondale's acceptance speech, followed by Carter's. Ford did not watch the speeches because he was busy throwing a State Dinner for the Chancellor of Germany and his wife. Mondale spoke for fifteen minutes. As his main job was to make Carter look ever more moderate, he called Nixon a deceitful barbarian and called out Ford for pardoning him. He got a standing ovation that lasted long enough for him to remember to smile and even take a drink of water. Kudos to his speechwriters! There is enough anaphora and other methods of repetition, enough subtle poetics in that speech that it should have been quite a memorable Republican drubbing. Too bad Mondale kept fucking up the cadences. On paper, his speech reads like a dream sermon. There's a good line in there about pirates of the sky, and a very solid thread about the Democratic mission of human justice, many echoes of Roosevelt and a nice quote from Carl Sandburg. But every time he gets rolling, there's an audible fumble just before the touchdown.

The thing that really gets me though, is why they asked John Glenn to keynote a convention that resulted in the nomination of Walter Mondale. Both of their speeches were terrible, granted, but the contrast in ideology cannot be overstated. I'm talking about space exploration. Senator Mondale served on the Aeronautical and Space Science Committee, mainly dedicating himself to preventing NASA from spending so much as another dime. He viewed space projects as expensive and unsafe. Oddly, Senator Glenn never served on this committee, though he was clearly more qualified than anyone else in Congress to do so. He was also pulled from further launches, basically because if one of them blew up with him on board, Americans would be extra super sad

that their space pioneer was killed.

NASA's Viking 1, the first spacecraft to successfully land on Mars, had been scheduled to do so on the 4th of July, but its landing site was not quite safe so the admin waited until July 20th. The purpose of this mission was to take photographs, collect soil samples, and search for signs of life. I do not need to remind you who the Vikings were, but I think we could actually use a reminder about this simple fact: space is out there, everywhere. So the ugly moral question is what we should do about it. Once upon a time, this was a hot button. Nobody really gives an ounce of political shit about space anymore.

There was this Roman genius, Enrico Fermi, who joined up with the Manhattan Project in order to come to America and avoid the madman Italian persecution of his wife, who was a Jew. He came and built our bombs for us, and then thirty years later, some other astrophysicist picked up on the other thing that Fermi was into, which was aliens. This new kid, Michael Hart, a Jew yet also a fervent white separatist who actually proposed partitioning modern America into four regions segregated by race, jump-started a discussion on what is now referred to as the Fermi paradox. Essentially, it's highly probable that alien life exists and simultaneously extremely sketchy that we have not yet found any evidence of it. The rate of earth's technological advancement makes it statistically quite certain that if there were life outside of earth, we could find it. Yet, we have not.

Of course, this is primarily a silly topic of conversation among academic astrophysicists. Most civilians in 1976 are only aware of two things: Kennedy said we should explore space and it looks like the Russians are going to beat us to all the good stuff if we don't speed things up. The implications for a national missile defense that could blunt the option of mutually-assured destruction, etc.

etc. This is before anybody gave a shit about climate change, but still, citizens dreamed of vacationing on Mars, went so far as to speculate on the cost of Martian real estate.

My in-laws, who retired to Florida like everyone else and who were around to remember Kennedy's space speech as well as the enduring competition of the Cold War before anyone was referring to it as that, always took the time to watch the shuttle launches from their backyard, sending us blurry photos of thick white smoke and some colored lights and maybe the tip of an occasional rocket. They are believers in the grandeur and glory of NASA's mission. I asked around about this and can't much find anybody who gives the thumbs down to space exploration. But I also can't find anybody genuinely interested to discuss space pollution or the colonialist dilemma of the whole thing either. Everybody knows it's expensive, but everything worthwhile nowadays is accompanied by a hefty price tag, so the cost doesn't seem to bother anyone. Exploration is such a deceptively neutral word.

This forces me to admit that I have been basically agnostic on the issue of space. I just have not considered it as a political issue, as something about which everyone ought to have a personal opinion. The few people I do know who have an opinion about it seem tentative and uninformed. But in 1976, it was a topic you could have debates about at happy hour. Mondale could serve on this committee and talk about what a tremendous waste of resources it was, how there would be no return on investment. And John Glenn mostly kept his mouth shut, banging away at a career in politics that divorced itself from those things that originally made him so damn beloved by the American people in the first place. His opponent in the primaries hit the nail on the head, asking what "on Earth" John Glenn had done for the

American people. Glenn was still our best symbol of the prospects of space, the beautiful orbit and nothing more sinister than to just be floating out there, collecting harmless data.

The aliens never contacted John Glenn. They never contacted any earthling at all, which leads me to believe that we are either so primitive we can't understand it when they do communicate to us, or we are so doomed by our own barbarism that the aliens have no desire to contact us. Earth is a hot mess, boys! Let's give them a few hundred more years in which to accelerate themselves into irrevocable demise, and not be bothered by the arrogance implicit in all homo sapiens advancement. They haven't even got as far as time travel yet. Let's partition their idiotic race off from our much older and wiser civilization. They will be blinking out in a heartbeat, the Milky Way and other galaxies unfazed by those inevitable fireworks.

I'm picturing all those kids and John Glenn and my mother-in-law staring up at the sky on 4th of July, piddly little Roman candles obscuring the immortality of the stars and the gaze of anything that might be staring back at us. We know best those things that are right in front of our noses, even as we covet a condo on Mars that we will simply never have. The conversation among astrophysicists in 1976 is about why we can never have it. Either there are no aliens or they are ignoring us. We can't find them because they don't want to be found. They've chosen independence from the earthlings, and my main opinion about space is that I hope they keep it that way because I'm concerned about the verbiage likely to follow on the heels of a word like exploring. Discovering, declaring, displacing, destroying, and so forth.

This dovetails with the other science thing going on at the moment. The new issue of *Science* came out on the 23rd, and in

it, psychologist Shepard Siegel had a little two-page report on situation-specific tolerance. Dr. Siegel had discovered that his lab rats could achieve a remarkably high tolerance for morphine, as long as they were at home. As long as the animals sat on the couch and felt at ease with being in their usual circumstances, they could dose way up and feel only moderate effects. But stick the animal in a taxi or a club to do the same dose, and those rats end up dead. It's a straightforward matter of Pavlovian conditioning. And I don't think there's any doubt as to the fact that this is how America was born. We are dosing ourselves at home. Our kidneys may be shot, but we don't feel it, just keep on ticking on the outside no problem.

At home in our new country, we had to up the injection of independence. By God, what a rush! The Roman Empire overdosed in about five hundred years. If the speed of our progress means anything, seems like we could set the over-under on America's own demise at half of that. You'd have to move to Mars to escape it. Put Americans on a new planet and hope they fuck it up more slowly next time, hope the new scene forces Americans to take it easy or else our soldiers will once again have some heavy lifting to do. Look, I don't necessarily believe in aliens one way or the other, but I do believe that if aliens are out there, they're not going to make contact with us unless it's to blink us extinct. It's hard to make peace with Americans and I just strongly suspect that aliens would know better than to try.

Situation-specific tolerance is also a good metaphor for the marriage of Ike and Tina Turner, concerning the great philosophical and practical debate over how often and how hard your husband needs to punch you before you up and defend yourself. He beat her so bad in Dallas that she finally filed for divorce on July 27th. The cause of the fight was Ike's excessive use of cocaine to mask

the pain from the hole in his nose that was caused in the first place by excessive use of cocaine. The Turners had checked into the Statler Hotel, which is, like everything else on this great gonzo plastic American trip, about six blocks from the site where JFK was shot.

You know, the practice run for that motorcade took place in our nation's original capital, in an open air car on a thirteen mile stretch of road that ended outside of the Bellevue-Stratford Hotel. The same day Tina Turner finally lawyered up, there was a state meeting of the American Legion at the Bellevue-Stratford. Guess how it ends. I'll give you a hint: 29 dead, 182 cases reported. Considering over two thousand people attended the convention in Philly and that the bacteria is a water-born, aerosolized pathogen, that's a pretty good showing. The hotel was shut down until they could solve their fatal little air-conditioning problem. So that's where Legionnaires' Disease got its name. Thank you for your service, boys!

There is a plague on the house of the American military. Everywhere we turn at the Bicentennial, the sons of Uncle Sam are paying the piper. And we cannot possibly close out the month without discussing Son of Sam. Most people overlook the fact that David Berkowitz served in the Army for four years right out of high school, shifting his natural pyromania into a fevered patriotism, complete with heavy weapons training that would later make him a wonderful candidate for auxiliary fire and police brigades. He came back from South Korea a changed man, a peacenik. Well, except for all the murders he successfully committed and unsuccessfully attempted and may or may not have planned or executed alone.

Just past one in the morning on Thursday the 29th, two teenage Italian girls were sitting in a car out front of one of their

146

houses, recapping that evening's exploits at the discotheque. Berkowitz had been circling the neighborhood all night. Donna Lauria opened the passenger-side door, spotted him and began to shoo him away. Berkowitz pulled the gun out of a brown paper sack, dropped to one knee and rested one elbow on it as he'd been taught, then fired the first bullet right into her throat with both hands. Donna died instantly, just like Kovic's corporal from Georgia. Jody Valenti took one in the thigh and lived to tell about it, not that she had much detail to provide. The third bullet went askew. Berkowitz got up and walked away without a word. Who knows how he spent the other two bullets. This was the first in a long string of killings that would terrorize brunettes all over New York for more than a year.

Until he got fancy with the love notes to NYPD and declared himself Son of Sam, the papers had dubbed him The .44 Caliber Killer. Although police had very little to go on as far as identifying the triggerman, ballistics revealed the gun itself quite quickly. It was a .44 Bulldog, a Charter Arms snubnose revolver that holds five rounds and is so weak in its aim that it is widely known to be effective only at point-blank range. It was made for defense, or else for recklessly bold, up close and personal offense. It's about an hour drive from Pelham Bay where the Son of Sam murder spree began to Charter Arms Headquarters where the Bulldog is manufactured. Charter Arms was also the brand of choice for the man who killed John Lennon and the man who tried to kill George Wallace.

The Bulldog is cheap, light, no sharp angles. It was a bestseller all the way through the 80s, with over thirty-seven thousand being manufactured every year. It's not a celebrity weapon. It's for ordinary, everyday people. This brings me to Judith Guest. If you are a reader who keeps current but doesn't dig non-fiction at the

moment of the Bicentennial, or you just don't like to read things that are so clearly politicized, you are casting Ron Kovic aside to spend your free time at the beach or on the porch or whatever reading the novel that is all the buzzy rage: *Ordinary People*.

Our story begins with the fact that I fucking hated my AP Lit teacher. Senior year was by and large a complete drag, with this wishy-washy, touchy-feely ex-hippie marching against my steely, cynical exterior in stark contrast to the beloved junior year English teacher who basically taught me everything I know about how to cope with literature and with life. I still keep in touch with her occasionally. I knew she hated him, so I hated him, too. My copy of *Ordinary People* is a leftover from twelfth grade and possibly the only one of those books I kept, so it must have had some significance for me. The pages have grown soft sitting on my bookcase for over fifteen years. Every single page has annotations on it. He made us do that. I never annotated shit unless I was forced into it.

It's a quick read, minimal and vague in the prose style, moving toward inevitability the same way Kovic's memoir does. In many ways, these books are about the same thing—wars abroad and wars at home. The novel details a couple of months in the life of a father and son who live just a few miles away from where I lived in high school. All the streets and buildings have real names I would have known. The father is struggling to accept that his son orchestrated a wrist-slashing in the vertical way that means business, and the son is struggling to accept that he couldn't save his older brother from drowning in a boating accident the previous summer. Both father and surviving son are grasping at any available straws, in obedient thrall to their mysterious oppression by Beth, the woman of the household. She is perfect and free of feelings.

At the end, she departs for an endless vacation all over Europe

while father and son reconcile a small piece of their peaceful family life together. Their fictional neighborhood was right next to my actual neighborhood, but it didn't matter. Old Connie finally gets laid and that was the only interesting thing. I am reading this novel about Conrad Jarrett's attempted suicide when I am seventeen and so is he. It should be resonant. My annotations make clear the fact that I failed to identify with any of the characters in the story. I wanted very much to know how their lives related to mine but I came up with nothing.

Like *Born on the Fourth of July*, the middle chunk of *Ordinary People* is all nostalgic sparkle while the end is a pile of disjointed crack and boom noises that strive toward an inevitable anti-climax, a blunt instrument of overkill on the best-selling message of the thing. Uncertainty abounds! Things happen without reason! Let's not blame anybody, but let's keep asking how this personally all relates to me. Ron Kovic is saying that Vietnam is all about him, the changes it irrevocably wrought in him. He, in turn, is just an empty husk, a sad placeholder for all the boys in uniform. Judith Guest is saying that every tragic moment is about the people who are left over afterward. Those people, in turn, are just empty husks, a bunch of sad placeholders for the existential crisis negotiated by homo sapiens at large. Ta da! The fireworks refuse manipulation.

AUGUST

Melting Ferrari ... Duck, Duck, Incumbent ... The Time Capsule Gag ... RNC Coincides with International Disasters ... How to Steal from or Seduce a Ghost ... Casey Kasem Spins the Truth ...

The Black Castle of Nürburg and its attendant voluminous hills are encircled by fourteen miles of racetrack known to its drivers as The Green Hell. It was a dark and stormy afternoon on Sunday the 1st of August when Niki Lauda, the only person in history to lap this longest track of the season in under seven minutes, proposed to the other Formula One contenders that they boycott this tenth of their sixteen races due to the weather conditions. He was voted down. Safety on the track was itself abysmal to begin with, having no serious guard walls or bumper room between the edge of the track and its surrounding mountains covered in thick trees. There were no access roads, meaning any necessary fire or medical help would arrive belatedly at best.

If there was going to be a race, Lauda was going to drive in it. He was the ace Ferrari driver and Ferrari was itself the juggernaut of the circuit, out-spending and out-publicizing any other riding outfit with half a fighting chance. Ferrari appreciated Lauda as a methodical, level-headed calculator with a great reserve of mechanical instinct. His driving was so preternaturally good that he was the incumbent World Champion of the previous year and in 1976, he led his nearest rival by double points more than half-way through the racing season.

His nearest rival was James Hunt. Hunt was two years older than him and four times as handsome. Handsome Hunt had a penchant for drinking with one hand while smoking with the other, each arm hung lightly across a different attractive groupie, in full view of the media outlets covering F1 racing. He was sponsored by Marlboro cigarettes and drove for McLaren. Indeed, he was a

cowboy, so good for the camera because he could be as wild on as off the track with an unpredictable streak that usually got him to the finish line somewhere toward the front. McLaren had no money to spend against Ferrari, but they had Surrey attitude in spades. Fans believed Hunt was destined for the ultimate victory sooner rather than later.

This was a German track, stubbornly cutting its way through the hostile terrain and deeply unsuitable for televising. You just couldn't get a crew in anywhere. Whether because of the legitimate safety concerns or the commercial pressure to televise and monetize more of the scene, everyone involved knew full well that 1976 was the last time there would ever be a race at Nürburgring. Niki Lauda was neatly in the lead until the crash. It was half-way through his second lap. He'd already managed the left kink at Bergwerk once and if he made it around that hairpin smoothly to the inside, he'd have a good long stretch of straightaway to solidify his early lead.

There was some kind of rear suspension failure and Lauda lost control of the car, bouncing off a laughably ineffective metal barrier and then striking two other cars. His Ferrari burst into flames. The foam inside Lauda's helmet compressed upon impact, causing the helmet to loosen and roll off his head. In the sixty seconds before enough other racers stopped to pull him from the burning wreckage, Lauda's fully fueled car melted the top of his head. He lost all his hair, much of his scalp, half his right ear, and was left with a puddle of flesh for forehead and eyelids, his lungs and blood poisoned by the fumes. With his best competition in a coma and on the way to the hospital, James Hunt won the race

easily.

Ferrari wasted no time in looking for another driver, but Lauda was out of the hospital in forty days. The doctors said it was nothing short of a miracle. He opted for the bare minimum in reconstructive surgeries and by the next race, his condition was no longer life-threatening. For races ten, eleven and twelve, Hunt had been free to rack up the points in Lauda's absence. As race thirteen approached, Hunt was only two points behind Lauda's first place standing when Ferrari announced that Lauda was going to get back in the car.

Race thirteen was in Italy, the home of Ferrari. In despair over desire for the preservation of his winning streak, Hunt made a charge at the pod of four leader cars after he'd been held back by a shady penalty for fuel irregularities given him by the Italians who were clearly rooting for Lauda. His surge was not a success. He spun out. Lauda took fourth and Hunt did not finish the race.

James Hunt would not be deterred. He took two wins immediately in races fourteen and fifteen, and as they headed into the final brouhaha in Japan, Hunt was only three points behind Lauda. Even a third place finish would give him the title as long as Lauda didn't rank. It was once again pouring down sheets of rain. Lauda quit after the second lap. He said it was too dangerous and Ferrari never quite forgave him for getting down off the championship pedestal he'd crafted for himself in the races of 1975.

Seeing that the spot was his for the taking, Hunt amped up his aggressive driving. The tires needed cooling, but Hunt refused to drive through puddles if it might cost him his newly widened

lead. His tires were melting down to canvas and then two of them were nothing but rims when he finally pulled in to change tires. The McLaren team couldn't jack both tires at once, so they lifted the rear end of the car with their hands. The extra few seconds of delay resulted in a third place win for Hunt.

James Hunt was therefore declared winner of the Formula One World Championship of 1976 by one point. Lauda would take back his title the next year, and win it again in 1984 for good measure just to punctuate his point. The two of them were friends the entire time. They respected each other as intelligent drivers with good instincts. I was hoping to pull this taffy right into a terrifically extended political metaphor, but this good-natured rivalry between Hunt and Lauda does not at all resemble the case of Gerald Ford and Ronald Reagan. While Niki Lauda is languishing in a hospital bed wondering if this is the end of not only his career but of his very life, Jerry and Ronnie are on their respective ways to Kansas City, Missouri, for the equally racy contest of the Republican National Convention.

It's fair to say that they hated each other for all the right reasons. Reagan was an ideologue who had risen from the silver screen to prominence as a half-hour televised special advocate for Barry Goldwater. His speech did not mention Goldwater by name even once. Ronnie could tow a party line only if he was at the front of it. Nobody voted for Goldwater, but a lot of people were interested to have a time to choose handsome Ronnie. So he cake-walked into the gig of Governor of California, defeating the incumbent. After he got a little too swept up in the moment in '68, he accidentally collected 182 of Nixon's delegates. Nobody had

ever challenged a sitting president at the RNC, so the Reagans worked quietly and diligently for Nixon at the '72 event, but the Nixon machine still kept one finger on their pulse the whole time.

Ronnie was content to wait out the incumbent, raking in the bucks from as many as twenty speaking gigs a month. Unfortunately for the Reagans, Nixon left office a little bit ahead of schedule, so instead of a clean slate going into the '76 convention, they faced the face of a fresh incumbent whom nobody had actually elected. By virtue of having held the position already, Jerry felt the delegates owed him their official nomination. Ronnie felt entitled to the same nomination by virtue of having waited in line for so long. Ford did not possess the dignity of having been voted into his position, but he certainly did possess all the resources of his position. He began to make good use of them by offering Reagan pretty much any post he wanted, if only he would drop out of the race. Meanwhile, it was c'mon in and see the Lincoln Bedroom, delegate friends!

In fact, Rockefeller had already declared he would not seek to return to his veep slot, so Ford definitely may or may not have offered the second slot on the ticket to Reagan and Reagan wouldn't have it. Reagan was thinking about who would serve as his own veep, and he picked Richard Schweiker, the moderate Senator from Pennsylvania whom he hoped would balance out the ticket and give him an edge in the territory that primaried cleanly for Ford. Ronnie hadn't even hit six percent against Ford in Philly four months before.

He thought he could deliver the Southern states on his own, thanks to early support from the whippersnapper freshman

Senator from North Carolina who gifted him his first primary win and all its subsequent fast-tracking, Jesse Helms. But Helms didn't like the choice of Schweiker, or perhaps more to the point, didn't like it that he wasn't consulted about a veep choice in the first place. So he pulled his support at the convention and put Ford ever closer to the magic number.

Meanwhile, Ford's running mate was still unknown. In despair over desire for the preservation of his dwindling momentum, Reagan's people made a charge at the rules committee to formalize a change that would force Ford to declare his veep contender before the roll call. I shouldn't have showed you mine, but you damn well better now show me yours because misery loves company. The petition was not a success. It was defeated by 111 votes. Jerry picked up the ball and ran toward the hole. He beat out Ronnie by 117 delegates.

In the interest of appearing unified before a national electorate still wary of the specter of Nixon, bullshittery began to fly about switching the votes to a unanimous consensus. They wanted to erase Ronnie's 47%. The California delegates would not turn their backs on their favorite son, whose campaigns they had been funding, running and praying over for more than ten years by that point. They wouldn't let it go, so the chair let it go for them. Procedural necessity suddenly cast aside for the convenience of better publicity, he declared the ballot was unanimous. Then Ford announced Bob Dole would be his veep and gave the acceptance speech he'd been working on with a video camera every night for at least two weeks. For once, Jerry Ford gave a speech that did not suck.

But once again in the interest of staying on message about party unity, he spontaneously invited Ronnie Reagan to join him on stage. It was unplanned, and Reagan had no prepared remarks. Ford had just jammed out to the best of his mundane ability for forty-five minutes. Then Reagan did six minutes of tight little impromptu and left the entire convention floor immediately regretting that they'd gone with Ford instead. At the end of his speech, Reagan put on his best reflective face and told the crowd that he had recently been asked to write a letter for inclusion in a Los Angeles time capsule, to be opened one hundred years hence on the American Tricentennial.

"And suddenly it dawned on me," he said. "Those who would read this letter a hundred years from now [...] will know whether we met our challenge." In any video of this speech, when Ronnie delivers the end of that line, you can hear one man in the crowd very loudly guffaw. If you are reading this and you are that man, from my vantage point forty years into the future, I'd like to buy you a beer.

The Republican National Convention began on Monday the 16th. As Jerry and Ronnie hopped from steak lunch to steak dinner trying to lay hands on as many delegates as possible that first day, the largest bay in the Philippines was holding on for dear life against an earthquake that rated an eight on the Richter scale. The Moro Gulf floats on top of several fault lines and earthquakes of significant magnitude are not uncommon. At least five thousand people were killed. This is 25% of the number of people that can be held in Kemper Arena, the site of the RNC. If Reagan had only managed to randomly disappear one quarter of the delegates, the

remaining portion almost certainly would've seen him win the nomination.

As many as ninety thousand people lost their homes. This is four and a half times the number of people who could squeeze into Kemper Arena. People on the islands were accustomed to earthquakes, but they did not expect the tsunami that followed. There was no time to issue an evacuation warning. The major aftershock ranked a 6.8 in its own right, and there were more than a dozen additional aftershocks. The wall of water rose sixteen feet in the air and sucked its casualties out to sea. If you're interested in transcendentalism, think about those thousands of unrecovered Filipino bodies and whether their ghosts might live in your faucet.

On the second day of the RNC, Alex Haley celebrates his 55th birthday by launching his novel, *Roots: The Saga of an American Family*. I would love to tell you I have read this book, but I haven't. What I did do though was steal it. This is significant because I've only stolen maybe a half dozen things in my whole life. The first one was a tiny piece of scented wax from Wicks N Sticks at the local mall where everybody hung out in junior high. Go mustangs. I only did it to be sure that I could. It was pale blue and I snuck back into the store a half hour later to slip it back into its fishbowl. I think most of the rest of what I stole was a couple of packs of smokes from other underage kids in the gym locker room and some signage, as in: this is a non-smoking room and temporarily out of order.

So, I have in my possession a first edition hardbound copy of *Roots*. Its possible former owner is Carson McCullers. That sounds pretty wild, but what happened was that I was staying at

her house and just saw it there. She was long dead at the time, but the house operates as a museum and runs a contest for writers in residence. Went down there to do a gig and ended up getting to stay in the basement bedroom. There's book shelves wall to wall, and I was innocently browsing around before bedtime when I saw it. Spine is three inches thick with a big block font, so it's hard to miss. I was already knee deep in research for this book here and I knew *Roots* was on my reading list. Surely this copy was calling my name. I mean a lot of people donate books to fill out the spacious shelves all over this place, so there's really a good chance it isn't property of McCullers herself at all. There are no markings in the text and the spine was cracked so little that the book may never have even been read by anyone. I hemmed and hawed for as long as it took to brush my teeth, then slid it off the shelf and into my backpack.

Here's where things get spooky. At precisely two o'clock in the morning with nary a remote control in sight, the television turned on and screamed at full volume until I got up and switched it off. So maybe one of the caretakers of the property was fucking with me. But the reality is that I had taken this copy of *Roots* from the shelf directly above that television, which then to my way of thinking was blaring at me and filling that three inch gap on the shelf with the sadistic blue light of reckoning. Next day at breakfast, I asked the director whether they generally mess with overnight guests in that way. She said no and I believed her.

So I vowed that in order to defer and ideally cancel my comeuppance at the apparently alert and potentially vindictive hand of the ghost of Carson McCullers, I would use the novel

for my research, then book another gig at the house to restore the novel to its rightful place. Since that time, it's come to my attention that the stewards of the house have taken an inventory of the books present in that library. *Roots* is not on their list because it was nesting in my office at the time of the headcount.

They will probably never inventory those books again, so even if I put it back, that knowledge of its return is just between me and this ghost. Or if they do check the books again and suddenly discover a new book, who knows what they might think about it. And there's the small matter of the fact that this particularly pristine copy is easily worth two hundred bucks. I sort of aimed only to borrow it, but it seems quite clear that the book is now stolen.

I've scheduled another gig at the McCullers house and am not above a deep appreciation of the moral dilemma this presents. My willingness to turn over the facets of such a problem can be traced all the way back to my namesake. I have seen all five-hundred and seventy minutes of the *Roots* miniseries, which aired just six months after the novel was printed. But I am named for the miniseries that is often mentioned in the same breath as *Roots* because its own generative novel came out that same year: Colleen McCullough's *The Thorn Birds*. Both television events were produced by David Lloyd Wolper, to whom I am surely somehow related. Yes, Meggie Cleary. I am named for a woman who spent four-hundred and sixty-seven minutes of television time, or sixty years of her fictional lifespan, seducing the family priest—successfully, might I add. My mother just thought it was a pretty name. But hell, she was only twenty-two at the time.

Symbolism be damned! Lest we be damned by symbolism.

On the third day of the Republican National Convention, North Korean troops breached the Joint Security area of the Demilitarized Zone in order to kill two Army officers in what would later be known as the ax murder incident. All negotiations between the North and South occur here, at Panmunjom. In between these formal talks and prisoner exchanges across the Bridge of No Return, it is the main stage for miscellaneous saber-rattling. On the 18th of August, the problem was a poplar tree. The United Nations checkpoint was monitored from afar by soldiers at an operations post, but the sight line was frequently blocked by this tree, which had grown to over one hundred feet tall. It was on the friendly side of the bridge, so they went to go trim down the branches.

There were twenty men and enough axes to do the job. At the other end of the bridge, fifteen soldiers appeared alongside Lieutenant Bulldog, who earned his nickname by being an aggressive North Korean pain in the collective ass of the armistice agreement. Bulldog ordered them to leave the tree alone and their commanding officer order them to keep trimming it. Two minutes later, Bulldog brought in thirty-five men and reissued his order to abandon the tree. Captain Arthur Bonifas, who refused to cease pruning the poplar, was beaten to death by five men with clubs and crowbars. The other men were rescued by United Nations Command forces who dispersed the North Koreans within thirty seconds, except for Lieutenant Mark Barrett. Barrett had taken cover in a nearby ditch with zero visibility from the operations post. The post watched for ninety minutes as North Koreans went

one by one into that ditch with an ax.

When word from the UNC guards finally reached the post that Barrett was missing, they deployed a search and rescue. Barrett died on the way to the hospital in Seoul. The guard at another post recorded the entire thing with a video camera. We went to DEFCON 3 and assembled 813 men for Task Force Vierra. At sunrise three days later, we sent in a 23-vehicle convoy and a ridiculous amount of armored air power that included bombers with nuclear capability.

Not sure what caused me to slip into that "we" for a minute, but I don't like it. After sending thirty men to secure both ends of the Bridge of No Return, some of the special forces guys strapped Claymore mines to their chests, stood on the bridge with detonators in hand and screamed at the North Koreans, daring them to cross it. Two teams of eight engineers went at the poplar tree with chainsaws.

The North Koreans bused in about two hundred guys. They set up their machines guns, but as soon as soon as they saw how many black birds were crowding up the sky, they got quietly back on the bus. No shots were fired. The tree was demolished in forty-two minutes. The task force left twenty feet of stump there to punctuate their point.

And on the fourth day of the convention, Ford edged out Reagan for the nomination. Bill Clinton turned thirty that day, but had little time to notice since he was busy enjoying running unopposed in the general election for Arkansas Attorney General, a position he held for about a year and a half before being elected Governor of Arkansas in a cake-walk with an even better margin

than Reagan's in California a dozen years prior. Tipper Aitcheson turned twenty-eight that same day, but likewise had no time to notice since she was busy enjoying her fiancé's running unopposed in the general election for the U.S. House Rep seat in Tennessee's 4th district, a position formerly held by his father, Al Gore senior.

No telling where Al junior would be without Tipper, or where he'd be without Clinton. No telling where South Korea would be without North. No telling where *The Thorn Birds* would be without *Roots*, or where my mother would be without *The Thorn Birds*. My father wanted to name me Mercedes, a car he could never afford. No telling where the Philippines would be without fault lines. No Reagan without Goldwater and then Helms. No Ford without Nixon and then no Reagan without Ford, no Hunt without Lauda. Larry Flynt got married again, for the fourth time, this month because why not. Althea stayed with him eleven years until she died of AIDS like everyone else. Liz Taylor divorced Richard Button again, for the second time, this month because why not. Everybody needs a partner, sometimes if only to suffer their opposition.

Every Saturday during the month of August, Casey Kasem is spinning the Top Forty like always, and coming in at number one is Elton John and Kiki Dee's "Don't Go Breaking My Heart." But they couldn't if they tried. They keep telling each other this and I definitely think there is something to that, about the way human beings usually end up sounding just the perfectly right weird note in an effort to marry two minds. We define ourselves by our relationships, no matter how fucked up the connection is.

Hell, even a broken clock is right twice a day. This is

particularly true of the Great Clock on the Elizabeth Tower of Westminster Palace, that famously reliable time teller just about eighty years younger than our nation, which stopped running on the fifth of August and would not chime properly again for nine additional months. It's the longest and only significant failure in the clock's history. Just before four o'clock in the morning, there was a tipping point in the erosion of a metal shaft that caused the entire force of the chiming mechanism to be applied continuously to the thirteen and a half tons of Big Ben. The damage ran deep and everyone heard it.

SEPTEMBER

The Ballad of Tony & Paulie ... 50th Anniversary Schlep ... Thunder Road Realism ... U2 & Siouxsie Sioux, Mao & The NY Yankees ... A Tree Grows in East Islip ... Sally Knows A Guy ...

couldn't get both days off work, so we flew out late Thursday night when there were no birds directly to Long Island. There was lightning on the runway so we got into LaGuardia a little before eleven and had made arrangements for a driver in the hopes of power napping through the hour of road before facing the whole gang. So we eventually distinguish Anthony's particular big black sport utility vehicle from the pod of other whales out front, and two minutes in, the wife and I look at each other in the back seat and realize: a nap? Fuhgeddaboudit. We'd hooked ourselves a chatty one.

Tony is the second oldest but the oldest is a deadbeat who lets his accountant wife take care of him. He's a house husband with no kids. The youngest is a girl with no name but she's got her act together fine. The middle child alongside Tony is Paulie, who died at age four. Tony still lives in the house with his mother, who is kicking around just fine for seventy. When the kids were small, this was at the time of the cesspools, and it was expensive. Ma could take three baths and still have one or two dirty kids, you know, so dad built a little well out back to run the washing machine off of, maybe two or three feet deep.

It had a lid on it but it wasn't screwed down good or one of the uncles had tipped it up or something just a little out of whack. Tony remembers this vividly because that morning he taught Paulie how to oil the chain on his three-wheel bike. So Paulie is pedaling all over in the yard and Tony is about to go play some stick ball with the other neighborhood kids. He comes around the side of the house and sees Paulie's feet sticking straight up out of that well. So Tony screamed for his ma and ran back in the house, but of course it was too late. At least the tide was low so maybe he didn't suffer that much.

But his ma never was the same after that, and neither was Tony. He believes there's a little piece of Paulie watching over him, like every time he gets close to getting in a fist fight, the other guy always backs down. That's Paulie privately giving the other guy some ghostly hell, little four year old tough guy that he forever is. And after fighting about it for a long time, his dad got a divorce and his ma got to keep the house where they still live.

There's a sticker bush in the back of the house that grows pretty much right in the spot where they tore out the well. He got a guy to come look at it, because whatever Tony did, the damn bush would grow back in that same spot, so he figures that's Paulie just living in the place. But what I'm getting at, says Tony, is how it's everybody's fault a little bit. Because his ma ran up the water bill, and his dad built the well too close to where they played, and then somebody left the lid off the damn thing, and Tony himself got Paulie riled up about the trike and then wasn't there to watch him on it, and nobody got to him quick enough and fuhgeddabout the ambulance.

Tony's had a lot of jobs, but the main thing is he drives for the company his dad started. His dad passed maybe fifteen years ago, and Tony still drives for the company. He's got that decent place just off Rockaway and he'll get it permanent when his ma's gone, then maybe he'll meet a nice girl to go out on the boat on Saturdays when the weather is nice. There was a young Russian girl who was on the phones at the company that he thought maybe would be good, and ma even liked her, but she was so young and that's not the type of lady who'll be happy just going out on the water with some beers and a joint for the afternoon.

The boat belongs to Tony's godfather and he lets him keep it on the side of ma's house so he can borrow it on weekends

whenever the guy isn't coming over to use it himself. It's a good size boat for a little boat. The tank holds about fifteen gallons. After Sandy, when the power had still been out for about three days more, Tony started siphoning out the gas. A little bit for the fireplace, a little bit for the car. Eventually everything was cleared and the guy came out for his boat and almost ran out on the water because he didn't look at the gauge before he went out. Tony said it must've evaporated during the icy part of the storm, and he felt a little bad, but not bad enough to tell the truth since the guy had been docking at the house free of charge all that time.

We got to the beach house just a few minutes to midnight, but not before Tony assured us that he was cool with the lesbians. With guys in the ass, he couldn't really understand that, but he was a supporter of ladies being able to get married, because hey, you love who you love and that's beautiful. He pulled our bags out of the back of the black beast, hugged us each goodbye and disappeared into the night. All the lights were out on Floral Drive, a tiny two lane that dead ends into Sound Beach, near Port Jefferson. In the morning if it's clear, you can see Connecticut from the back deck.

It was definitely the right house, because my sister-in-law had made signs for the yard: Just Married...50 Years Ago! Happy Anniversary Ellen & Ira! And there's a photo of them from their wedding on there, stuck in the sandy grass like any of the other four houses near here give a shit. But in the middle of the night when you don't know where the hell you are, it's perfect. So I open the front door and feel around for a switch. When I get one, I flick it on and we are greeted by the sight of a completely unfinished basement, all plywood and fairly freshly poured cement, cobwebs and a couple of very frightened mice. Major vacancy.

But then we went around back, fumbling among the shadows of a dozen adirondack chairs, a wicker coffee table and three dangerously tall sprinkler spikes, up the back stairs and into the part of the property that is, by comparison, finished. We are greeted by my wife's immediate family. We are here for her parents' 50th wedding anniversary party, which is simply the ten of us in a beach house on the part of Long Island that is not at all the Hamptons, because this is where their family began, in Patchogue near Holbrook.

What I'm getting at is, I married a nice Jewish girl from Long Island. She turned out that way, either in spite of or because of growing up in the very definition of the suburbs, like Tony and poor little Paulie. They did not grow up in New York. Ellen and Ira did, in Brooklyn right near Coney Island. But as soon as they could afford it, when their own oldest son was about to turn four, they schlepped everyone out to Long Island and never looked back. It was a good neighborhood. They made us rent a sixteen passenger sardine can to tour it. I'd never seen where my wife grew up, so I was actually kind of enthused about jamming everybody in there and seeing the personal sights, everybody squawking over each other and pointing out the windows in opposite directions.

So finally we were approaching the last intersection before their block of Greenbelt Parkway where we're all preparing to file out and surprise whoever now lives in their house, when I see it: Thunder Road. My wife grew up just past the corner of Greenbelt Parkway and Thunder Road. Yeah, I fucking realize it's not the actual street that the Boss sang about. But I'm not from here so Jersey may as well be just two blocks over and this Thunder Road is plenty good enough for me as far as the emotional mileage, so what I'm getting at is: here I am now on the deck with my beer

watching the sun go down on Long Island Sound, listening to the damn song as Mindy slams the screen door to come out and tell me something funny she said to our niece while I am out here like a bastard, satirizing the great suburban schlep her family made to make a grab at whatever the American dream looked like as 1969 became 1970.

She was a tiny little kid during the summer of '76, riding her trike in the local Bicentennial parade and preparing to go into grade school in September. As we're driving around in the sixteen passenger death trap, I am looking at the predictable intervals of strip mall and tree line. That's really all there is and I don't know what I thought it would look like, but Long Island is basically the same as everywhere else, except that there's boats all around the edge of it. I've seen more El Caminos in the past forty-eight hours than I may have seen in the rest of my entire life, but otherwise, the suburbs are the suburbs.

But what I'm getting at is, when the summer of your life comes to a close and the leaves turn a little bit red, everybody ends up migrating to some version of Long Island. I had to see it to believe it, but yeah, my wife grew up in a pretty good neighborhood. It's the original, first American suburb, actually. So did I, come to think of it. And this exceedingly quick and talky trip to the butt end of the world's greatest metropolis leaves me with a fucked up feeling of optimism, like: Erma Bombeck was absolutely right. There is no end of shit to make fun of about the place and populace of suburbia, but she still did live there very happily. In September of 1976, she published *The Grass is Always Greener Over the Septic Tank*, and if you searched the houses on Long Island, you could still probably pick up a dozen copies of it. It was a major bestseller.

When you're a kid, it seems like hell. Being a vessel for that feeling is a large part of how Bruce Springsteen continues to make millions of dollars. And in the little coastal suburb of Clontarf, which is Gaelic for "meadow of the bull," outside of Dublin, a couple of guys equally acquainted with the nightmare of outlying provincial overstretch are this month answering fourteen year old Larry Mullen's ad in search of musicians up on the bulletin board at Mount Temple Comprehensive School. Two years later, this band began calling themselves U2.

There are stirrings from the east end of Dublin to the east end of London. And in the dreary sprawl of suburban Bromley, which in Old English means "woodland clearing where the broom grows," high school drop-out Susan Janet Ballion is phoning up Malcolm McLaren to beg for a suddenly vacated slot at the 100 Club's Punk Festival the following day. She had a bassist who was decent, plus a guy who kind of played the drums and called himself Sid Vicious. They didn't know any songs, but she had a look that Vivienne Westwood immediately stole and subsequently marketed with a success so extreme it came to define the very essence of punk fashion for decades to come. Susan recited bits of poetry that she had memorized, most notably "The Lord's Prayer."

So it was Our Father who art in heaven and all that. Her own father was dead, but prior to his death, he had been a resounding asshole. He'd worked as a bacteriologist, spending his days milking venom from poisonous snakes, but eventually his work became drinking. When Susan was molested at the age of nine, her father paid it no mind. When she was fourteen, he died and left her with a bad case of ulcerative colitis. It was during her hospital stay after the surgery that she first watched David Bowie on television. Three years later, she quit school to follow around

the Sex Pistols with the rest of the Bromley Contingent. Susan then got to open for The Clash opening for the Sex Pistols on Monday the 20th of September, this twenty-minute set of banshee-shrieking blasphemous improvisation eventually detonating into the legacy of Siouxie Sioux. The venue could hold about 600 people. I personally know about 6,000 people who claim to have been there that day. None of them report seeing Sid Vicious chuck the glass at The Damned that ended up instead as splintered shrapnel in a promising young art student's face, but she lost one eye all the same, whether anybody saw it happen or not.

At the same time at the other end of the earth, in a part of the Hunan Province that was the wealthy farming suburb of Shaoshan, which is Chinese for "south of the lake," the locals took a major hit when their most favored prodigal son died of his third and final heart attack, plus maybe also Parkinson's or Lou Gehrig's and a few other things that weren't publicized. He left behind three children, having outlived three others. He was eighty-two, for crying out loud, but still, that was the beginning of the end for something about communism. Jesus, imagine Chairman Mao, Brother Number One, dying of complications from a disease named after the American League's two-time Most Valuable Player and six-time World Series Champion of the New York Yankees.

My wife never watches baseball, but she still has a soft spot for the Yankees and is always full of pride wearing her knit cap with their logo on it when it starts to get cold out. So as I come to grips with the autumn of my life, you know, it seems like Mindy's parents were not that crazy to leave the city. If I had kids, I'd probably be siphoning gas out of that same boat. So I'm not having kids and I get to keep my city. Or any city. So during the course of

174

my own personal September, I can just take a little vacation out to the suburbs and remind myself of what family is all about.

We planted a tree for the happy old couple at East Islip High School, where they worked together side by side for half a million years, him in the math department and her in accounts payable. The wife and I will get our own 50th someday, and schlep all the nieces and nephews out somewhere to watch old home movies and whatever, get them tipsy and warble out a few refrains of "Me & Bobby McGee" around a good-sized fire for a little fire. Ira and Ellen had the time of their life that weekend in Sound Beach with everybody on their absolute best behavior, and thank god they did, or there's no way we'd ever hear the end of it unless we could somehow make it right on their 75th or something.

Sunday the car came around twenty minutes early. We finished our bagels in homage to the gods of the water in Brooklyn and then headed out with Salvatore, who owns the other half of Tony's dad's car service and basically took Tony under his wing after his father passed.

They were great friends, Sally and Tony's dad, and Sally busted his ass in construction for the Teamsters for thirty years to buy this little car company. He grew up in Brooklyn and was a life guard at Coney Island as a kid, probably saw Ellen in a bathing suit two hundred times and never knew it. But then he met a nice girl who got him drunk, you understand, and pushed him out to Long Island. Twenty years later she got him drunk again, on chocolate martinis, and to this day they call him the martini king. Those things really sneak up on you and she dragged him out a little further. So now they've been together thirty-eight years and he's all the way out in Sayville, carting us around in his boss black Escalade with a rosary dangling from the rearview.

Sally doesn't have any interest in a little boat. He's restoring a gorgeous white Jag with a license plate that says M1STRESS, either because it's his lady on the side, or you understand, says Sally winking, because it's my number one stress. His kids are grown and he's getting ready for his granddaughter's sweet sixteen party. He's looking for a maroon tuxedo jacket with a black lapel and he already found the shoes to go with it. The man loves clothes and shoes. He knows a guy and would be glad to get us the family discount. There's a good seafood place and a butcher, too, if we're interested. He's happy to help, you understand, because he loves lesbians. He's got a niece who's a lesbian and everything, too.

He's got a gold chain on his wrist an inch thick, twenty-four carats with his name on it in diamonds, made in Italy by his own godfather who still lives there. Sally's father came over when Sally was little, and it was hard to leave so much of the family behind because family is the most important thing. If Sally goes out and buys himself two pairs of wingtips, he buys four pairs of wedges for his wife. She was a nurse for twenty years, you understand, but when they started laying people off, she went back to school and now she's a big wig for some audio hardware company so she has to dress nice for work.

When he drops us off at the airport, he gives us a hug and shows us where his car number is printed on the receipt so we can get him direct next time we're coming in, and then he'll show us that seafood place. He also wants us to meet his son, Angel, who he adopted as a baby after Angel's father died serving in the Marines. We'd like Angel because he's an artist type who makes weird graffiti shit and smokes dope all day long. He's a good kid, you understand, just not real ambitious, but that's OK because hey out in the suburbs family is family and Sally's pretty much

taking care of everybody who needs it whether they want it or not. Fuhgeddaboudit.

OCTOBER

Presidential Birthday Gifts ... Also-Ran: Sex Pistols & ABBA ... Reasons The Yankees Suck ... The Politics of Richard Avedon ... A Face For Everyone Who Touched Watergate ... Erasures Are Not Accidents ... Hoodie Crusader ...

The first Friday in October, Jimmy Carter celebrated his birthday by back-pedaling from the lust in his heart that he had confessed to *Playboy*, an interview the magazine released for its November issue a month early in order to get out ahead of Election Day. Ford celebrated Carter's birthday by finally displaying enough lust for the office to take part in his own campaigning, lest he fall behind on the big day for getting actually elected to that same office. He immediately did fall behind by tanking their second debate together, during which the American people decided that they prefer a candidate with a sinful heart to one that does not acknowledge threats posed by the Soviet Union. Five years later, my mother would celebrate Carter's debate victory by giving birth to me.

On the following Friday, EMI officially signed the Sex Pistols. There was a full moon. ABBA attempted to thwart the punk revolution by launching *Arrival* mid-week, and in fact succeeded in turning basically everyone who was not protected by a black t-shirt into a dancing queen. On the third Friday, nobody watched the first ever vice presidential debate because everybody was watching the Yankees kill it in overtime against the Kansas City Royals in their epic Game Five brouhaha. Down the street from the stadium and watching every minute of it at home on Ocean Parkway, just across the block from my future wife, mafia mastermind Carlo Gambino was so pleased with the performance of his beloved Yankees that he celebrated their entry into the World Series by dying of a heart attack, much to the chagrin of the assorted unsavory neighboring famiglias that had been plotting to kill him.

One week later as the Yankees are suffering their fourth and fatal defeat in a terrific sweep by Cincinnati's defending

championship Reds, *Rolling Stone* launches issue number 224: Richard Avedon's seventy-three political portraits of "The Family." This yearbook cost eighty-five cents at the time, little more than a penny per photo to round up the savviest, most moving and shakiest bunch of pols in modern American history. What depth! What excitement to see all those faces of powerful people who'd rather be caught with a hand in the cookie jar than be stripped down to a white paper backdrop facing the firing squad of one apolitical photographer. And of course, you could look at a couple of Bee Gees album covers to find out about the fashion of the period, or you could round up this bunch of drunken stalwarts and see what their publicists advise they dress up in when some hippie cats from *Rolling Stone* send over Andy Warhol's favorite photographer for a quick sesh between bouts of concocting those nefarious deeds that ruin our country into something great.

Page fifty-one, John DeButts: This first photo immediately makes me feel stupid because I have no idea who John DeButts is—and whoever he is, he warrants not only a whole page but the first page, with his giant dark suit taking up three quarters of the frame and his tiny head balanced on top of it. His tie pin is not a flag, but he has a nicely organized pocket square. When you finally do make it up to his face, his lips are a thin approximation of smiling. Yes, he is smiling with his eyes. He is looking at the camera and his eyes are glossy, almost as shiny as his hair and he has his hands in his pockets. It's breezy. You probably don't mind asking him things. He looks like he's a nice guy. Neighborly. Occupation: CEO of AT&T and Major General in the war against federal antitrust regulations.

Henry Kissinger: this guy is Henry Kissinger? This is the face of Henry Kissinger. He's got on a three-piece suit, black, left

hand in the pocket. His glasses are crooked and so is his nose; his hairline is receding and also a little crooked. So this is Henry Kissinger. That's it. Kissinger looks pretty unassuming, like he spends all his time trapped in a cubicle, or stunting his personal growth in a dark closet somewhere. Occupation: Secretary of State to Nixon and Ford, Peace Prize winner and at-large war criminal.

Mike Mansfield is wearing no jacket, white shirt, hands on hips, flashy diamond tie, check, pattern on the pants. He's got a clicky ballpoint in his pocket. Mansfield's looking right on, both shoulders up and ready for action. He's a doer. He gets it done, Mike Mansfield. Skinny guy, fat resume. Occupation: Senate Majority Leader, D-Montana.

A. Philip Randolph is a guy who kind of smiles by turning down the corners of his mouth. Head straight, cardigan under his overcoat, hand in his pocket. He is doing the hip uncle pose. He looks a little tired and equally sad, humping around with that overcoat. Occupation: head of the March on Washington, union organizer and prominent atheist.

George Meany, boy, does he look like a meany. The corners of his mouth are turned so far down that they just run right down into his jowls. The points of his collar are demonstrating his shirt is way too old, with some kind of a pin on his dark jacket. You can't even see his arms. Avedon just did the top third of him— those thick black glasses that hug his face too close, and that bald head mirroring the round shape of the underside of his glasses. George Meany is the pointy-eared troll under the bridge where you'd really rather go find some other bridge to cross than try going over his. Occupation: President of the AFL-CIO.

Then you can look across the page and you know who it's

going to be. Two full-size side-by-side portraits of Jimmy Carter and Gerald Ford. You want to look between them, instead of at them. Ford placed an American flag poking out on the left side of the frame between them, dividing them. One's got a dark suit and one's got a light suit; both of them are faintly checked just for texture. Both of them have ties with wacky patterns. Ford's has what looks like groups of three tiny soldiers, maybe drummer boys, marching across his dark tie and Carter has an oddly striped, weirdly embroidered, two-color—I don't know. Carter is just looking nice and Ford is going full bore on the symbolism of things.

Both of them part their hair on the right side of their head. Jerry does not have nearly as much of it to part as Jimmy does and neither of them bother with smiling—not with their eyes, not with their mouths. Ford looks like he's ready to spring into action. He's got one eyelid slightly droopy, whereas Carter looks just a touch sad or concerned, and maybe like he's shitting himself a little bit. Jimmy Carter's collar is significantly more in the right place, knot of his tie reasonably proportionate. Gerald Ford, not so much. Ford's a little more disheveled. Carter's got his right hand in his pocket while Ford has both hands at his sides. Both of them are just looking right at you. Wide, peak lapels on both of them. One button suit on Ford; two button suit on Carter. Carter gets the left side of page; Gerald Ford gets the right side of the page. Oh, the choices we'll make! Decisions, decisions.

Hubert Humphrey is carrying a very thick and important looking file in his hand. The cuff is jutting out of his jacket so that you can infer a pair of cufflinks. He wears a striped shirt like a banker, dark suit, thin lapel for the times, right hand in his pocket, not looking at the camera, looking off to the right side of the

camera, thin-lipped, concerned. Occupation: Nixon's punching bag in '68.

Jerry Brown wears a super unusual and equally loud tie pattern that has little buckles and chains all over it. Very east coast dude, darkest hair out of any of the pictures we've seen so far. Maybe most hair altogether out of the pictures we've seen so far. Double-breasted suit, brass buttons, reflecting the light. One hand in front of him, one hand behind his back, looking left. Occupation: Governor of California.

Katharine Graham is tired. She looks like she's been waiting up, consternation on her face. Her simplistic dress blends into the background, white on white, or cream. Her glasses—why did she take off her glasses and then still include them in the photo? Dark glasses on her white shirt, dark eyes on her white face, dark hair on her white head. She's waiting with her sleeves rolled up a little, her arms crossed in front of her, defensive. Something in her pocket, but it's not a pen because it's not sticking out far enough. Occupation: first female Fortune 500 CEO, publisher of *The Washington Post* who oversaw the coverage of Watergate.

Nelson Rockefeller is smiling the way all rich men smile, with one corner of his mouth and a squint in his eye, huge glasses on his face. His suit's better cut than a lot of the suits we've seen so far. Occupation: Vice President explicitly asked to step off the '76 ticket in favor of somebody less mellow.

F. Edward Herbert has on a two button jacket with the lower button unbuttoned, hand at where the seams meet, very old-fashioned. Is that a pinkie ring on his finger? And then a very audacious silken pocket square next to a conservative parallel tilted flag pin, looking right at the camera. A man for all seasons, maybe. Occupation: House of Representatives, D-Louisiana.

The Honorable James Skelly Wright mainly wears a big smile, judge's robe unbuttoned, hands on his hips, conservative pattern on the tie. No glasses, for the Kennedy-appointed anti-segregationist judge of the U.S. Court of Appeals for the D.C. Circuit is not at all myopic.

Barbara Jordan: an obelisk with her hands on her hips, white shirt and white jacket on white background, just the blackness of her face at the top of the frame and the blackness of her hands at the bottom of the frame. The shirt and the suit are buttoned well, but they're creasing in a way that bespeaks action. She looks right at the camera; it looks like she hasn't blinked in a while and it furthermore looks like that doesn't bother her. The lower half of her face is relaxed, neither smiling nor frowning. Conservative earrings, conservative hairdo. It's confrontational and comfortable with itself. Occupation: House of Representatives, D-Texas.

Now we're onto the quarter-page spreads, those children who become lesser gods. Leonard Woodcock with overcoat in hand and jacket unbuttoned, President of United Auto Workers and slot #9 on Nixon's personal enemies list, next to Frank Fitzsimmons, President of the Teamsters with a buttoned-up two button jacket and maybe a flag pin on the lapel there. Crinkly eyes, eyes that are used to saying, "what!? What?" Arnold Miller, President of United Mine Workers of America, is equipped with a super-wide tie, super-wide tie pin, two or three ballpoint pens in his pocket, both hands in his pockets. He looks worried that he's in trouble. Thomas Gleason, President of the International Longshoremen's Association: Huge tie, tiny knot. Huge head, tiny pocket square. He looks like he can't believe he has to do this. He's not frowning about it, but he's not happy to be there, either.

Frank Church, Senate, D-Idaho: Running his hand through his

hair, trying to act like it's cool to be running his hand through his hair. French cuff and cufflink clearly on display, paisley tie. You can tell that it's really loud colors; it just doesn't translate, his jacket over his arm, and some file or something under his arm. He's working, he's in progress. He's busy; he is almost too busy for this photo. And it's crazy to slot him next to Daniel Inouye, House of Reps, D-Hawaii: full body, down to his hips just so you can see one side of his jacket has no hand at the end of the sleeve. At first you almost don't even notice it. The shirt is super kitschy. Strong eyes. He doesn't look sad; he looks like he's hanging in. But there's that suit jacket arm—just hanging there. I mean it's right in the middle of the photo. It's pointing right at the center of the page where your eyes naturally want to go. It's a setup, to be looking at that. Church with his right hand going through his hair and Captain Inouye with his right hand made of air. It's a grenade.

Tip O'Neill, House Majority Leader during Watergate, D-Massachusetts: two hands in his pockets and gut practically bursting out of his one button jacket. Looks like he's got little soldiers on his tie, or maybe liberty bells, and he's just making a grumpy face. Peter Rodino, Chairman of the House Judiciary Committee during Watergate, D-Jersey: is slightly staring off to the side and his right eye is a little bit lazy.

Andrew Young, House of Reps, D-Georgia: has his head tilted to the side in a way that says, "really?" His hands up, maybe fidgeting, slightly defensive. Dark jacket, dark tie, much more sarcastic and also much less threatening than Barbara Jordan's photo. Carl Albert, Speaker of the House, D-Oklahoma: two pens poking out of his pocket, hair poking out from behind his ears. He's balled his fist up at his chest and flung his jacket over it. He looks like he had some type of military service; he's holding

himself so sternly, but is relaxed into the sternness of his posture. Emanuel Celler got a bunch of extra white space cause he's leaning on his cane on the other side. Looks like everybody's favorite grandpa, just resting on his cane. Celler almost had Rodino's pleasure of dismissing Nixon, except that instead the fifty-year incumbent took a surprise beating from the left when primaried by a female attorney in favor of the ERA. Thomas Eagleton wears an unbuttoned jacket, hands in pockets, shadows up over the top of his eyes, little bit of a smile, but not too much. He looks nefarious; he looks smug. Occupation: exemplar extraordinaire of the importance of vetting your veep candidate. Neither the first nor last sick gopher to pop up on the ticket, merely the clearest representative of their ilk.

Charles Shaffer's tie is a little crooked, but he's got a nice full head of hair. He's wearing a grandpa suit, but looking sort of young in it with those devil may care eyes. Richard Kleindienst is in a striped jacket and dotted tie. He's holding his lapel in a weird way and he's got his hand in his pocket, one arm super formal and the other arm super casual, smiling with his head titled a little. He's kind of psyched to be there. Herbert R. Miller Jr. is clasping his belt buckle, tie too wide for that tiny tie bar, hand on the inside of his belt loop. This guy's real insecure about his dick. He's got his jacket draped over his arm in front of him, two hands on the belt, the jacket covering himself up. He's defensive about himself, or used to having to play somebody else's offense. All three Watergate guys, and then Joseph Califano, public health guru with two hands in his pockets, a face that's kind of wide-eyed, googly. Lips parted a little bit, like he's a mouth breather or something. Suit just a little rumply—looks like somebody gave him that job and now he's somebody's errand boy.

Then a return to full-page majesty with Cesar Chavez, the corners of his mouth naturally curving down, but he's smiling with his eyes. He feels good about his life. This is not a man who is haunted, but a man who has seen things. He looks wise, perceptive in a fairly simplistic worker shirt, maybe green, maybe khaki. Top button unbuttoned, one of the two front pockets unbuttoned. This jacket is for using; it's work clothes.

Ronald Reagan, ghost of Christmas future! Most everybody that has a pocket square is using a triangle point sticking out of the top, but Ronnie's got the box top on his pocket square with a spread collar and on the whole far more fashionable armor, more California. Perfect tie knot, perfect tie. The lapel cuts down a little lower. This man knows a tailor or two. Hands out of his pockets, just enough cuff, but not enough to see whether it's French cut or regular, and he is not looking at the camera. He's looking inward toward the centerfold with his lips pursed a little, like he has just finished saying something or he is about to be saying something. Nice tall head of hair, good body and volume on the top there, especially compared to his colleagues in these other photos.

Walter Annenberg, Ronnie's bagman: arms crossed, a very prominent display of both cufflinks, dotted tie, jacket buttoned all the way up—defense. He's looking to the inward fold, which highlights this sort of mole or birthmark that's on one side of his face. You can even see more of the baldness that's underneath his comb-over from this side. Avedon used his bad side, unless whatever is on the other side is somehow worse. This is a behind the scenes guy. His bad side is his calling card.

Edmund Muskie, the momentumless man: Hands behind his back, furrowed brow, looking off to the side, skinny tie, pointy jacket, not very well tailored. Hair is just a little bit unruly. This

guy is a bureaucrat, this is a guy who works hard for the money and probably shouldn't be in front of a camera, let alone in front in the polls.

Eugene McCarthy, the D-Minnesota, kids, not the R-Wisconsin: I think he's actually sitting down, pigeoning on a stool. He's looking off into the distance in a very judicious manner. He's got his light-colored overcoat in his hands against his dark suit. He's clutching it with two hands and his hands are touching each other, like a gesture not quite of defense, but of conciliation to himself, to make sure his left hand is meeting up with his right hand. He's looking down a little bit, even though it accentuates his jowls and his chins.

Bella Abzug is hands down the cheeriest picture we've seen yet. It's so fucking slap happy it stands out immediately—even though she's got this huge hat on her head and this very loud printed dress, even though she's kind of dumpy in it and it exposes the rolls at her wrists. You can't see her hands but you can see a couple of liver spots. She's smiling her lipsticked head off and she's just so psyched. A photo shoot is a good time. This is somebody whose work is mainly about socializing. You wouldn't mind getting a hug from her. Occupation: House of Reps, D-NY.

Melvin Laird is wearing maybe a seersucker or maybe a linen jacket, summer weight even though it's October. His tie has got flags all over it and "Ford 1976, Ford 1976" in a banner across the middle. Like you can't look in his beady eyes and infer that tidbit of allegiance on your own. He's showing off his cufflinks, but you still can't make out the design of them in the photo. Probably they say "property of Gerald Ford" on them. The light catches them in a funny way and you can tell there's some writing around the outside but you can't see what it is, so mission fail. Occupation:

Nixon's Defense Secretary.

George Bush, the elder, is in a three button suit with the bottom button unbuttoned, with a pocket square so dark against the suit that it doesn't work in the photograph. Hands in both pockets, slouchy in his rep tie with single-color stripe, looking straight ahead at the camera but kind of lit from the left so one side of his face is slightly more shadowy than the other. He looks pretty young. He looks astute, like he's listening. But his tie knot is crooked, swinging gently toward his darkened right side. Occupation: DCI of the CIA.

James Angleton, molehunter, has both hands in his pockets, big white pocket square flying around like crazy. It's got so many edges it looks like it might be a piece of Kleenex. And some sort of mark on the bottom of his tie that looks like it says CW. Like some sort of monogram, but it isn't his, so maybe a brand logo. Or a secret sign to somebody who knows to look for it. And he's got a huge contrast-stitching button hole on the lapel, a crazy big flair on the bottom part of it, just like the supersized flair of his ears. A guy with ears like that should not be wearing a peak lapel. All distractors aiming your eye away from that CW. He looks a little nefarious, at best.

Donald Rumsfeld, henchman: A name that I have heard so much in my own political time, both the oldest and youngest Defense Secretary we've ever had. One hand in his pants pocket, one hand holding a dark leather portfolio that doesn't even look like it has any files in it. He has a huge peaked lapel, just enormous. Even though the suit does seem like it's pretty finely tailored, the lapel is ridiculous. Hair slicked back, same type of receding hairline and parting decisions that are being made by Bush. He's got these aviator style glasses that are so huge the lights are shining off

the top of them and the net effect is that you can't see what he's looking at. You can't tell whether he's looking at the camera or slightly to the right of the camera because the glare blocks you from seeing which way his eyelashes are pointed. He's sort of snarling or pursing, a faint twitch to the left side of the upper lip. And he's pretty trim for a guy whose fashion choices emphatically endorse the philosophy of go big or go home.

Elliot Richardson, Commerce Secretary, is a snappy bureaucrat in a two button suit, a tie that's got maybe bumble bees on it, dark glasses. He looks a little like Clark Kent, actually, and he's holding his briefcase in one hand. He's holding it with his thumb braced against it in a way that says there probably actually is stuff in there.

Lady Bird Johnson, wife of Big Man #36, is trying to smile, but against that pointy nose she can't help it that she comes off looking like the wicked witch of the west. She's got one eyebrow arched up, but with her eyes, you can tell—she is really looking at you and it seems kind. Her hair is very dark, but her expression confirms she has plenty of grey hairs. Her hands are at her sides but one hand is slightly toward the front, as if she is smoothing her skirt or holding her skirt in place. Her face is toward the camera head on, but her body is turned slightly to the right like they do for every kindergartener's first school picture.

J. Paul Austin, King of Coca-Cola, has folded his arms so that you can see his super hairy hands poking out, but not his cufflinks. He's kind of scrunched up, but actually you can see he's got big biceps. He's like the Incredible Hulk, straining the fabric of his jacket. His tie is bunched up, and he's pursing his lips in a frown like he is meditating on the future. He's thinking over some next few moves. His hair is kind of tousled in front of his face;

he obviously is too preoccupied with life to be concerned about hair product.

Jules Stein, founder of MCA and agent to the stars, looks like someone with whom you might badly want to have dinner. His suit is very thin, very finely tailored. He has a three-prong pocket square that's either sewn that way or very carefully arranged, cuffs peeking out of his jacket just a precise quarter of an inch, very dark suit, very dark tie with conservative pattern on it, and a cane. And he's leaning on the cane, but the cane is also leaning on him. They are in a dialogue together. It's pointed inwards, causing him to point outward toward the side, and clear frames on the glasses that don't take away from his face. He generally doesn't hide his face; he's bald, some white hairs on the back but his ears don't stick out too far. He's very well-groomed—he's like someone you would have tea with, and he probably also has a signature scent both delicious and memorable. This is a good picture. Maybe the finest in the whole bunch.

Then we return to the quarter-page portraits with Shirley Chisholm, the first African American woman elected to Congress, D-NY. She's got crazy hair and maybe is smiling, but her face is just doing something weird and she has on a kind of military-looking dress with epaulettes on the shoulders, kind of like a Girl Scout. But then she has this huge pendant hanging over a very oddly shaped collar and she's got a belt around the middle so that it's sort of like a safari girl, and a big bracelet on. It's unique, but you don't know what else the message is. And I'm also not at all sure that's her real hair. She's just trying so hard to show off so many things. It's an interesting contrast to George McGovern, introduction painfully unnecessary, who shows off nothing. Two-button suit with a vest underneath, ticket pocket, dark tie. He's not

smiling, he's not frowning. He's peering off into the side of the frame and his mouth looks like he's just getting ready to maybe say something. An astute man, but a man who is tired.

W. Mark Felt, also known as Deep Throat: Strong nose, weak chin, he looks a little like a Robert DeNiro type. Weird seams on the pockets, like the jacket is made of poor-quality material. Rose Mary Woods, Nixon's gatekeeper, looks like somebody's secretary and nobody's wife. Competent like a bulldog, she knows what you think of her and she wears that loud shirt anyway. The pearls are just to pour salt on your wounds. Arms at her sides, but a little out from the sides, not touching herself, so she is ready to move whether on offense or defense. She is taking up her space and if you want any of it, you better ask nicely.

Arthur Burns, FRB Chair, has glasses in hand, trying really hard to look super serious. It comes off cheesy instead. White hair, not a lot of people parting it down the center on gentlemen of this time period, but this guy is going to risk it. Interesting choice. William Simon, Treasury Secretary: why would you ever take a photo with one hand behind your back? I mean, it just looks so deceiving. He's got those coke-bottle glasses on so his eyes are magnified and also you can't really see his eyes because of the glare. Earl Butz, Agriculture Secretary, doing it traditional with flag pin, conservative jacket and conservative tie and conservative haircut and conservative eye glasses. This is a bureaucrat. He's a dinosaur. Benjamin Bailar, Postmaster General, has put hands in his pockets in a way that makes him look super fat, which doesn't make any sense; it's just something about the way his black suit is catching the light here. But he looks worried. He looks like he's somebody's errand boy and he spilled the coffee.

Ralph Nader, five-time presidential candidate and full-time

business agitator: skinny, slumpy, neck bunched forward, hair acting crazy, no tie pin, no lapel pin, no pocket square, one thumb stuck in his pocket like, "see, it's casual." He's concentrating all his energy on that thumb in the pocket. The rest of him just looks very uptight. Clark Clifford, lawyer and loyal adviser to many a Democratic president: now that looks natural! Two hands in the pockets, kind of smiling, but he looks like he knows a couple of dirty jokes. Super tight knot on the tie, like he probably just leaves it that way overnight and puts it back on over his head in the morning. Cyrus Vance, Kissinger's successor, has both hands behind his back and is smiling in a way that you don't really know if he's got a knife back there or a bouquet of roses. Hyman Rickover, Father of the Nuclear Navy, looks off to the side, a little slumpy with some sort of very ostentatious tie pin that is possibly a flag pin being reappropriated as a tie pin.

I.F. Stone, investigative journalist, is the only guy in a polo shirt. Very unruly hair, genuine smile, wrinkly face. This looks like another guy you'd like to have lunch with, but off the record. Pete Rozelle, NFL Commish, stares straight at the camera and is awkwardly caught between informal hands and formal posture. You'd think he was saying to the camera guy, "like this? Put my hand in my pocket like this?" Like they took the picture one second too soon. Edward Wilson, the world's leading expert on the study of ants, looks like that guy in every office to whom everything bad happens. Daniel Boorstin sports a loud, hand-tied bowtie and a conservative suit. Two hands in his pockets, little round glasses. He's smiling and squinting; his job is probably not very important, but he's good at it. Gives him a lot of time to do whatever else he's going to do, like hit up a nearby bathhouse. Occupation: Librarian of Congress.

Again with the full pages beginning on page eighty-seven, A.M. Rosenthal has a newspaper in his hands behind his folded arms with his watch showing. That newspaper looks like a natural part of him. He's not even worried about getting newsprint on his suit or anything. It's not for security; it's not protecting him. He's protecting it, the natural extension of him. Occupation: executive editor of *The New York Times*.

Felix Rohatyn, NYC municipal bagman, has both hands in his pockets, even though his pants are tightly tailored. To declare it generously, it looks like his tan might be a little fake. The corners of his mouth are turned down, not frowning—he's smirking. I think that's actually meant to be a smile. He's a shyster, this guy. He's holding somebody else's leverage.

Daniel Patrick Moynihan, Senate, D-NY, is a guy with whom you could go bowling. His suit's still buttoned, but he's got his hands comically perched, not only at his ribs, but like his elbows are pointed back—I want to say it's the classic idea of "arms akimbo," but it actually almost looks like Superman, like he just landed on the spot or something. And he's got a bowtie that looks like he tied it himself. It's just got pin dots on it but he's got these huge bushy eyebrows, and his hair is a little long, a little less greasy than the other men of his age, and he just looks so thrilled to be there. He's kind of cheeky, even kind of a clown. Good sense of humor about himself, rare for a political animal.

Roger Baldwin has got his hat in hand and is gripping tightly to the brim of it in front of him, fig-leaf style. His chin sticks out really far. He looks like a guy who has seen a lot of shit go down and can make sound judgements about who belongs on the clean-up crew. Occupation: founder of the American Civil Liberties Union.

William Paley, who built Columbia Broadcasting System, has been fucked over by a misprint on this page. It has some white streaks that are going across his very dark suit and a couple more over his face, where it looks like the page was printed with a fold in it that has since been smoothed out—but it cost them some ink in a few places. Not very interesting and it really distracts. The suit is so dark that these white lines going through it seem so, you know, like the fates leapt in on this one schmuck and none of the other bloodsuckers. And if you look at his face, he looks a little worried. But really, you can't even—he fades out just behind the couple of white stripes erasing across his countenance.

And on the back side, sharing a page with him is Edward Kennedy in the same situation of these couple of white lines that are just going across the page, but even though there's one going right through the top of his face, somehow it just doesn't distract. Kennedy has much stronger eyes than the other guy. The other guy doesn't draw you. I don't even remember his name already, but Edward Kennedy? It's not clear whether he is looking at you or looking off to the side, but you know, he's looking, definitely. Well-tailored suit, tie nice and straight, hair in good shape. He knows how to take a picture and he's been taking pictures a long time. Doesn't matter about a couple of marks messing up this particular image. The American people can always fill in the rest with their collective imagination.

Rose Fitzgerald Kennedy is wearing a beautifully draped dress. It might be cream-colored—it might even be rose-colored—with big three strings of pearls clasped together through a broach around her neck. The dress has these very flowing chiffon sleeves. You can see her hands poking out of the bottom and they look weathered but it also seems she has her nails painted. Some light

pink color, maybe. And pearl earrings to match the pearl necklace, plus the very voluminous hair that runs in the family—a little bit of gray around the temples, but you wonder how much of that is her natural color and how much isn't, seeing as how Ted Kennedy on the opposite page has more gray hairs than his own mother. And she's not smiling, but her face is doing something definite. It's conveying that she knows who she is, and she knows that you know who she is, so she will endure the camera while it looks at her because that is the life of a Kennedy.

Huh, a two-pager for the Joint Chiefs of Staff with the two tallest guys on either end and three shortest guys in the middle. One guy with both arms at his sides. One guy with his right hand in his pocket. One guy with his arms behind his back, one guy with his arms in front of him and the other guy with his arm at his side. Everybody's got their own unique pose. They're all in their uniforms. Four dark ties, and then the guy on the end's got a light tie. Four out of the five of them are looking directly at the camera. These are all team players. Their faces are all in various uncomfortable states of merging best photo face with heavy job title face. Primarily, I wonder how they would each look alone. They're all shoulder to shoulder, touching each other.

And last but certainly not least, George Wallace is seated in his wheelchair with the wheelchair visible, his hands resting separately at ease in his lap. You can see his wedding ring and some other ring, maybe a class ring, plus a gold band on his wrist, and also part of his watch. His tie pin, his pocket square. He is a big-time accessorizer, lots of flash. He's looking down at the ground even though he is facing forward, like he's looking at a dog that wants to pounce on him. This poor schlub. Seriously, somebody get this man a hoodie!

I feel strongly that every person should own a good hoodie, you know, just a really nice hooded sweatshirt. So I went in quest of the ultimate hoodie, and I eventually found it. It was manufactured entirely in the USA, had excellent support at crucial seams like at the edges of the pockets and the shoulders, included sturdy zippers and handmade grommets on the drawstrings for the hood, and so on. And it was ninety bucks, so I really had to mull it over, meaning I had to take a full day's thinking space to really gather up momentum on talking myself into it. Eventually I did, and I was going to buy it this Saturday, but then I didn't, because my wife and I went out for Chinese food after work on Friday night.

We went to this amazing little hole in the wall of a strip mall joint that's close to her work. They have a sweet chili sauce on top of a cold noodle dish that I dream about with a frequency that puts it on a whole other level from any other food I've eaten so casually. At the other end of the plaza was a discount wholesaler clothing store. My wife needed a new belt, because her reversible black and brown one was beginning to separate on the edge and she wanted a quick substitute. Well, it led to a lot of browsing around, like you do. I started just by waiting around, trailing my wife at a safe distance, and idly flipping through some long-sleeve button-downs, but at some point it occurred to me that my closet is already full of too many shirts I don't wear often enough, and I decided instead to poke around in the racks of coats toward the back.

I've had a wool coat quest on the back burner for a while now. I acquired a terrifically rugged, double-breasted navy blue peacoat a few years ago. It's from the '90s and looks it, as far as things like fit, length and lapel. I can wear it well, but it's not

totally the perfect thing. So I've been on the lookout for a better, more modern parallel. This involves trying on a cornucopia of options, but it's not easy finding the right coat. This would be just for riding in a car and heading into the winter with a good thick scarf for a business or fancy-like occasion in a shiny pair of wingtips. It had to be a little bit professional and dashing, maybe even something a politician would wear. Sometimes there are excruciating but slightly entertaining days when I'm more of a politician than a sailor.

So there I was in the discount place, overheating with all the inadequacies of abundant choice, when I happened to pass a coat that calmly reached out from the rack to metaphorically flick me on the back of the ear. It danced annoyingly, magnetically, in the corner of my field of vision. I knew instantly that I must try it on, and as soon as it crested my shoulders, I knew immediately that I would buy it. I knew this before I rounded the bend of the rack to look at myself in the mirror. It didn't have to look right, although it absolutely did. It had to feel right, and damn did it meet me where I was at on that score without reserve.

This wasn't a coat for once in a while, it was a coat for every day. It has all the things, and bear in mind that I'm an all-weather biker, so that's a lot of unusual things. It has side hand pockets that are reinforced slits with no zippers, so I don't have to take my gloves off to unzip my pockets before shoving my hands in there to get warm, I can just shove them in gloves and all for double warmth without stretching out the pocket seams. It has an inner fleece lining with its own secondary zipper, so the cold from the sixty mile per hour wind won't bleed into my chest through the coat's front zipper too quickly. It's got a left sleeve zipped pocket that is a great place to keep my iPod and earbuds, but it also has

a pocket inside the jacket actually dedicated to mp3 players that includes a buttonhole to thread my earbuds through, ensuring that after my ride when I put those little plastic nuggets in my ears, they are not freezing from the wind either. It's got a cavernous hood that zips off if I get tired of it, that meanwhile protects me from both wind and precipitation once my helmet is off and the bike is parked. It's got two thick collars, one from the inner fleece layer that comes up like a mock turtleneck, and another on the outer layer that rises to my chin. It hits me at the right place on the hips without squeezing them or riding up. It's a beautifully crafted gray bomber jacket. And of course, it takes the business of waterproofing very, very seriously.

It's a modern, science-riddled, urban textile coat that will replace my current winter riding coat—a coat that is a highly expensive, extremely high-performing pro snowboarding jacket that I found in an obscure corner of the internet. It had been serving me faithfully for several years, and I never dreamed I'd find an upgrade so I really never even looked for one. But it made me look like a fucking suburban soccer mom and it was clearly sending a message that I was trying very hard to sacrifice fashion for function. The sudden appearance of this new gray bomber jacket provoked in me a major realization about my personhood, which is this: I am not a person who wears wool coats.

I am a person who wears textile coats. I do not like to wear trendy things unless they are firstly cleanly useful to me and secondly comfortably usable for me. Only then am I in the mood to entertain the prospect of fashion-forward clothing. Wool generally gets wet and stays that way, and it doesn't breathe. It gets bent out of shape or the fabric piles and it needs a dry cleaning. I'm not really into any of that and I don't think I'm alone on that.

To paraphrase a great bit about torture from a children's book turned cult favorite movie: we are men of action; wool coats do not become us. All my life, I've been given to understand it is trouble to be judging a book by its cover, and I have easily agreed with the sentiment there. But the truth is also this: you can judge most motherfuckers by their coats.

NOVEMBER

Beatles Bomb With All This & WW2 ... First Megamouth Shark Discovered ... Surrealist Painter Dead: Man Ray "Unconcerned, But Not Indifferent" ... Armed, Drunk, Arrested: Jerry Lee Lewis at Graceland ... Howard "Mad As Hell" Beale Assassinated ...

Dear Bapa,

You must've heard by now that Jeni's been in the hospital. It's some kind of aneurysm thing, and they're keeping her konked out so she doesn't wake up and freak out about the NG tube. The doctors say if she lives through the weekend, there'll be a lot of work to do to get her motion back. Jeni has always been a stalwart Viking queen, but look here: seems like you're going to be my last grandparent standing, at least literally.

So this letter is just to say congrats. You deserve it. You earned it. Jeni's husband died when I wasn't yet walking and I don't remember him at all. He must've been one tough bastard for how fucked up my dad is. And Jeni was always good to me, bless her, but we were never close. It was always you and Lulu being my family, as far as my memory can reach.

Lulu was such a whippersnapper. She was beautiful like Judy Garland. Remember when I did that report on your service in Casablanca for my World War II project in high school, Mr. Garvey's Honors Euro class? You gave me all those pictures of you in uniform, with the little hat on and your boot up on the fence, sipping a Coca Cola with one elbow resting on your knee like the war was far away. There were a couple pictures of you and Lulu dancing in the front yard of a house I've never seen, and damn it she was so pretty—smiling like she knew it, too. Smiling the type of smile that transforms into laughing sounds.

I bet you were sacrificing for her from the very beginning, and doing it happily. She was the center of everyone's universe when I was a kid. All the kids felt so special and I have no doubt it was always worth it to you to stick by her side. Even to this day, no

girlfriends for you in the old folks' home, faithful to the very end. I've married a woman like that, too, and when she's gone I know that's it for me just like it is for you. I'll have my books, same as you do. It'll be enough.

You're a fucking saint to me, Bapa. Seriously: that life-long love of learning and carnivorous reading, that willingness to work hard and be satisfied with whatever fruit it will bear, that quiet sublimation of your own big personality to the demands of your shining wife and nutty family. I ended up doing all that, and the only reason I do it with any grace is because I've had you to model it for me all these many years.

So this letter is to officially say thank you for all you have given me and all you've shown me about how to carry on in life as my best self: about self-examining reflectively but not obsessively, about the true nature of contentment. I like who I am and I wouldn't be at all who I am without you.

It's good that you'll likely be my last grandparent to go. When you do finally kick the bucket, I promise to lose my mind in enough moderation to help everybody else get through it, just like you did when Lulu died. Remember when I came over for a little while after sitting shiva for her, and we were doing whatever in the bedroom when the lightbulb on her side of the dresser (hell, the whole dresser was her side, but still) started flickering and went out? Neither of us were near the lamp or the light switch, and for a few seconds we just sort of stood there knowing she was sending us a sign. Or not, and it was just the bulb's time to go. We kind of laughed about it, the kind of laughter preceded by frowning, because we were both a little spooked. When you die, please don't bother me with that type of shit, ok? I know you're an atheist, but still, just in case you're not right on the money on

that one, go in peace from me.

Meanwhile, I'm enclosing twenty bucks. Go down the block and get yourself a drink on me. I know you don't really imbibe much at all anymore, but being the last grandparent is a damn fine special occasion for some single malt if ever there was one. Toast to yourself, old man: the last leaf on my own family tree that I'm proud to call an influence. Here's to as many more years as you can handle. Makes me a little nervous thinking about it one way or another, kenahora, so I will end this here. You go get that drink. I'll go listen to some Tom Petty and try to relax.

All my love,
Megan

If I'm being honest, Tom Petty saved my life. From my grandfather, I inherited two things that will never go away: a curious mind and a GI disease. The intellect was evident before I could even walk, but the ulcerative colitis didn't show up until my mid-twenties. It's a painful thing to be shitting blood thirty or forty times a day. Drop somebody in the desert for two or three days and they could probably retain more water than I could during a flare. Most people don't know that the body's automated processes have their own nervous system with a direct link to the brain that remembers to perform them. This includes your entire GI tract. You want to feel a type of pain that you have literally never felt before, just jack up your GI real good for a little while. You can go blind; you can taste colors; you can die. Worst trip I've ever been on and it took a long time to come down.

We could spent a couple of pages drawing out a solid simile from the White House to autoimmune diseases. Hell, the American

idea of independence in 1976 is nothing if it is not the excruciating devotional song of a body under attack from itself, eating the imagined enemies within until the whole body vanishes. It's in our Founding Fathers' genes! But instead we're going to spread some peace and love, man. We're going to examine at length some philosophical propositions for the practice of everyday living within Tom Petty & the Heartbreakers' self-titled debut, because when I was laid low by my liquefying insides and found no respite but in the ugly honey of my own death, this fucking album was there for me and it kept me from doing the dirty deed. Furthermore, we are going to compare this first volley of Petty's, released on the 9th of November, to an album released by Petty's one true hero on the 19th of November: George Harrison's *Thirty Three & 1/3*.

Everybody knows Harrison ran deep. He took no end of shit on behalf of Krishna. Still, most people think the album title refers to a record's revs per minute, that it's all just rock and roll in the end. It isn't. The title refers to the age he was when the album was released. It's at this point I should mention that it's also my own current age. Tom Petty had just turned twenty-six—the age I was when I first came down with the fever from which only his album gave my gut relief. Similarities between the two men are as easy to come by as this numbers game. They're both notoriously private and crabby people with an ax to grind against the music machine and a keen enough sense of humor to do it with a little poise. Petty doesn't ever say much about religion, but that doesn't mean there's no church in his songs. And a dozen years after the Bicentennial, they'll be performing in the Traveling Wilburys together.

They met briefly for the first time in 1974. George was doing

some things over at Leon Russell's place and Tom was helping out around the house—because Lord knows all roads through politics lead to a Kennedy and all roads through rock music lead to Leon Russell. Tom reports that George was very nice to him. Two tracks on Tom's debut album were actually first cut by Tom alone, both playing and producing, just fiddling with the boards in Leon's studio when nobody else was home. Russell helped found Shelter Records with Denny Cordell, though Denny did the legwork for Tom's first album. Russell had known George forever, doing the Concert for Bangla Desh and so on well past the Beatles and well into the Traveling Wilburys. The other guy George and Tom had in common was poor Jim Gordon. Gordon did a bunch of George's solo work and then played drums on one of the tracks for Tom's debut. Now he's serving life in a mental health facility outside Sacramento for stabbing his mother to death. Schizophrenia eats your brain; it's a terrible disease.

The recording of *Thirty Three & 1/3* was stymied by Harrison's bad case of hepatitis, but in his case it would seem to be more about sobriety than autoimmunity. He also came down with a bad case of copyright infringement, initially resulting in a huge debt for "My Sweet Lord" to The Chiffon's "He's So Fine," but ultimately raging on for more than twenty years as one of the longest litigations in U.S. history only to conclude what everyone already knew: Allen Klein managed the Beatles like a scumbag. So George had all this ill to shake off while Tom was lighting a fire up under himself and at the end, each delivered unto the huddled masses in November a truly spiritual triumph parlayed through ten tracks of unerring guitar.

Clocking in at a mean 2:29, the first track on *Tom Petty and the Heartbreakers* is "Rockin' Around (With You)." This song is one

of two that co-credits guitarist Mike Campbell, because Mike's riff with the long singular note at the beginning of each line is what structured the lyrics Tom wrote. At first listen, it sounds like whining. That long note draws out a hold on the first word of each line, which is almost always "why," "I" or "you." But the longer I listened to it, the more open the vowel sounds became and the wider my mouth got trying to sing it loud. And coming out Tom's nose the way it does, it begins to sound like a mantra. I mean, this song has a total of thirty unique words in it, and this long note occurs fully eleven times. Begins to sound like George's "Wah-Wah" a little bit. Meanwhile, track one on *Thirty Three & 1/3*—whose fraction at the end there is transformed into an Om on the cover art, by the way—draws out the end of each line, leaving "Woman Don't You Cry For Me" as a sort of oppositional mirror image of Tom's opening track. Tom is latching onto a lady while George is aiming for detachment from one with a whopping fifty-nine unique words in an equally tight 3:18.

But they both search for the same level of spiritual connectivity on their second track. Tom wrote "Breakdown" all in one quick sitting, on a break between sessions at Shelter's Hollywood studio in the middle of the night. The band had played it all the next day, with some versions stretching out past the seven-minute mark. Tom had every intention of stripping it down to whatever lick worked best, but Mike hadn't played that famous descending riff until near the end. The band woke up in the middle of the night, came back in and played a tight take around Mike's one perfect lick, and that was the 2:43 cut that went on the album. Tom reports that he was going for the drum beat on one of the Beatles' records from 1963, but he explained it to the band wrong and "Breakdown" was the result. "All I've Got to Do" was a

Lennon-McCartney job, but the quietest Beatle picked up that nasal chant from Tom's opening track and ran it into a proper devotional. That's the constant question in Harrison's lyrics: is it Krishna or Olivia? He is writing about god and/or about a woman with equal reverence in the same language. Tom says, "something inside you is feeling like I do," and George says, "my feelings call to you now." The urgency of this "now" requires some emotional permission to break down, to say "now I'm standing here / can't you see" or to say "move me toward thee with each pace" because these two men are sides of the same coin.

Tom's third track is "Hometown Blues," which owes everything to the famous Duck Dunn, sessions bass for Stax who backed up everybody from Albert King to The King. The demo track for this song was recorded at Leon's house, probably just because Duck was hanging out and Tom wanted to harness some of that Memphis for a moment. He called in two Mudcrutch guys and the Heartbreakers dubbed over later on. So Tom had Duck Dunn while George was using the great Willie Weeks for the third time in a run of six albums for his third track, "Beautiful Girl." Tom and George are both desperate to get the girl, but achieve varying levels of success. George had begun writing the song several years before about his first wife, but by the time the song was released, they were filing for divorce and he was writing the lyrics about Olivia instead. Tom would remain with his own first wife for twenty more years. His ode to scene queens and screaming girls is actually sort of a keen portrait of George's first wife, who he met on set for *A Hard Day's Night* while she was between modeling gigs. It also wonderfully downplays Tom's own career, commenting to the surviving members of Mudcrutch and Duck Dunn playing with him at Leon's that night that it "might

not last, but it's no big deal," referring to either their improvised jam session or his big chance at a strong debut or both. And both did last, as did George's love for Olivia. Sometimes it seems the stakes are high and sometimes it seems they're low, but Tom and George agree that the outcomes are no surprise in either case. Tom forgives his flaky lady, because hey, everybody's trying to beat those blues. George is shaken to his core by this grand love, amazed without being taken aback by it.

Tom does know that feeling, too. He runs with it in "The Wild One, Forever." There are only a few hours to share with the girl, but capriciousness has ripples that affect a lifetime. Two odd things about this song. For one, Ron Blair played the cello on it. But Ron's a bass player; he doesn't know one damn thing about the cello. Still, there it is if you listen very closely to the track, giving the whole thing a resonant shimmer it otherwise wouldn't have—that odd little through-note a mere inch away from dissonance that George brought back with him from India many years before. Though it only runs 3:03 on the album, I've seen bootlegs from live shows that double down on it with ease. The other bit of weird is that Tom was aiming at a refrain that resembled the Rascals, who of course opened for the Beatles way back in the day. A lot of people don't remember the Rascals too well, because hey, this ain't a three-party system and the Beatles and the Stones beat them to the punch. And a lot of good that did George, who consistently made fun of his own sad fame amongst the Fabs, and suffered many a lawsuit from having made so much hay in his heyday. Up against "The Wild One, Forever," we have George's viciously ephemeral "This Song." It's directly and specifically about the "My Sweet Lord" faux pas, which at that moment in the everlasting chain of court proceedings was on

record as going to cost him $1.6 million.

Doesn't sound like a lot for a former Beatle, but it is much more than the money. It's the principle of the thing, which Tom would also come to know too well. While George battled endlessly over a single song, Tom would have repeated smaller skirmishes with the recording industry over the same number of years. First they transferred his song rights to another company without so much as asking him, then they wanted to raise the price of his next album as soon as he got a good bit of height on the charts, and finally, he wrote all of *The Last DJ* about the greed of the industry—no doubt bolstered by George's previous outspoken compositions on this same subject. George did his best to laugh about it, even though it's clear he also wanted to ice-pick them in the eye. He was running around with the *Monty Python* people and asked Eric Idle to produce the video for "This Song." It appeared on *Saturday Night Live* just before Thanksgiving, and charted in the U.S. because Americans love a good ice-picking. Only two tracks on the album are longer than "This Song," because once George got riled up to something truly funny, it was hard to get him to "cheer down," as Olivia was fond of saying.

Side one, final track! That's the anchor bit there, you know. This is an LP you'll have to flip over, so the last track on the front side had better be good enough to get your ass out of that chair and turn on the second half. It's on a serious mission. Tom's goes for a slight 2:24 and George's goes just :27 longer, neither of them interested in the three mark because the principles here are sweet with brevity. Tom judges that he can no longer play "Anything That's Rock 'n' Roll" because the voice is so juvenile. He was aiming at Chuck Berry but ended up closer to Buddy Holly. First verse: we partied all night and I quit my job. Second

verse: parents suck and school does, too. Chorus! Third verse: I am emotional about this and am going to assert myself. Chorus! It peaked at #36 in the U.K. and wasn't even issued in America as a single, despite representing everything that Americans stood for at that moment in history: the disdain for responsibility and authority, the yearning to fly free into something a little cooler, and a fierce sense of self that supplants everything else broken.

But you can't say its rebellious spirit is proto-punk. Nope, part of the problem for this band was in the brand—that they weren't punk or new wave or alternative or any specific and thereby commercial genre. Because seriously, as the song states right there in the fucking chorus: anything that's rock and roll is fine. Tom Petty is agnostic on the cornucopia of sub-compartments lining the belly of the beast that answers to the name of rock and roll music. And George, in his slightly older and infinitely wiser way, agrees on "See Yourself." He ends side one with a series of simple juxtapositions like killing a fly or turning it loose. He's all for doing the harder work of letting go those little annoyances. After all, "it's easier to criticize somebody else / than to see yourself." The boss, the school, the parents are all little annoyances to George. Tom is still green and focusing there, doing his best to seem chill through his dismissiveness of everything. George says this is the easy way out. Tom eventually came around to that understanding also, so he doesn't play the song live anymore because it's endorsing a teenager's cowardly rebellion.

The tougher rebels hold out for self-awareness or as George clarifies on track six, "It's What You Value." This song appears to be about cars, playful in its honky-tonk and sax appeals. George is making fun of people who drive souped-up autos, who value that kind of speed and style. As the quietest Beatle has often made

clear, he doesn't value a show stealer. At the same time however, let it be known that George was a collector of fine automobiles, the clearest motorhead among the four Fabs. He once wrote a hilarious three-page letter to one of his buyers about the proper seven-step way to wash his car. He had a Benz, a Jag, a Ferrari, an Aston Martin, a custom McLaren F1 that was built to race. It could do 230 and was chassis #25 out of only 100 manufactured. So this song really cuts either way—the title being both what the driver would say about his car and what an enlightened person would reply to the driver about his car—and is all the more funny if you grant that George knew full well the pose he was striking, holding up his own hypocritical fantasy of being a race car driver. George is both dudes in the conversation.

Tom's opening track on side two is also a conversational blame game. "Strangered In The Night" takes on race relations, first as a confrontation between a black man and a white man, then the white man's wife confronting the black man for shooting her husband, who dumbly brought a knife to a gun fight. Seems the black guy had an ancient beef with the white guy, where the beef was significant to the black guy but the white guy may not remember it. There was a scuffle, a crowd gathered, the white guy dropped his knife, the black guy shot the white guy's head off, everybody ran, then a white lady cursed at the shooter. The chorus just rhymes "light" with "night" repeatedly, also a black / white thing. The story is less than clear and our judgement of the crimes perpetrated has no reasonable basis in either direction. Tom's title says it all, the two sides were strangered—a verb meaning the grieved parties' complaints were made foreign to each other. We don't know if the white guy deserved it or if the black guy went to jail afterward. It's just a violent incident, caused by our failure to

understand what other people value. Tell you what, I bet this song isn't on too many of Tom's set lists because some of those sets are played for hillbillies who'll read it as precisely the opposite of what Tom intended. That's the terrifying joke of striving for ambiguity.

Of course, shooting straight for clarity holds horrors all its own. George's seventh track is a cover of Cole Porter's "True Love." Lots of other people did it first, from Bing Crosby to Elvis to the Everly Brothers. George's version is an uptempo pop devotional, expressing gratitude for the guardian angel watching over him and Olivia. Tom's seventh track also involves a third man in a romance. The other lover in "Fooled Again (I Don't Like It)" isn't exactly a welcome addition to his relationship. This was the only song Tom recorded in the old Warner's studio, because the place was run by iron-fisted grown-ups who took proper lunch breaks and closed up shop every day at a reasonable hour. In a song of 29 lines, 9 of those lines are Tom just howling "I don't like it" over and over again. The third man of the studio got in between him and his music that time, no doubt.

George and Tom become myth-builders on their eighth tracks. "Pure Smokey" marked the second and more soulful time that George paid tribute to Smokey Robinson. Interestingly, this song was one of the few instances where he chose to ditch the slide in favor of electric soloing, which was overdubbed later. George's guitar work grew momentarily more precise, while Tom's got more slippery and resonant on the deceptively country jam "Mystery Man." It was recorded live, no dubs, at the A&M studio where Charlie Chaplin used to film. Tom would always go around poking his nose into everybody else's studio. He saw Johnny Mathis there, and Mathis would later be doing Smokey Robinson

covers while Tom and George were rehearsing together as the Traveling Wilburys. George attributes mythic status to Robinson for his musical accomplishments. Tom imagines mythic status for himself as the anonymous sideman on the arm of his lady love. Again we have two sides of the same coin: a legacy based on one's own success or a legacy based on everyday support for someone else's success, and eagerness to serve a legend in either case.

There are the legends you package as people, and then others you cement through place. George's penultimate track on *Thirty Three & 1/3* is "Crackerbox Palace," the affectionate nickname given to the Los Angeles home of surreal, proto-Kesey performance artist Lord Buckley. Harrison was given an opportunity to visit the house of his comedic idol, but once the song was written and he was given an opportunity to shoot a video for it with comedian Eric Idle, he chose another house in which to shoot: his own. George's Friar Park has legendary gardens, lovingly maintained by George himself for a long time. The house previously belonged to oddball attorney Sir Frank Crisp, who also adored gardening and was furthermore a prominent figure in the Royal Microscopical Society. They were men of like mind, and George once cribbed some lyrics from an engraving Crisp had put on the property, "ring out the old, ring in the new / Ring out the false, ring in the true." That song charted and so did "Crackerbox Palace." The tone and tempo are light-hearted, but the video reveals something more sinister. The mansion is filled with vampires, surgeons, cops, priests, stern-faced nursemaids, lurking elves, skeletons, razor wire, gargoyles—you get the idea. It's ultimately depicted as a gothic menagerie or an insane asylum, really creepy to watch and then impossible to forget the next time

you've got the song in your headphones.

"Luna" is the song that Tom, trapped inside the oppressive and ever-watchful circus of Crackerbox Palace, might sing to alleviate the burden of being imprisoned there. The original demo was cut live in a church in Tulsa, just a basic chord progression and totally improvised lyrics. It was Shelter's other studio and they were ripping it out so Tom went down there at the last minute to squeeze in a free session. But it reads like a meditation visualization: white light cutting through the sky to pool around the singer, gliding and floating and freeing into weightlessness the mind of a trapped man. It's a tossed off little song, dreamy of setting, Tom just absolutely falling back on first instincts for a quick minute. And his gut goes to the same type of images that would ground George's peace of mind for the better half of his life.

The final song on George's album was the one song that he felt was as good as "Something" that he had done for the Beatles. Indeed, there's something in the way "Learning How To Love You" is written that attracts me like no other song on this album. It's the first three lines: "While all is still in the night / and silence starts its flow / become or disbelieve me." Let's unpack what the fuck that means! The first line refers to the type of tranquility sought and found by the singer in Tom's "Luna." It's the hour of the wolf, everything unmoving but clearly present, prime time for Transcendental Meditation technique. The second line forms a twin set of koans, briefly casting great doubt on the validity of the first line. For one, to flow requires action while all being still implies the opposite. The lyrics therefore posit an unmoved moving, which is a performative contradiction. For two, within the second line itself, silence cannot start to flow because silence

is an absence and flow requires presence. The lyrics therefore posit a present absence, another supposed impossibility. These are no more or less guiding ideas than Linji's famously scary one, "if you meet the Buddha, kill him." These are mysteries of essence! Your two options in the face of this entirely gray area, according to George Harrison, are to "become or disbelieve me." If you are willing to become him, you will be left alone with your heart (another space for contradiction), learning how to love. Become is to grow. Disbelieve is only to think. Let's not get too thinky, everybody!

In the "not too thinky" department, we close now with some meditations on the final song of *Tom Petty and the Heartbreakers*, "American Girl." Tom reports that this song has nothing to do with a college girl who jumped out the window in Gainesville. He wrote it in Malibu, listening to the highway noises and mentally transforming them into ocean sounds. Another classic meditation visualization. This American girl was "raised on promises" and still "had one little promise she was gonna keep." Wondering what it was? Because most of the fans believe it was suicide, not exactly the American Dream. "It was kind of cold that night," she was "alone" and "desperate," but above all, "she was an American girl." And that's it, man, with the present absence of that twisted little annoying pause between "she was" and what exactly she was. Song didn't even chart in the United States and now Tom's got to play it at every show for the rest of his life or suffer the angry mob. There's a whiff of nihilism in there somewhere. *Rolling Stone* said it's one of "The 100 Greatest Guitar Songs of All Time." In fact, it's #76.

Then more than twenty years later, the Strokes plainly stole Mike Campbell's gorgeous "American Girl" riff for their pretty

lame hit single "Last Nite." Tom thought the fact that they admitted it in print and in public was so funny, he didn't even sue them for copyright infringement. Indeed, not only didn't he seek to ruin them, he asked them to open for him and the Heartbreakers a few years later. Cheeky bastard. At the end of that tour, Julian Casablancas announced that the Strokes were going to take a long break. The break lasted a little longer than Jimmy Carter got to be the President.

Boy, that one was a squeaker! Carter came out ahead by 2.06% of the popular vote. That's a mere 1.6 million people. Turns out, 1.6 million is a tremendously large sum of money to a former Beatle and a tremendously large sum of votes to a sitting President. It's a 57-point spread in the Electoral College. State for state though, Ford actually took Carter by five. Carter was the last Democratic President to win in Texas. The Bushes are starting to get traction, you know.

DECEMBER

Arguing With My Father-in-Law ... Why Hate Blondie ... Standard American Samurai ... The Offices of Bergen, Curtain & Radner ... Diana Nyad Is A Lesbian Atheist ... The Bangs- Belushi Affect ...

ave I said anything about women yet? Let's briefly recall that I am one of these. The other day, I found myself embroiled in an argument with my father-in-law concerning the intellectual abilities of Marilyn Monroe. He said she was above average in the smarts department and I said she probably wasn't. At first, his main warrant for this absurd claim was that we should take a look at her husband because Arthur Miller wouldn't marry a dummy. Setting aside for a moment both the problem of judging a lady by her man and the problem of trusting Arthur Miller's character judgment at all, I told my father-in-law that I know hundreds of writers and would lay good money that every single one of them would jump at the chance to marry Marilyn Monroe with utter disregard for how stupid she might be. For some vaporous but deeply held conviction about the independence of the American Dream Girl, he continued to pursue this line of shoddy reasoning featuring Joe DiMaggio and then JFK, as if it was only a question of ethos and surely one of Monroe's men had enough of it that we should accept his love for her as proof of what she had upstairs.

The second round in this battle for the soul of America's sweetheart occurred the following morning, when I found my inbox stuffed full of articles that he had researched and forwarded to me, all testifying to the brains behind the broad. Fair person that I am, I skimmed each of these articles before concluding that they were of insufficient evidence to prove his point. I mean some of them just said she read a lot of important books like *Moby Dick*, and others gave personal anecdotes involving deep conversations she is supposed to have had about her career ambitions. I've been known to chase a white whale now and then, too, but it doesn't speak to my smarts, does it? My father-in-law eventually gave

up trying to convert me, which left me free to ponder two more useful questions, namely: why did I give a fuck whether Marilyn Monroe was smart, and why was I so unwilling to give her the benefit of the doubt? Feminism means never judging a woman's brain by her vagina, right?

I care about Monroe's IQ for two reasons. First, because she became an iconic American thanks to her outer beauty. Everybody was dying to know what was under there, but a few of us might like to put her on a celebrity pedestal the better to hear her voice, as opposed to the better to look up her skirt. Second, because she died of acute barbiturate poisoning at the age of thirty-six. I believe dying young on purpose or in an overdosing accident requires a special skill set that tends not to loop in a great deal of participation from the brain. But hey, let's keep blaming fate, not Marilyn. It's a better tragedy if you do!

So if I give her the benefit of the doubt, I'm trapped with a version of history where a woman who was empowered by both her body and her mind could've had all the success of which she dreamed so ambitiously, but instead allowed herself to be subjugated to the position of sex symbol until coping with the emptiness inside herself required so many drugs that she torched her own rise to stardom and died in the weakest way at the least opportune moment. She ain't no Joan of Arc, you see what I'm saying? I'd rather believe she was a little too dumb to handle it and she just lost control over her own trajectory. I don't want to believe that Marilyn Monroe was a picture of the consummate professional, full of intellect and common sense, who nevertheless cracked. Let me start her out at a little bit of a disadvantage, because if she was the total package and couldn't maintain, what chance do the rest of us schmucks have?

Talking about Marilyn gets me down, man. I always end up blotting it out by shifting gears to Blondie. Now Debbie Harry has smarts! Plus, she looks just like Marilyn Monroe. In the beginning, that's all people could see about her. Debbie was adopted, too, and the timing of things matches up to a remarkable degree, such that it's not too hard to see why urban legend posited one was the mother of the other. The lead singer of a band could ride that wave of public conversation for a long time, like three-quarters of the way to fame. What an easy band to photograph! Never mind that they maybe kind of sucked at first, because this band had star quality. Don't you just want to rip them to shreds? Look at that zebra print dress.

From the beginning, Debbie Harry was in charge of herself. She gleefully and often campily capitalized on her own sex appeal to drive the band's image into record sales. The CBGB regulars cold-shouldered them a bit, whispering about how they were sell-outs before Blondie really sold anything at all. But you could see how the standard American male was going to buy in in a big way, once you wiped away the drool hanging out of their collective mouth. When Blondie's debut album dropped in December of 1976, nobody in America bought it. The band bought out its contracts and reissued the record a year later, when it once again failed to catch on. Their second album came three months later and the third album came just seven months after that. At that point, America realized Blondie was serious.

Or did they realize she was not serious? I'd like to give Blondie full credit for importing irony to the music business. No other band in rock history has so aggressively and winkingly exploited its own titillating image to achieve world domination. Then with every lyric, Debbie Harry is smiling at you only for you

to understand a moment later that she's actually laughing at you. Every song has a serious reading and a smart reading, and it's so constantly well-balanced that we can feel safe attributing actual brains to Debbie Harry. She produced an imminently sellable, salacious band concept. Even today, you still see hordes of gay men at Blondie shows because they are proficient at reading the language of ironic distancing.

Meanwhile, millions of standard American males were duped. They had worshiped her and she cared nothing for them. Take Lester Bangs, whose contributions to rock criticism are as clear as a bell. Bangs had been a huge fan of Blondie's debut. He was preaching the gospel of Debbie Harry all over the place, but the more work the band did, the more Bangs began to feel as though he'd missed something. By the time their third album was out, Bangs was on the rampage, writing a quickie hundred page fan bio of Blondie in two or three speed-fueled days of fever dream. It was supposed to be an authorized biography, but ended up like an ex-boyfriend's crazed public service announcement about the bitch that dumped him.

Debbie Harry and Lester Bangs never hooked up, mind you, but the number of times Bangs likely jerked off to her picture can't be overestimated. He was jilted to discover that she was her own boss, and in misconstruing the emotive capacities of her singing as earnest and serious, he was shamed by the sudden realization that she had a tricky sense of humor. He conflated passion with earnestness! He fell for the joke! She was therefore smarter than him and he was threatened. So Bangs retaliated with a public screed, a burn notice that Blondie was a soulless piece of commerce. Fortunately, the angry misogynist rant read just like what it was, and Blondie sallied forth unscathed with the lesson

of that whole ordeal tucked quietly into her back pocket. Debbie Harry has been rocking for forty years and who the hell still reads Lester Bangs?

The standard American male is raised to privilege a specific language, rife with belches of chauvinistic drivel and surrealist detours that, when boiled down to its essence, most closely resembles John Belushi's samurai character from *NBC's Saturday Night*. Sure Belushi was a genius, but he was also a pig who wouldn't give full voice to bits during a table reading if he knew that those bits were written by a female staff writer. He thought women fundamentally lacked the capacity to be funny, let alone rise to his level. Belushi was poised to be a big deal at the end of this year on *Saturday Night* primarily because Chevy Chase had just exited and Bill Murray had not yet arrived. So the Season 2 Christmas Special should've showcased every talent Belushi had. Yet, skit for skit, the women are the ones who're crushing it.

This episode is hosted by Candice Bergen, doubling down after having nailed the Season 1 Christmas Special. She was the first woman to host it, the first person to host it twice, and also a fashion model who happened to help organize the McGovern campaign. She once pulled a prank with Abbie Hoffman that shut down the New York Stock Exchange. The smarts are right there on her sleeve, but she's also just beautiful. So *Saturday Night* skips the traditional on-stage intro in favor of walking the camera over to Candy's locked dressing room door. Jane Curtain knocks gently and after a few minutes of girl talk, uncovers the fact that Candy is too nervous to do the intro because all she can think about is her unrequited love for scoundrel John Belushi. Belushi struts around the corner trailing a cigar and white tails, coaxes her out from behind the door and onto a nearby set where they reenact

the end of *Casablanca*. So schlubby Belushi gets to be Bogart and this terrifically capable young lady has to act like she's weak in the knees for it.

Then Dan Aykroyd as Jimmy Carter explains that campaign promises are meant to be broken, so the American people shouldn't expect too much from him. He is sitting on a hay bale and munching on a bag of peanuts. In the next scene, he's a huckster pitching the Santi-Wrap, which is a red and green toilet seat cover that you put on Santa's lap before you sit down. Santa is extremely drunk and disorderly, and is played by Belushi. Then Frank Zappa plays "I'm the Slime," which is beyond question the weirdest musical guest situation available at the time, until he plays "Lagoon" in the second set and garners a special place in *Saturday Night* history for having his song interrupted by an impromptu appearance of Belushi's samurai character. The song has nothing to do with the character. Belushi may be a musician, but he is not demonstrating any real musical ability when his character interrupts the song. The band, unfazed by a sudden complete change of plans because they do after all work with Zappa, begins to follow the samurai's lead and do so with musical precision for over a minute before Zappa resumes control of the situation.

So far, we have Belushi playing one of few stars huge enough to dwarf the charisma of Candice Bergen, a very sloppy Santa Claus, and a dangerously interruptive character based on exaggerated cultural stereotype. But it gets worse! Belushi also plays himself, in a sketch where Bergen puts the word out that Belushi needs a place to go for Christmas because his girlfriend has kicked him out for being a dog. Belushi says that his only requests for his adoption are that he go to a home where the

holiday dinner is stuffed with drugs, he'll have a new car at his disposal, and maybe an under-aged daughter with whom to pal around. Why can't he just go home with Candy? A half hour ago, she said she was pining away for him. It was so obviously untrue that trying to extend the premise wouldn't last another scene. To try that joke the first time was already to risk beating it to death or finding it dead on arrival. Candy just keeps playing the straight-woman to Belushi's jokester. She also plays it for Aykroyd as Irwin Mainway in the recurring "Consumer Probe" sketch where he is the purveyor of a variety of terrible and dangerous toys for kids that she patiently attempts to debunk to no avail.

At no point during any of this macho bullshit does Candice Bergen break character and laugh at anything these men say to her. She famously lost her shit during her one scene with no men in it. She and Gilda Radner were doing a public service promo for the Right to Extreme Stupidity League—which apparently has no men in it? Radner is playing a super dumb girl, and Bergen's character is slightly and smartly coaching her through their moment, right up until Bergen forgets which of them has which name. She uses her own character's name on Radner, immediately realizes her mistake, and instead of fumbling for cover, she bursts out laughing. She doesn't even bother trying to hide it or collect herself. She laughs for a full minute longer while Radner turns to the camera and finishes the scene in between her own adorable crack-ups. They are having so much fun at nobody's expense but their own. The scene went fine and ended up with more chuckles than the Extreme Stupidity League could've collected on its own merits, in which the sole premise is that extreme stupidity should be considered "a God-given American right."

Radner seldom had to play the straight-woman. She was just

too funny, and she almost never broke character. Her most famous recurring bit, Roseanne Roseannadanna, was predicated upon the idea that women are dumb and first aired in a segment called "Hire the Incompetent." But before that there was Emily Litella, a frumpy old deaf lady who mistakenly took issue with a variety of non-issues in her Op-Ed portion of the long-running "Weekend Update" segment. The Christmas Special was Jane Curtain's fourth episode as official anchor of "Weekend Update," and it was Emily Litella's first appearance in the sketch since Chevy Chase bailed out. At the end of her mistaken rant and subsequent recant once she realizes the issue is UNICEF and not "unisex," Emily looks over at Jane and asks "Miss Clayton," not Curtain, why she hasn't been invited to be on "Weekend Update" that often anymore. Jane smiles coldly into the camera, gives Radner's arm a squeeze, and suggests she work on funnier bits than "unisex." Emily says she'll try. Jane says good. Emily smiles into the camera and calls Jane a bitch. Thunderous applause, and the scene ends with Emily leaving while Jane shoots eye-daggers at her back.

These daggers may or may not be real. Certainly, they are convincing. But let me not mistake passion for earnestness! Surely Jane Curtain and Gilda Radner loved each other as dearly as sisters, holding fast to their bond as two very funny ladies trapped in a sea of coke-addled beer-bellies at what is supposed to have been the pinnacle of personal success at the epicenter of American comedic history. Radner and Curtain were so different, and both utterly singular in their shared moment. Gilda could do voices and characters, really warm and silly people. Curtain was always doing parts that were just some version of herself, a smart cookie with good instincts and a no-nonsense attitude that forced her into the straight-woman role. Kind of a feminist and

kind of a leftist and pretty unkind about the boozy atmosphere at *Saturday Night*, she was so good at not breaking character that just as in that first bit with Litella, it was often very difficult to tell if Curtain was kidding.

Putting her on "Weekend Update" was a no-brainer. No matter how unusual or hilarious the news was, she could report it without cracking. She is the original queen of deadpan, keeping cool in the face of ridiculous emotional outbursts like Aykroyd regularly beginning to make some point by first declaring, "Jane, you ignorant slut!" In the Christmas Special "Weekend Update" opener, Jane and her husband have not noticed the camera is rolling. He is begging her to quit anchoring for housewiving, and she says she has to earn their living so he can keep sitting around working on his alleged book project. Jane Curtain was the first lead female anchor on "Weekend Update," and it would be twenty years before *SNL* had another one.

For me, the oddest moment in the December eleventh episode is the Gary Weis video. If I'm not mistaken, the two bedrock criteria for airing something on *SNL* are that the segment be funny and that the segment be relevant. Funny because "live" and relevant because "Saturday night," right? And yet, here is three minutes of documentary film about Diana Nyad, the twenty-five year-old marathon swimmer who did her thing around the island of Manhattan in just under eight hours. It is not funny whatsoever. The film is inspirational and motivating, all in all quite serious. It's also not exactly tied to this particular Saturday night, since Nyad's Manhattan triumph had occurred way back in the fall of '75. On October 6, to be exact, which also happens to be my birthday. I remember being startled by my own feeling of how cool it was that she had accomplished this profound and weird

non-sequitur on my birth date, the unusual joy of knowing my special day aligns with a gorgeous irrelevance like that. Maybe I, too, can make history in that way. The video fades to black as Diana Nyad concludes, "for, after the pain, the cold, the hours, the distance, after the fatigue and the loneliness—after all this, comes my emergence. And my emergence is what it's all about."

At age thirty-three right now, I'm just trying to get a fucking handle on my emergence. You know what John Belushi and Lester Bangs were doing at my age? Dying of drug overdoses! Meanwhile, every single one of the blondies we've been discussing is still going strong—except Marilyn Monroe, which must have implications for her intellect.

EPITAPH

Plenty of Room at the Hotel California ... Four More Years ...
Fear & Loathing Above All ...

didn't talk about the attempted assassination of Bob Marley. We skipped the premiere of *Rocky*, the world's most forgiving movie franchise. Those two things happened on the same day! I also have opinions about the message of *The Selfish Gene* and the Nobel Peace Prize not being awarded this year, about the deaths of Jack Cassidy and Richard J. Daley. Jesus Christ on a cracker, the Eagles did *Hotel California* in 1976 and rated barely a mention here.

There's a ton of stuff I researched that didn't make it into this collection because it didn't jive for whatever reason, or it did fit but then a book must always come to an end anyway. I know there are those who've trudged begrudgingly to the finish line of this majestic tome waiting for the barbarians. And there are probably an equal number who've melted gratefully into the ebb and spin of the situation, hoping now at the revelations bit that I am not the destroyer of worlds.

Maybe I will do a sequel about 1981, but what the hell happened in 1981 besides the birth of me? I'm sure I could figure it out, let it be same, same but different. The importance never arrives though. These things are really about process over product, which is symbolic of our collective human journeying throughout blah blah blah. Let's talk about Fleetwood Mac. *Rumours* is coming in 1977, a rough beast slouching toward a Bethlehem soon to be presided over by Ronnie Reagan. That's somebody's fault, I guess. Those who don't learn from the mistakes of the past are groomed to eat them, with a bottomless cup of platitudes.

Anything I say epiloguously might well ruin it all, and if that's the way you feel about turning our last page together, please do kindly take a few steps to the right and quietly form a line single-file behind the problem of I do not give a damn what you think.

This head is heading to Maui instead of dealing, trading my own windiness for the trade winds. I'm going my own fucking way, as usual.

This is the longest sunset of my life, flying from east coast to west, gaining three hours of imaginary time by chasing the sun into the horizon over the course of five actual hours trapped in an iron balloon hurtling toward someone's idea of a city of angels. And the Percocet is about to kick in, so I'm thinking about how someone once posited that time is a flat circle. Next week is the new year and everyone is clamoring for peak levels of self-reflection, struggling to adequately conclude something— anything, really.

1976

ABOUT THE AUTHOR

Megan Volpert writes for *PopMatters* and is the author of seven books on communication and popular culture, including two Lambda Literary Award finalists. She has been teaching high school English in Atlanta for a decade and was 2014 Teacher of the Year. She edited the American Library Association-honored anthology *This assignment is so gay: LGBTIQ Poets on the Art of Teaching*. See meganvolpert.com for more.

ABOUT THE ILLUSTRATOR

Asher Haig graduated from the department of Comparative Literature at Emory University with a Ph.D in artificial intelligence and psychoanalysis. His dissertation formally defined the logical requirements for building Artificial General Intelligence, which he is presently executing as the company StrongAI. His illustration work is the product of many strange intersections with this pursuit, exploring problems of dimensionality internal to the emergence of chaos found in the representation of environments.

ABOUT THE PRESS

Sibling Rivalry Press is an independent press based in Little Rock, Arkansas. Its mission is to publish work that disturbs and enraptures. This book was published in part due to the support of the Sibling Rivalry Press Foundation, a non-profit private foundation dedicated to assisting small presses and small press authors.

ACKNOWLEDGMENTS

Thanks to the following publications, in which some form of some parts of this book originally appeared: *Frontier Psychiatrist*, *Hobble Creek Review*, *Fall Lines*, *Creative Thresholds*, and *Loose Change*. And of course, very many high fives to Karen Zarker and the gang at *PopMatters*.

CPSIA information can be obtained
at www.ICGtesting.com
Printed in the USA
FSOW04n1935250217
31162FS